Claude Monet

Authors: Nina Kalitina and Nathalia Brodskaia

Designed by:
Baseline Co Ltd
61A-63A Vo Van Tan Street
4th Floor
District 3, Ho Chi Minh City
Vietnam

© 2011 Confidential Concepts, worldwide, USA
© 2011 Parkstone Press International, New York, USA

ISBN: 978-1-84484-902-4

Printed in China

Nina Kalitina and Nathalia Brodskaia

Claude Monet

PARKSTONE
INTERNATIONAL

Claude Monet

Contents

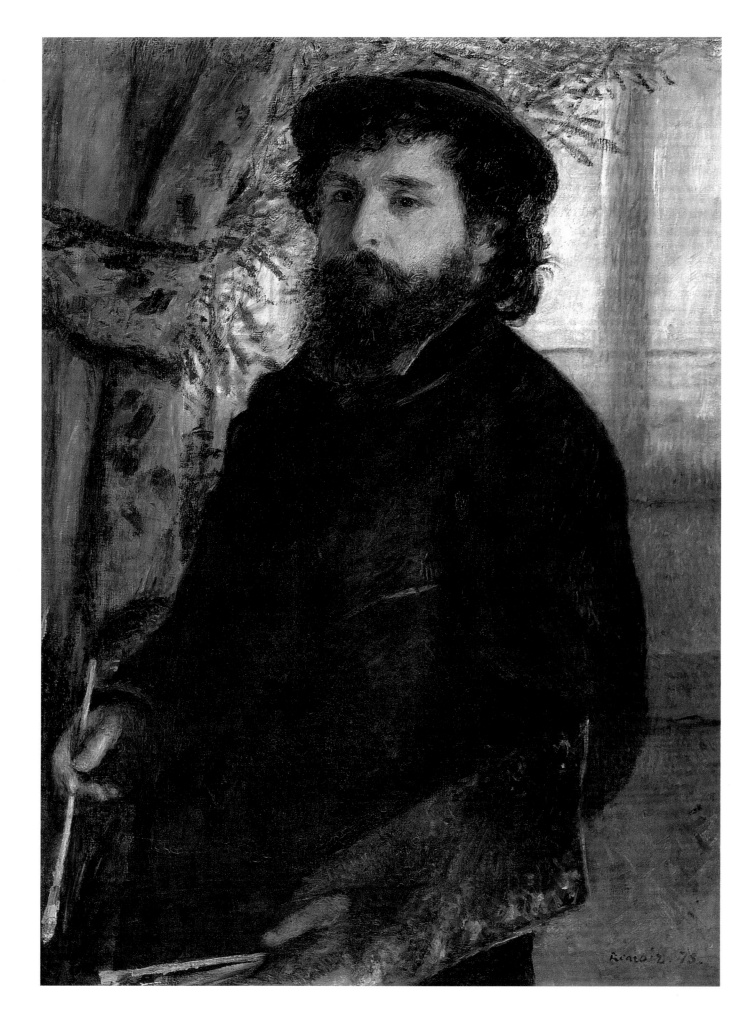

The Beginnings of Impressionism

The term Impressionism not only designates a trend in French art, but also a new stage in the development of European painting. It marked the end of the neo-classical period that had begun during the Renaissance. The Impressionists did not entirely break with the theories of Leonardo da Vinci and the rules according to which all European academies had conceived their paintings for over three centuries. All the Impressionists had more or less followed the lessons of their old-school professors, each of them having their preferred old masters. But for the Impressionists, their vision of the world and their concept of painting had changed. The Impressionists cast doubt on painting's literary nature, the necessity of always having to base a painting on a story, and consequently, its link to historical and religious subjects. They chose the genre of landscape because it only referred to nature and nearly all the Impressionists started their artistic itinerary with the landscape. It was a genre that appealed to observation and observation alone, rather than to the imagination, and from observation came the artist's new view of nature, the logical consequence of all his prior visual experience: it was more important to paint what one saw, rather than how one was taught – that was a fact! It was impossible to see the workings of nature within the confines of the studio, so the Impressionists took to the outdoors and set up their easels in fields and forests. The close observation of nature had a power which was, until then, undreamt of. If the natural landscape was incompatible with the traditional concept of composition and perspective, then artists had to reject academic rules and obey nature. If traditional pictorial technique stood in the way of conveying the truths artists discovered in nature, then this technique had to be changed. A new style-genre of painting that lacked traditional finish and often resembled a rapid oil sketch appeared in the works of the Impressionists. But the Impressionists still lacked a new aesthetic theory that could replace tradition. Their one firm conviction was that they could employ any means to arrive at truth in art. "These daredevils assumed that the work of the artist could be done without professing or practising a religious respect of academic theories and professional practices," wrote one critic, three years after the first Impressionist exhibition in 1877. "To those who ask them to formulate a program, they cynically reply that they have none. They are happy to give the public the impressions of their hearts and minds, sincerely, naively, without retouching." (L. Venturi, op. cit., vol. 2, p. 330).

Painters born circa 1840 entered the field of art already armed with the notion that they could use subjects from everyday life, but in the early nineteenth century, France still had the most conservative attitude in Europe when it came to landscape painting. The classically composed landscape, although based on a study of details from nature, such as the observation of trees, leaves, and rocks, reigned over the annual Salon. The Dutch masters, however, had started painting the well-observed living

Pierre-Auguste Renoir,
Claude Monet, 1875.
Oil on canvas, 85 x 60.5 cm.
Musée d'Orsay, Paris.

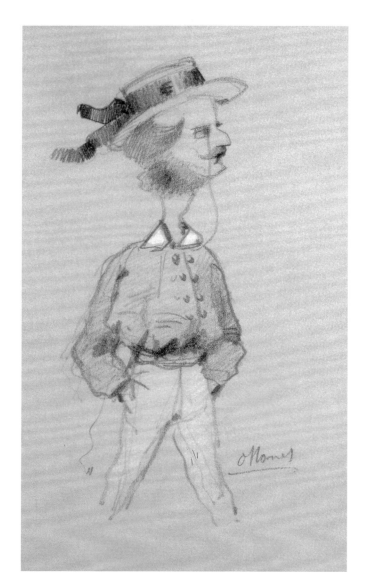

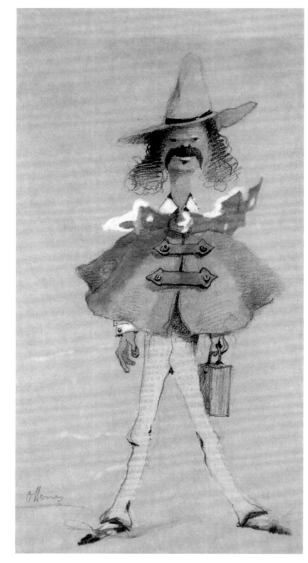

Man with a Boater Hat, 1857.
Pencil on paper, 24 x 16 cm.
Musée Marmottan, Paris.

The Painter with a Pointed Hat, 1857.
Pencil and gouache on paper.
Private collection, Paris.

Black Woman Wearing a Headscarf,
1857.
Charcoal and watercolour on paper,
24 x 16 cm.
Musée Marmottan, Paris.

nature of their country in the seventeenth century. In their small, modest canvases appeared various aspects of the real Holland: its vast sky, frozen canals, frost-covered trees, windmills, and charming little towns. They knew how to convey their country's humid atmosphere through nuanced tonalities. Their compositions contained neither classical scenes nor theatrical compositions. A flat river typically ran parallel to the edge of the canvas, creating the impression of a direct view onto nature. Elsewhere, the Venetian landscape painters of the eighteenth century gave us the specific landscape genre of the veduta. The works of Francesco Guardi, Antonio Canaletto, and Bernardo Bellotto have a theatrical beauty built upon the rules of the neoclassical school, but they depict real scenes taken from life; indeed, they were so noted for such topographical detail that they have remained in the history of art for their documentary evidence of towns long since destroyed. Moreover, the vedute depicted a light veil of humid mist above the Venetian lagoons and the particularly pellucid quality of the air over the riverbanks of the island of Elba. The future Impressionists also had a keen interest in painters whose work had yet to find its way into museums, such as the

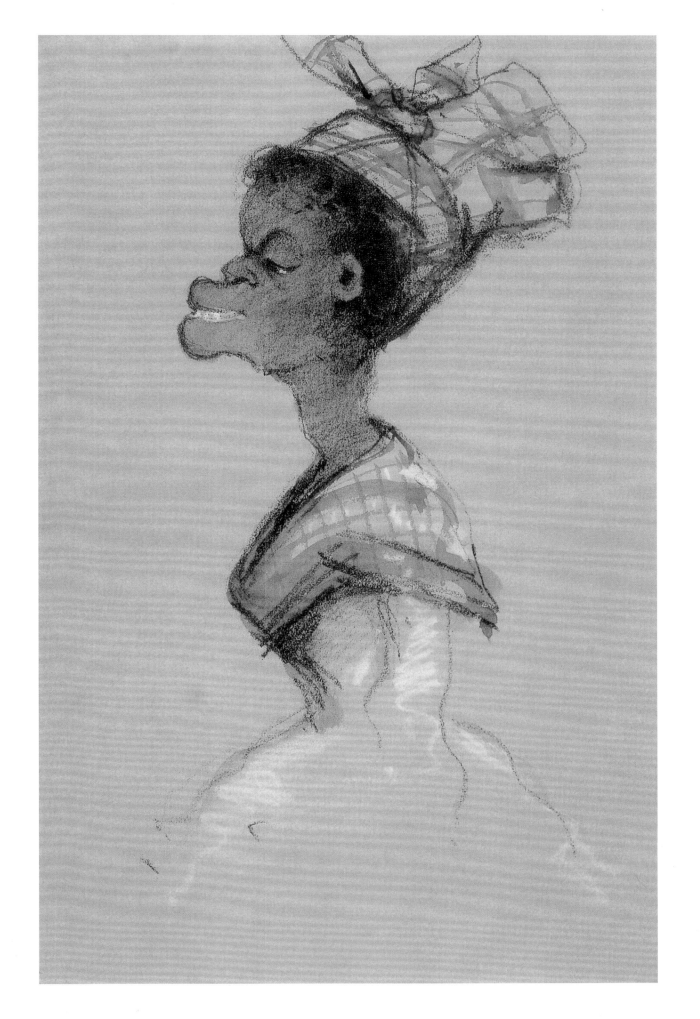

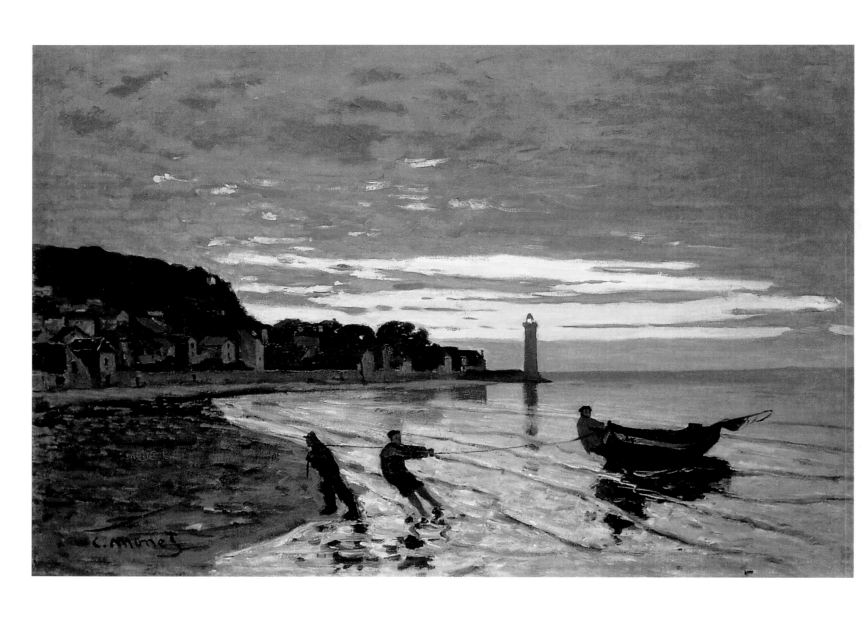

sketching club founded in England in the late eighteenth century. Its members, who worked directly from nature and specialised in light landscape sketches, included Richard Parkes Bonington, who died in 1828 at the age of twenty-six. Bonnington's watercolour landscapes had a novel limpidity and grace as well as the subtle sensation of the surrounding air. A large part of his life had been spent in France, where he studied with Antoine-Jean Gros and was close to Delacroix. Bonnington depicted the landscapes of Normandy and the Île-de-France: locations where all the Impressionists would later paint. The Impressionists were probably also familiar with the work of the English painter John Constable, from whom they may have learned how to appreciate the integrity of landscape and the expressive power of painterly brushwork. Constable's finished paintings retain the characteristics of their sketches and the fresh colour of studies done after nature. And the Impressionists surely knew the work of Joseph Mallord William Turner, acknowledged leader of the English landscape school for sixty years until 1851. Turner depicted atmospheric effects; fog, the haze at sunset, steam billowing from a locomotive, or a simple cloud became motifs in and of themselves.

His watercolour series entitled "Rivers of France" commenced a painterly ode to the Seine that the Impressionists would later take up. In addition to this, Turner painted a landscape with Rouen Cathedral, which was a predecessor of Monet's own well-known Rouen Cathedral series. Professors at the École des Beaux-Arts in mid-nineteenth-century Paris were still teaching the historical landscape based on the ideal models created in seventeenth-century France by Nicolas Poussin and Claude Lorrain. The Impressionists, however, were not the first to rebel against clichéd themes and to stand up for a realistic and personal style of painting. Pierre Auguste Renoir told his son of a strange encounter he had in 1863 in Fontainebleau forest. For whatever reason, a group of young ruffians did not like the look of Renoir, who was painting in the midst of nature dressed in his painter's smock. With a single kick, one of them knocked the palette out of Renoir's hands and caused him to fall to the ground. One of the girls struck him with a parasol ('in my face, with the steel-tipped end; they could have put my eyes out!'), but suddenly, emerging from the bushes, a man appeared. He was about fifty years old, tall and strong, and he too was laden with painting paraphernalia. He also had a wooden leg and held a heavy cane in his hand. The newcomer dropped his things and rushed to the rescue of his young fellow painter. Swinging his cane and his wooden leg, he quickly scattered the attackers. Renoir was able to get up off the ground and join the fight and in no time the two painters had managed to successfully stand their ground, sending the troublemakers off. Oblivious to the thanks coming from the person he had just saved, the one-legged man picked up the fallen canvas and looked at it attentively. "'Not bad at all. You are gifted, very gifted…' The two men sat down on the grass, and Renoir spoke of his life and modest ambitions. Eventually the stranger introduced himself. It was Diaz." (J. Renoir, op. cit., pp. 82-83).

Towing a Boat, Honfleur, 1864.
Oil on canvas, 55.2 x 82.1 cm.
Memorial Art Gallery, University of Rochester, Rochester.

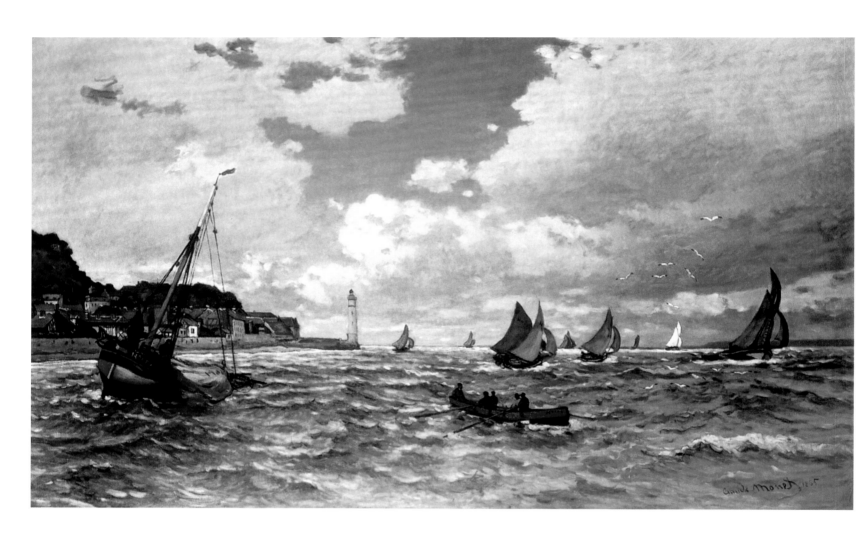

Mouth of the Seine at Honfleur, 1865.
Oil on canvas, 89.5 x 150.5 cm.
The Norton Simon Foundation,
Norton Simon Museum, Pasadena.

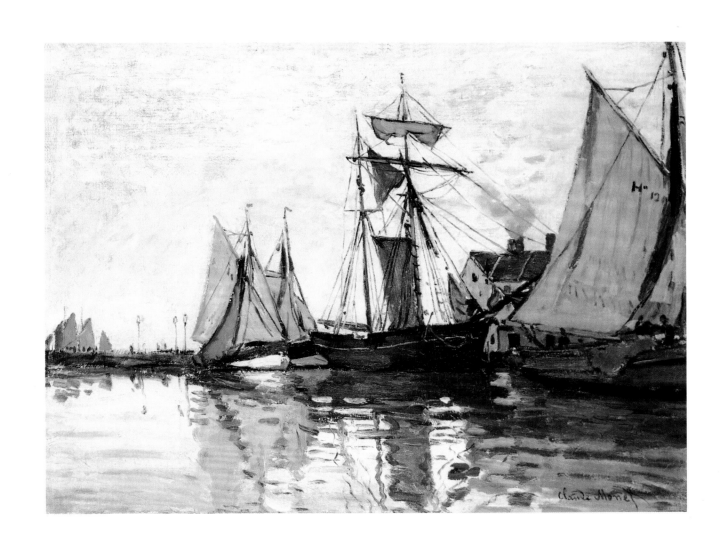

The Port of Honfleur, c. 1866.
Oil on canvas.
Private collection.

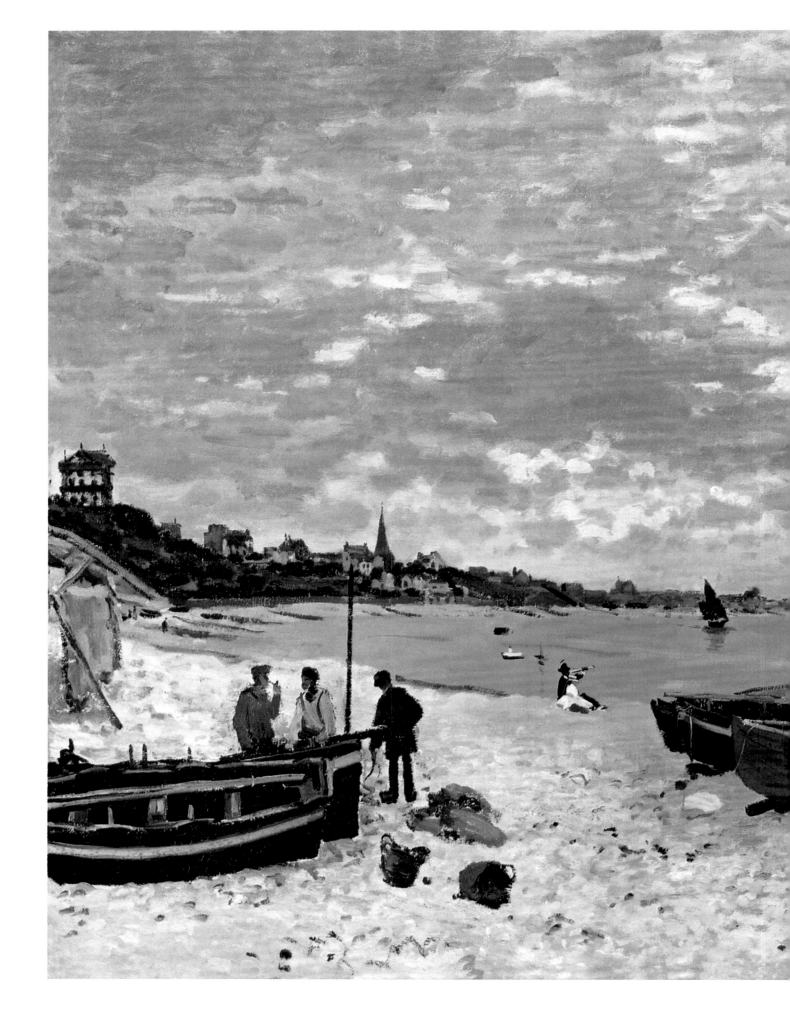

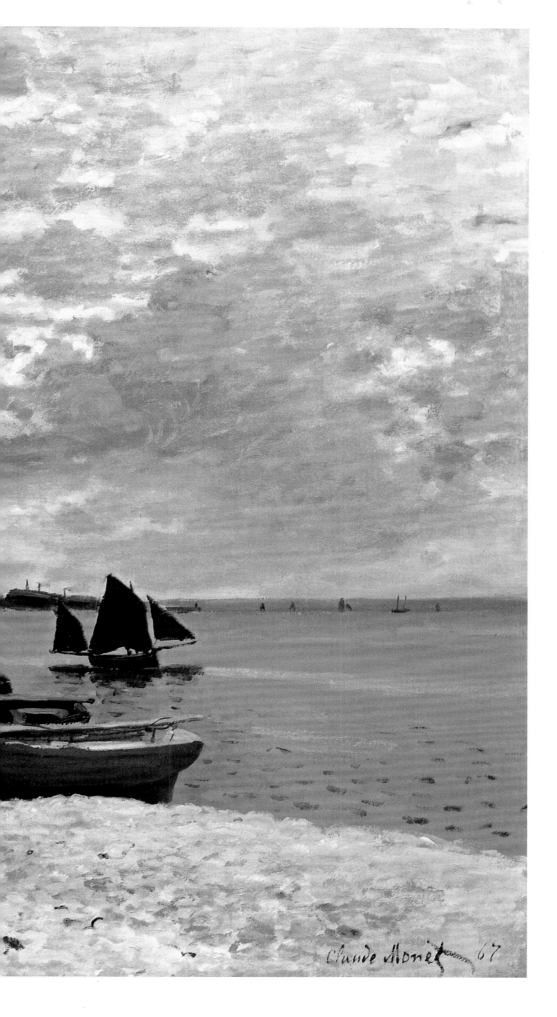

The Beach at Sainte-Adresse, 1867
Oil on canvas, 75.8 x 102.5 cm.
The Art Institute of Chicago, Chicago.

Narcisse Virgilio Diaz de la Peña belonged to a group of landscape painters known as the Barbizon School. The Barbizon painters came from a generation of artists born between the first and second decades of the nineteenth century. Almost fifty years separated them from the Impressionists. The Barbizon painters had been the first to paint landscapes after nature. It was only fitting that Renoir met Diaz in Fontainebleau forest. The young painters of the Barbizon School were making traditional classic landscapes, but by the 1830s this activity no longer satisfied them. The Parisian Théodore Rousseau had fallen in love with landscape in his youth while travelling throughout France with his father. According to his biographer: "One day, on his own and without telling anyone, he purchased paints and brushes and went to the hill of Montmartre, at the foot of the old church that carried the aerial telegraph tower, and there he began to paint what he saw before him: the monument, the cemetery, the trees, the walls, and terrain that rose up there. In a few days, he finished a solid detailed study with a very natural tonality. This was the sign of his vocation." (A. Sensier, Théodore Rousseau, Paris, 1872, p. 17).

Rousseau began painting "what he saw before him" in Normandy, in the mountains of the Auvergne, in Saint-Cloud, Sèvres, and Meudon. His first brush with fame was the Salon of 1833, well before the birth of the future Impressionists, when his *View on the Outskirts of Granville* (The State Hermitage Museum, St. Petersburg) caused a sensation due to its focus on a mediocre, rustic motif. A contemporary critic wrote that this landscape "is among the most realistic and warmest in tone of anything the French School has ever produced." (A. Sensier, op. cit., p. 38). Rousseau had discovered a sleepy little village called Barbizon at the entrance of the forest of Fontainebleau. There he was joined by his friend Jules Dupré and the aforementioned Narcisse Diaz de la Peña. Another of Rousseau's painter friends who often worked at Barbizon was Constant Troyon. In the late 1840s, Jean-François Millet, known for his paintings of the French peasantry, moved to Barbizon with his large family. Thus was born the group of landscape painters that came to be known as the Barbizon School. However, these landscape artists only executed studies in the forest and fields, from which they subsequently composed their paintings in the studio. Charles-François Daubigny, who also sometimes worked at Barbizon, took the idea further than the others. He established himself at Auvers on the banks of the Oise and built a studio-barge he called the *Bottin*. Then the painter sailed the river, stopping wherever he wished to paint the motif directly before him. This working method enabled him to give up traditional composition and to base his colour on the observation of nature. Daubigny would later support the future Impressionists when he was a jury member of the Salon. But Camille Corot was perhaps the closest to the Impressionists. He was living in the village of Ville-d'Avray near Paris. With characteristic spontaneity, Corot painted the ponds near his house, the reflection in their water of weeping willows, and the shaded paths that led into the forest. Even if his landscapes evoked memories of Italy,

The Chailly Road through the Forest of Fontainebleau, 1865.
Oil on canvas, 97 x 130.5 cm.
Ordrupgaard, Copenhagen.

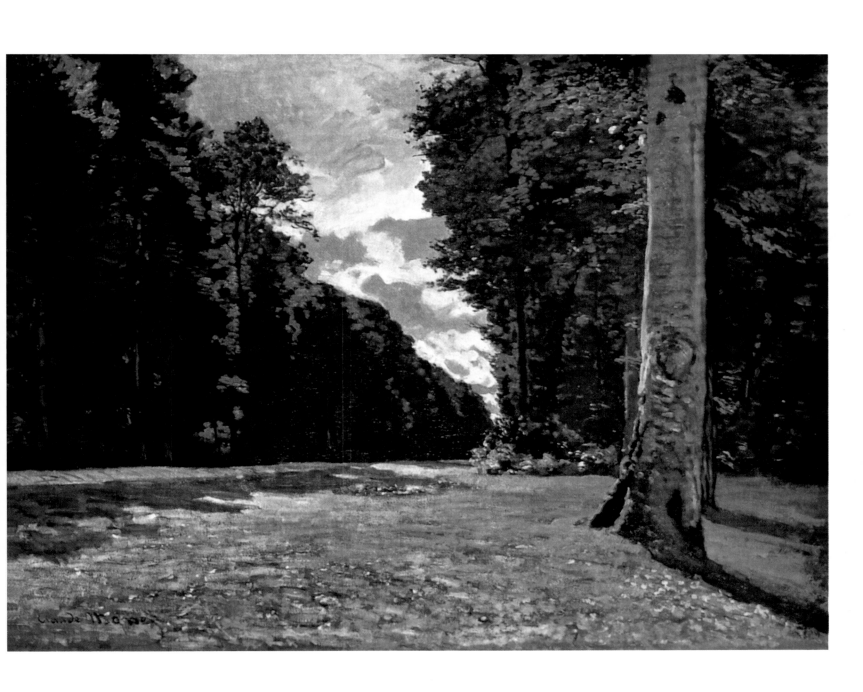

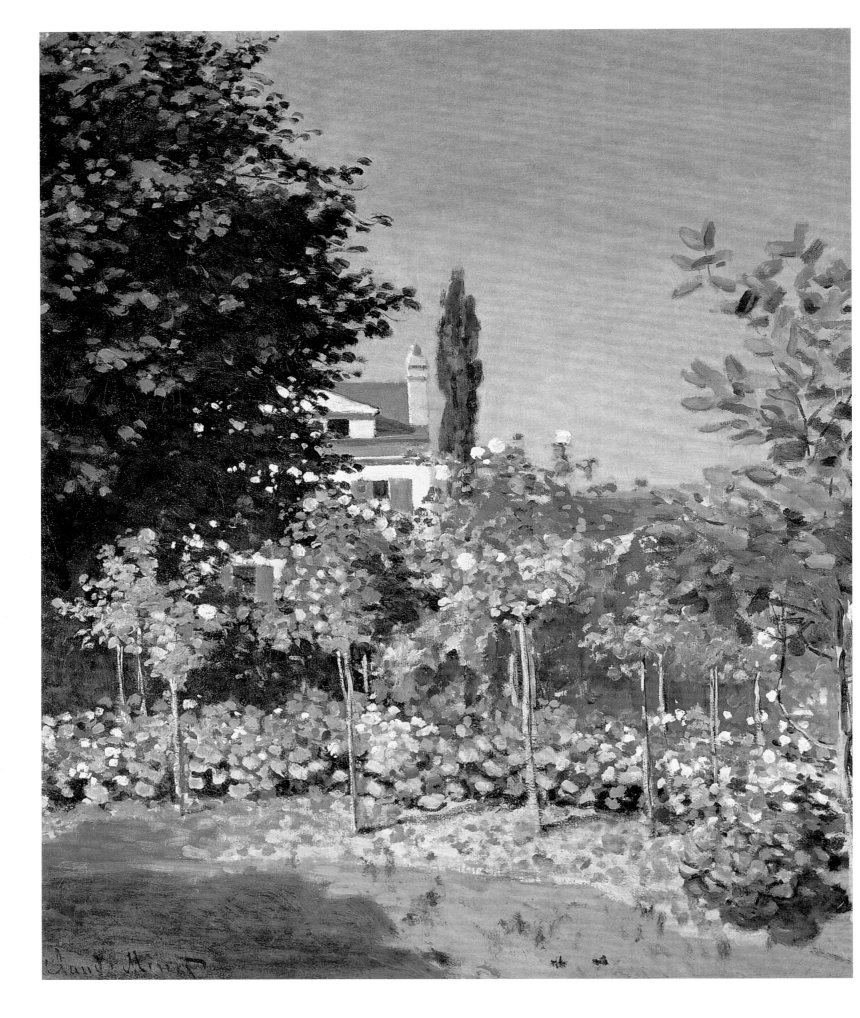

Ville-d'Avray was recognisable. No one was more sensitive to nature than Corot. Within the range of a simple grey-green palette he produced the subtlest gradations of shadow and light. In Corot's painting, colour played a minor role; its luminosity created a misty, atmospheric effect and a sad, lyrical mood. All these characteristics gave his landscapes the quality of visual reality and movement to which the Impressionists aspired.

Claude Monet – The Person

Gustave Geffroy, the friend and biographer of Claude Monet, reproduced two portraits of the artist in his biography. In the first, painted by an artist of no particular distinction, Monet is eighteen years of age. A dark-haired young man in a striped shirt, he is perched astride a chair with his arms folded across its back. His pose suggests an impulsive and lively character; his face, framed by shoulder-length hair, shows both unease in the eyes and a strong will in the line of the mouth and the chin. Geffroy begins the second part of his book with a photographic portrait of Monet at the age of eighty-two. A stocky old man with a thick white beard stands confidently, his feet set wide apart; calm and wise, Monet knows the value of things and believed only in the undying power of art. It was not by chance that he chose to pose with a palette in his hand in front of a panel from the *Waterlilies* series. Numerous portraits of Monet have survived over the years — self-portraits, the works of his friends (Manet and Renoir among others), photographs by Carjat and Nadar — all of them reproducing his features at various stages in his life. Many literary descriptions of Monet's physical appearance have come down to us as well, particularly after he had become well known and much in demand by art critics and journalists.

How then does Monet appear to us? Take a photograph from the 1870s. He is no longer a young man but a mature individual with a dense black beard and moustache, only the top of his forehead hidden by closely-cut hair. The expression of his brown eyes is decidedly lively, and his face as a whole exudes confidence and energy. This is Monet at the time of his uncompromising struggle for new aesthetic ideals. Now take his self-portrait in a beret dating from 1886, the year that Geffroy met him on the island of Belle-Île off the south coast of Brittany. "At first glance," Geffroy recalls, "I could have taken him for a sailor, because he was dressed in a jacket, boots and hat very similar to the sort that they wear. He would put them on as protection against the sea breeze and the rain." A few lines later Geffroy writes: "He was a sturdy man in a sweater and beret with a tangled beard and brilliant eyes which immediately pierced into me."

In 1919, when Monet was living almost as a recluse at Giverny, not far from Vernon-sur-Seine, he was visited by Fernand Léger, who saw him as "a shortish

Garden in Blossom at Sainte-Adresse, 1866.
Oil on canvas, 65 x 54 cm.
Musée d'Orsay, Paris.

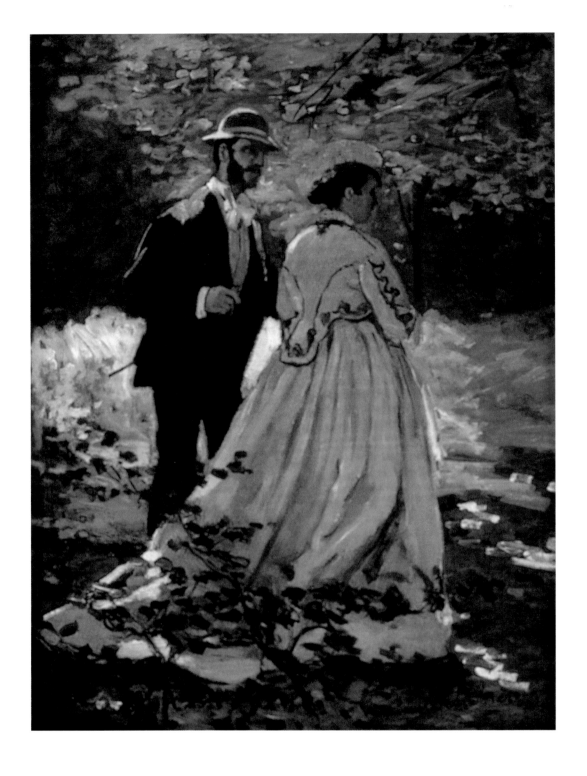

Bazille and Camille (study for
Déjeuner sur l'Herbe), 1865.
Oil on canvas, 93 x 68.9 cm.
National Gallery of Art,
Washington D.C.

Ladies in the Garden, 1866-1867.
Oil on canvas, 255 x 208 cm.
Musée d'Orsay, Paris.

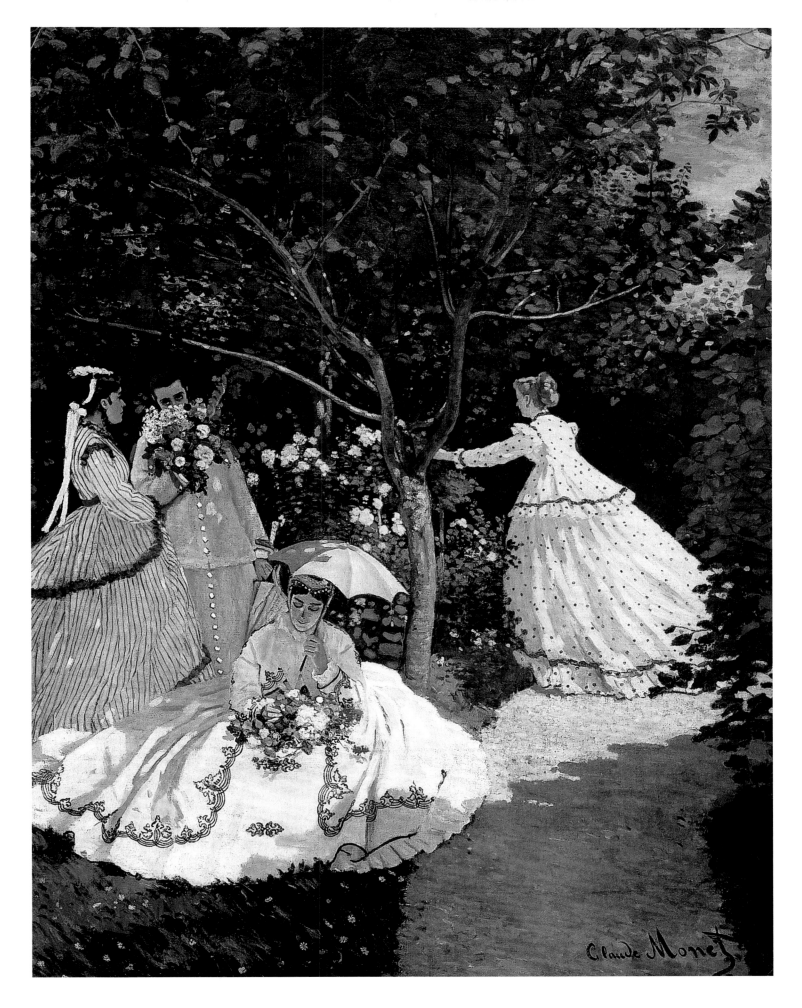

Claude Monet

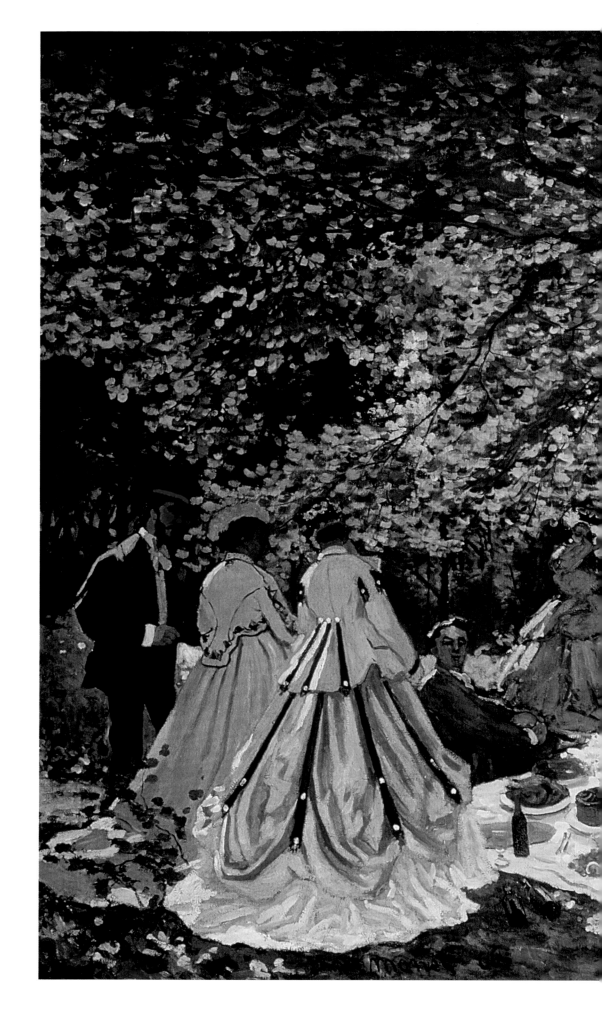

Le Dejeuner sur l'Herbe
(Luncheon on the Grass), 1866.
Oil on canvas, 248 x 217 cm.
Pushkin Museum of Fine Arts,
Moscow.

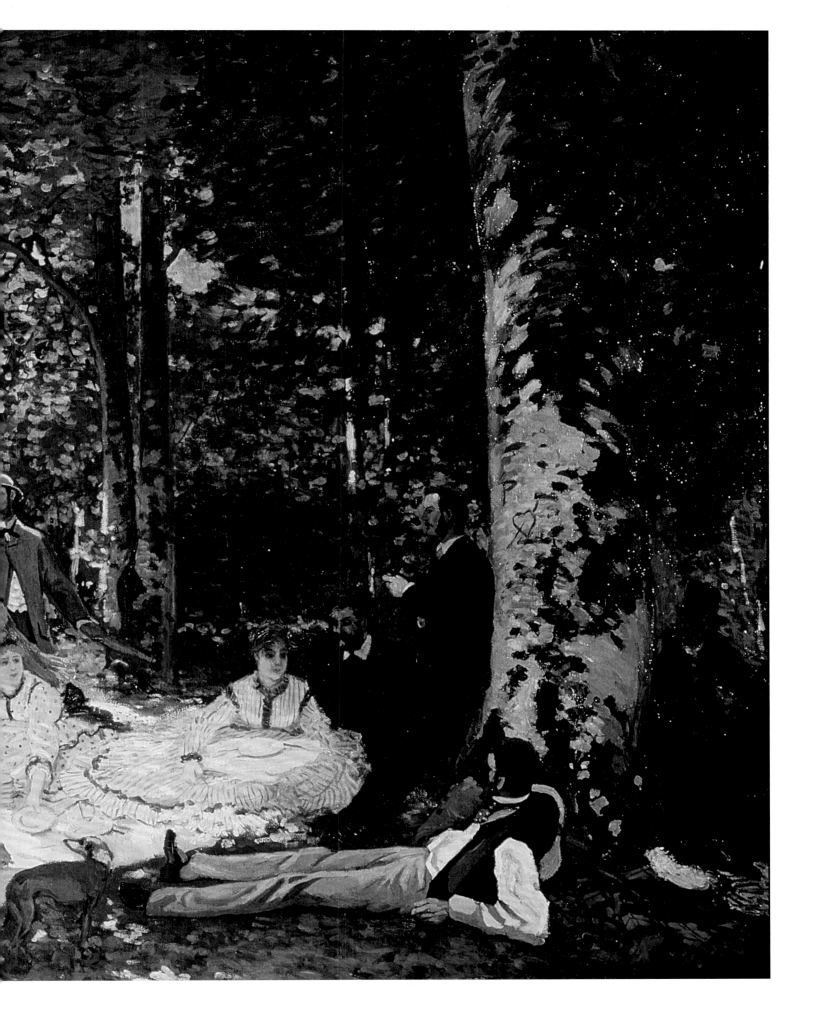

gentleman in a panama hat and elegant light-grey suit of English cut… He had a large white beard, a pink face, little eyes that were bright and cheerful but with perhaps a slight hint of mistrust…" Both the visual and the literary portraits of Monet depict him as an unstable, restless figure. He was capable of producing an impression of boldness and audacity or he could seem, especially in the latter years of his life, confident and placid. But those who remarked on Monet's calm and restraint were guided only by his external appearance. Both the friends of his youth, Bazille, Renoir, Cézanne, Manet, and the visitors to Giverny who were close to him — first and foremost Gustave Geffroy, Octave Mirbeau and Georges Clemenceau — were well aware of the attacks of tormenting dissatisfaction and nagging self-doubt to which he was prone. His gradually mounting annoyance and discontent with himself would frequently find an outlet in acts of unbridled and elemental fury, when Monet would destroy dozens of canvases, scraping off the paint, cutting them up into pieces, and sometimes even burning them. The art dealer Paul Durand-Ruel, to whom Monet was bound by contract, received a whole host of letters from him requesting that the date for a showing of paintings be deferred. Monet would write that he had "not only scraped off, but simply torn up" the studies he had begun. He would say that for his own satisfaction it was essential to make alterations, and that the results he had achieved were "incommensurate with the amount of effort expended", that he was in "a bad mood" or would even go so far as to say that he was "no good for anything."

Monet was capable of showing considerable civic courage, but was occasionally guilty of faint-heartedness and inconsistency. Thus, in 1872, Monet, together with the painter Eugène Boudin, visited the idol of his youth, Gustave Courbet in prison — an event perhaps not greatly significant in itself, but given the general hounding to which the Communard Courbet was subject at that time due not only to his political leanings but for suggesting the disassembly of the Column Vendôme, Monet and Boudin's act was both brave and noble. With regard to the memory of Edouard Manet, Monet was the only member of the circle around the former leader of the Batignolle group to take action upon hearing, in 1889, from the American artist John Singer Sargent that Manet's masterpiece *Olympia* might be sold to the United States. It was Monet who called upon the French public to collect the money to buy the painting for the Musée du Louvre. Again, at the time of the Dreyfus affair in the 1890s Monet sided with Dreyfus' supporters and expressed his admiration for the courage of Emile Zola. A more domestic episode testifies to the warmth of Monet's nature: after becoming a widower, he remarried in the 1880s. Alice Hoschedé had five children from her first marriage. Monet received them all with open arms and invariably referred to them as "my children".

There was, however, another side to Monet. In the late 1860s, suffering acutely from poverty and lack of recognition, Monet deserted his first wife Camille and

Woman in the Garden. Sainte-Adresse, 1867. Oil on canvas, 82 x 100 cm. The State Hermitage Museum, St. Petersburg.

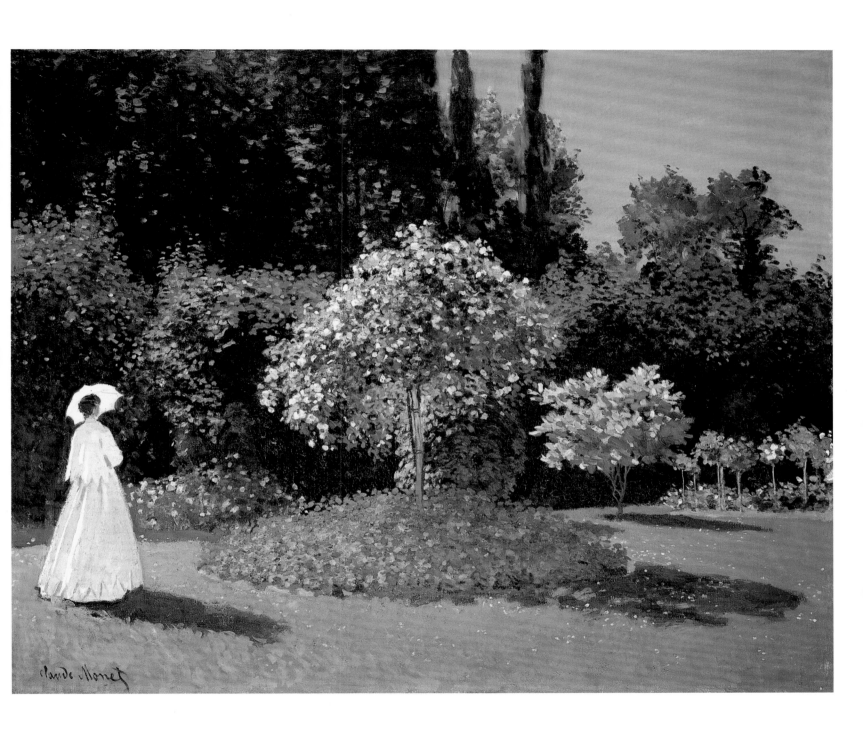

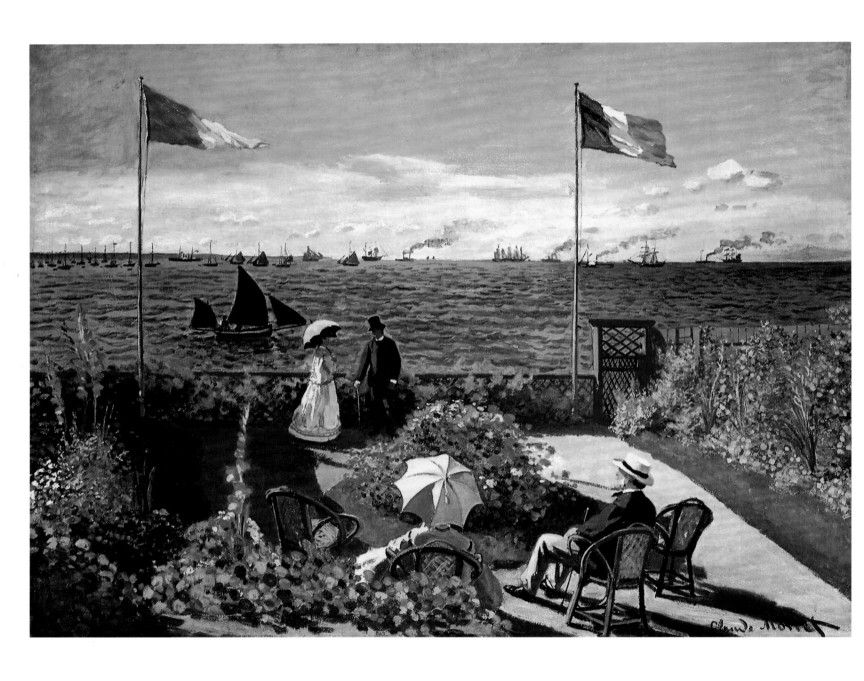

their young son Jean on several occasions, virtually abandoning them. Giving in to fits of despair, he would rush off somewhere, anywhere, just to change his surroundings and escape from an environment in which he had suffered personal and professional failure. On one occasion he even resolved to take his own life. Similarly hard to justify is Monet's behaviour towards the other Impressionists when, following Renoir's example, he broke their "sacred union" and refused to take part in the group's fifth, sixth and eighth exhibitions. Degas was not unjustified in accusing him of thoughtless self-advertising when he learned of Monet's refusal to exhibit with the Impressionists in 1880. Finally, Monet's hostile attitude to Paul Gauguin was quite indefensible. These examples make the contradictions of Monet's character quite clear.

The reader might justifiably ask: why write about personal features in an essay on an artist, particularly when some of these show Monet in a not especially attractive light?

It is always dangerous to divide a single, integral personality into two halves — on the one hand, the ordinary man with all the complexities and upheavals of his individual lot; on the other, the brilliant painter who wrote his name in the history of world art. Great works of art are not created by ideal people, and if knowledge of their personality does not actually assist us in understanding their masterpieces, then at least it can explain a great deal about the circumstances in which the masterpieces were created. Monet's abrupt changes of mood, his constant personal dissatisfaction, his spontaneous decisions, stormy emotion and cold methodicalness, his consciousness of himself as a personality moulded by the preoccupations of his age, set against his extreme individualism — taken together these features elucidate much in Monet's creative processes and attitudes towards his own work

Early Life

Oscar Claude Monet was born in Paris on November 14, 1840, but all his impressions as a child and adolescent were linked with Le Havre, the town to which his family moved about 1845. The surroundings in which the boy grew up were not conducive to artistic studies: Monet's father ran a grocery business and turned a deaf ear to his son's desire to become an artist. Le Havre boasted no museum collections of significance, no exhibitions and no school of art. The gifted boy had to be content with the advice of his aunt, who painted merely for personal pleasure, and with the directions of his school-teacher.

Yet the little boy began by drawing caricatures. He copied them from newspapers and magazines – caricature playing a central role in France's political life during the

The Terrace at Sainte-Adresse, 1867.
Oil on canvas, 98.1 x 129.9 cm.
The Metropolitan Museum of Art,
New York.

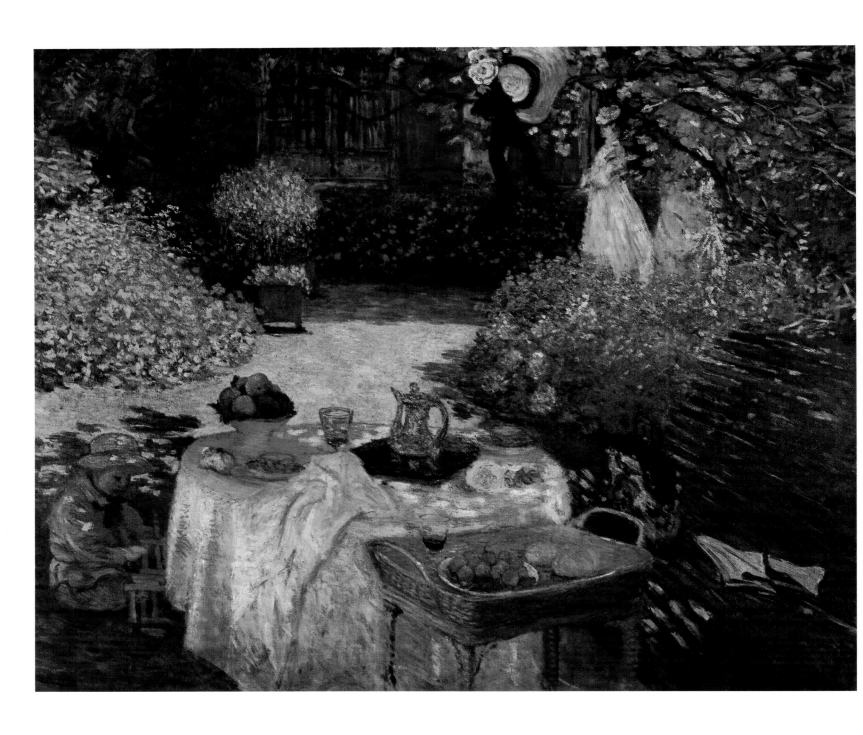

The Luncheon (decorative panel), 1868.
Oil on canvas, 160 x 201 cm.
Musée d'Orsay, Paris.

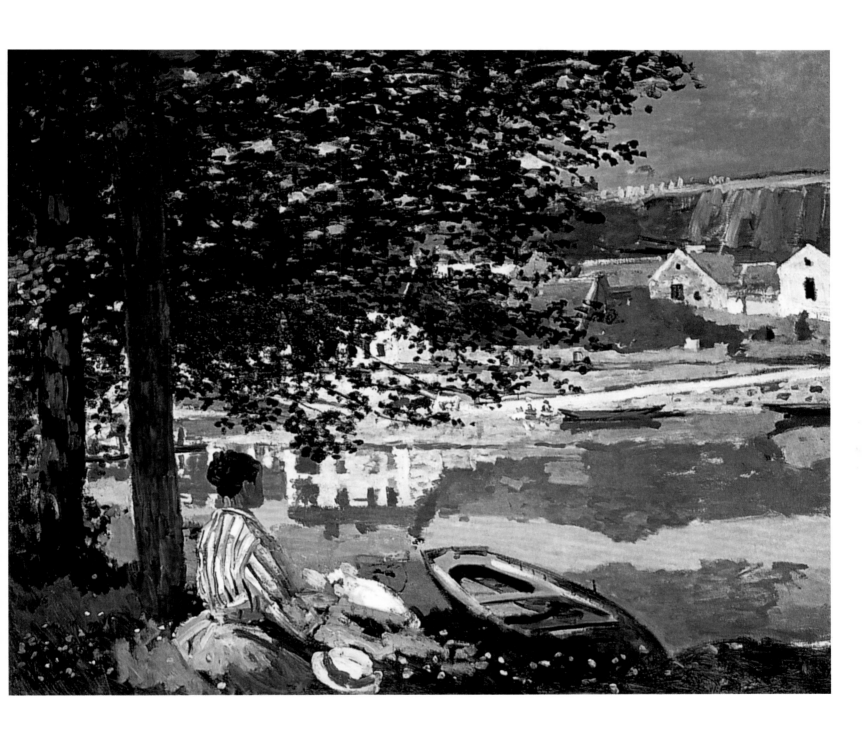

On the Bank of the Seine,
Bennecourt, 1868.
Oil on canvas, 81 x 100 cm.
The Art Institute of Chicago, Chicago.

mid-nineteenth century. In addition to his caricatures, the young Monet drew portraits for which his neighbours paid him. From the outset what is striking about his caricatures is the maturity and proficiency of the drawing, as well as a degree of experience surprising in a young man of eighteen. It is true that at sixteen years old Monet was already taking drawing classes with professor François-Charles Ochard, a former student of the famed Jacques-Louis David. But the way his models are individualised, the accuracy of the drawing, and the clever simplification of the figures' distinctive traits all testified to the artist's brilliant individuality and to his talent, which went beyond the modest abilities of a copyist.

During this period, he signed his drawings "Claude". There was a frame shop next to his father's store, and its display window became the site of Monet's first "exhibitions." A local painter by the name of Eugène Boudin also exhibited there. Boudin's seascapes seemed baffling and repellent to Monet, as they did to many others. All the same, this odd painter took note of the drawings done by Monet, who was practically still a child at the time. One day, as Monet recalled it, Boudin told him that he always enjoyed looking at his caricatures, that they were funny, and that they had been drawn with intelligence and fluency. Boudin believed Monet's talent was obvious even from the first glance, but that he should not let it rest there. In addition to the natural talent displayed in his cartoons, Monet still needed to learn to see, to paint, and to draw. Boudin advised Monet to stop doing caricatures and to take up landscape painting instead. The sea, the sky, animals, people, and trees are beautiful in the exact state in which nature created them – surrounded by air and light. For Boudin himself, painting meant landscapes alone. He felt a warm attachment and a great sense of responsibility for Monet's education and progress as an artist. He explained to his young colleague that the Romantics had seen their day and that now one had to work in a different way. The charm of Boudin's own canvases came from their spontaneity. When he endeavoured to complete a landscape successfully it lost that sincerity which, in his small studies, could make the viewer feel the cool gusts of the ocean breeze and the gentle rustling of shingles on the beach.

Monet said later that Boudin's exhortations made no impact at first: he hardly paid attention to his words and always found an excuse not to go work with Boudin in the open air. He wasn't yet able to digest Boudin's strange, unusual work. Nevertheless, as Monet said himself, he liked this man. He had conviction, and he was sincere. During the summer Monet was relatively free and had run out of good excuses for declining Boudin's offer to work alongside him. The latter, in spite of everything, set about to oversee Monet's apprenticeship, and together they would paint studies along the seashore. "Eventually my eyes were opened," admitted Monet, "and I really understood nature. I learned to love at the same time" (D. Wildenstein,

Bougival Bridge, 1870.
Oil on canvas, 65 x 91.5 cm.
The Currier Gallery of Art, Manchester, New Hampshire.

The Luncheon, 1868.
Oil on canvas, 232 x 151 cm.
Städelsches Kunstinstitut und Städtische Galerie, Frankfurt am Main.

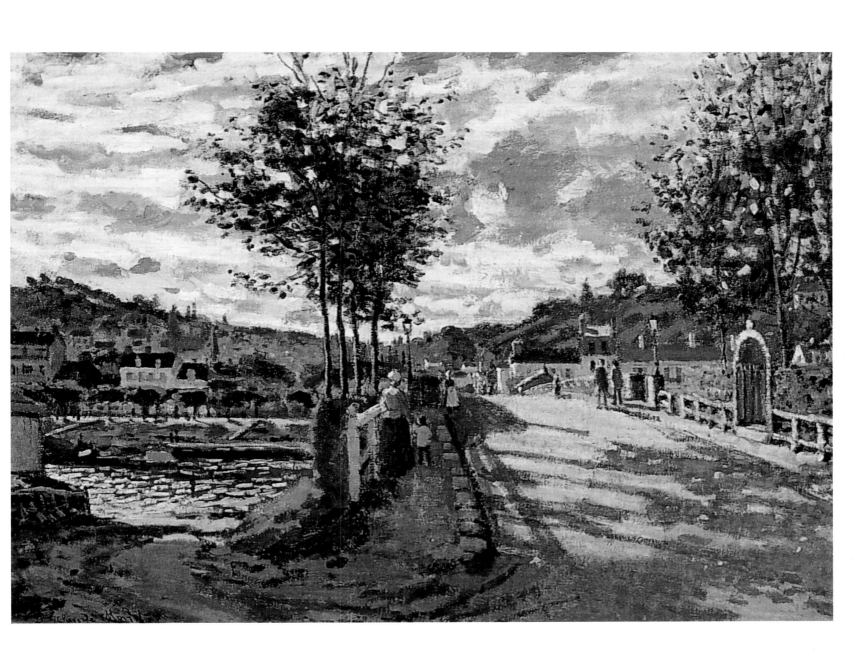

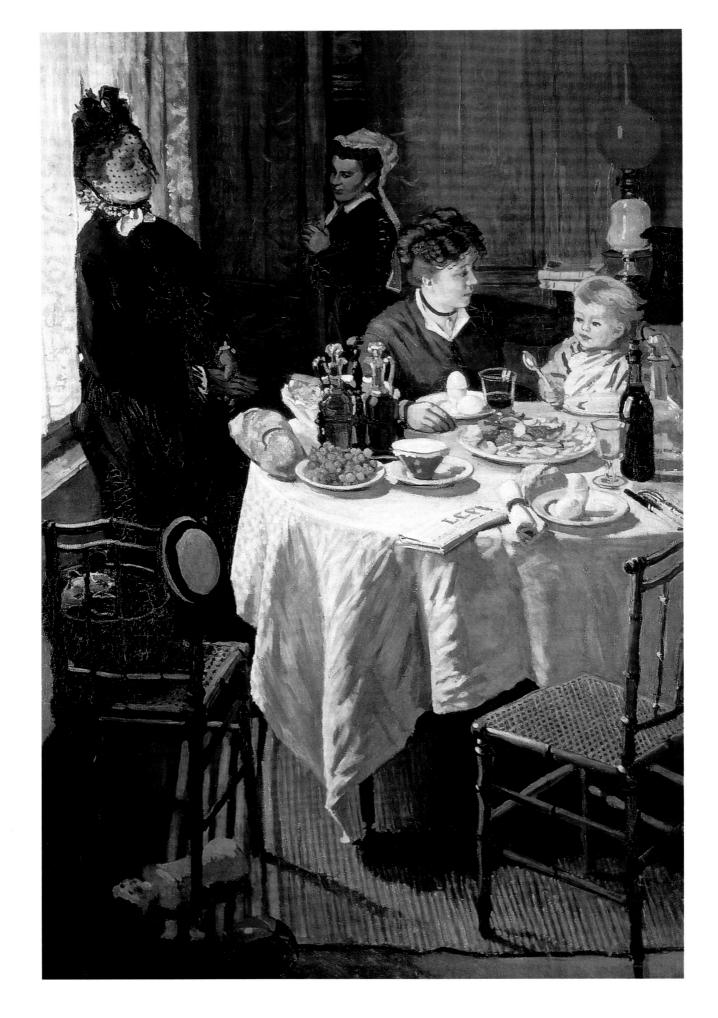

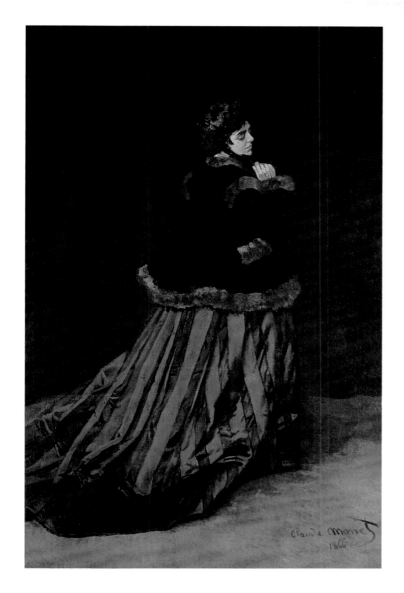

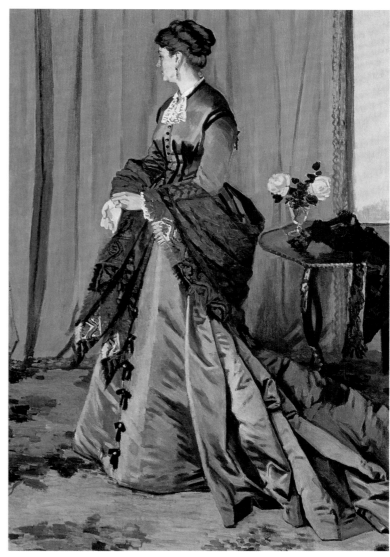

Claude Monet, Paris, 1974, p. 13). Boudin's own talent had developed in the same way, through direct contact with nature. He had previously been the owner of that same frame shop where Monet was exhibiting his caricatures. Boudin showed his own landscapes, painted on site in Normandy, in the display windows of the shop. He also sold paints, brushes and canvas to artists. One day Jean François Millet, one of the founders of the Barbizon School, came into his shop. With Millet's encouragement Boudin gave up his business and went to Paris. He copied from paintings at the Louvre and benefited from the advice of the Barbizon School painter Constant Troyon, as well as from Édouard Manet's teacher Thomas Couture. All the same he received no systematic education and disappointed his benefactors with his steadfast attachment to landscapes, and his revulsion at painting in the traditional genres adopted by the schools. He returned to Le Havre to work in direct contact with nature. He was the decisive factor for Monet's future. Indeed, it was Boudin who passed on his conviction of the importance of working in the open air to Monet, a practice which Monet would in turn transmit to his Impressionist friends.

Woman in a Green Dress (Camille), 1866.
Oil on canvas, 231 x 151 cm.
Kunsthalle Bremen, Bremen.

Portrait of Madame Gaudibert, 1868.
Oil on canvas, 216 x 138.5 cm.
Musée d'Orsay, Paris.

Monet's further development took place in Paris, and then again in Normandy, but this time in the company of artists. His artistic formation was in many ways identical to that of other painters of his generation, and yet at the same time his development as an artist had profoundly distinctive individual features. Almost every young artist to arrive in the capital from the provinces was dazzled by the magnificence of the Louvre's collection of paintings. It was the Louvre that had subdued Jean-François Millet's desire to head back to Normandy from the city that was so alien to him. Gustave Courbet, arriving in Paris from Franche-Comté in Burgundy, ostentatiously rejected the idea of being influenced by museums, but was himself strongly affected by the Louvre's collection of Spanish painting. And although Manet and Degas, both born in Paris, knew the Louvre from an early age, they never tired of making studies of the Old Masters and always displayed great reverence towards the classics; indeed, during their travels abroad, their first priority was always to visit museums, not as tourists, but as attentive students eager to encounter the creations of great teachers. Monet, however, preferred current exhibitions and meetings with contemporary artists to visiting museums. A study of his letters provides convincing evidence that contact with the Old Masters excited him far less than the life around him and the beauties of nature.

What was it that struck Monet during his first trip to Paris in 1859? An exhaustive reply is given by his letters from Paris to Boudin after his first visit to the Salon. The young provincial passed indifferently by the historical and religious paintings of Gustave Boulanger, Jean-Léon Gérôme, Paul-Jacques-Aimé Baudry and Jean Francois Gigoux; the battle-scenes depicting the Crimean campaign attract him not at all; even Delacroix, represented by such works as *The Ascent to Calvary*, *St. Sebastian*, *Ovid*, *The Abduction of Rebecca* and other similar historical paintings, seems to him unworthy of interest. Camille Corot's work on the other hand is "nice", Theodore Rousseau's is "very good", Charles-François Daubigny's is "truly beautiful", and Troyon is simply "superb". In Paris, Monet called on Troyon, an animal and landscape painter whose advice Boudin had earlier found valuable. Troyon made recommendations which Monet relayed in his letters to Boudin — he should learn to draw figures, make copies in the Louvre, and should enter a reputable studio, for instance that of Thomas Couture.

The Salon of 1859 included no paintings by the leading Realist Courbet, and the jury rejected Millet's *Death and the Woodcutter*. Monet saw this latter work in 1860 and estimated it as "fine", while at the same time viewing several canvases by Courbet which he considered to be "brilliant". In this same year he discovered the seascapes of the Dutchman Johan Barthold Jongkind and declared him to be "the only good painter of marines."

Monet thus immediately identified the figures who would provide the artistic framework with which he would aspire to innovate. These were the landscapists of the Barbizon

The Café "La Grenouillère", 1869.
Oil on canvas, 74.6 x 99.7 cm.
The Metropolitan Museum of Art,
New York.

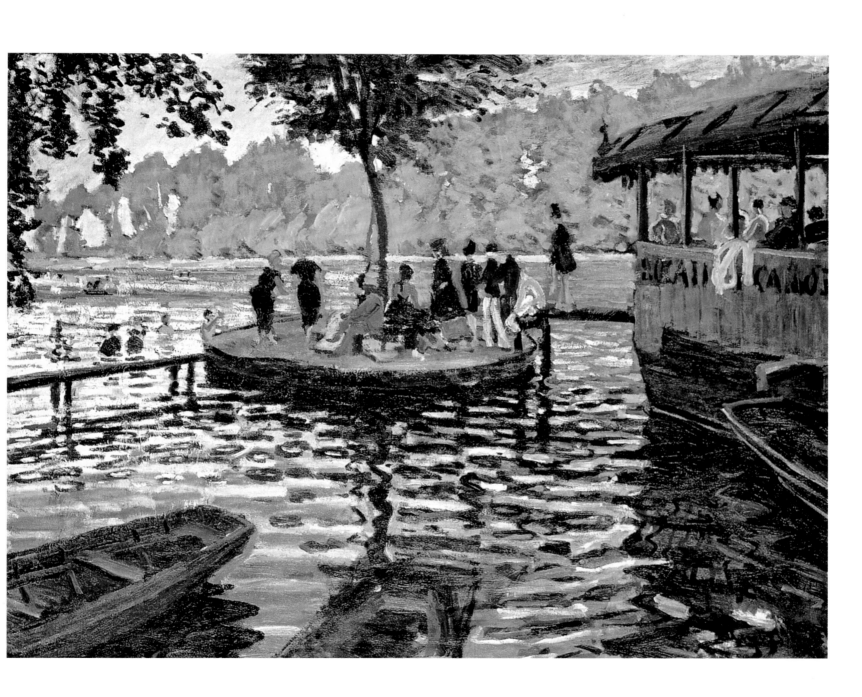

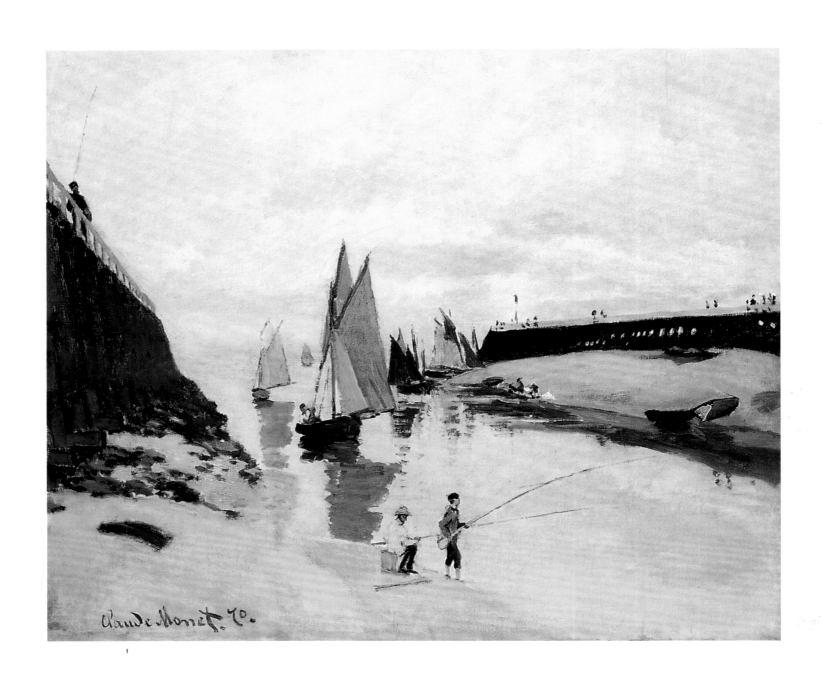

Entrance to the Port of Trouville, 1870.
Oil on canvas, 54 x 65.7 cm.
Magyar Szépmuvészeti Mùseum,
Budapest.

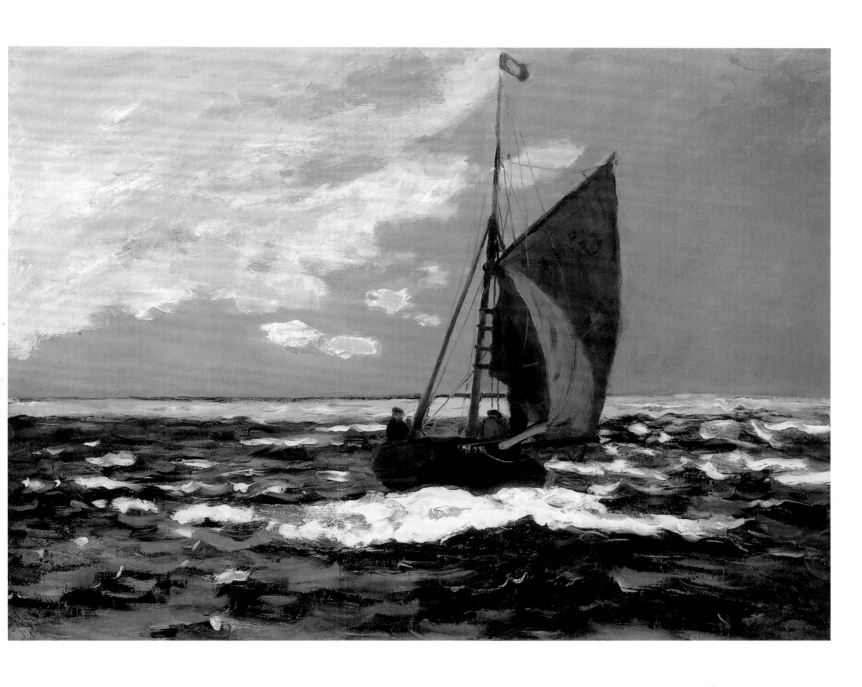

Seascape: Storm, c. 1866-1867.
Oil on canvas, 48.7 x 64.7 cm.
Sterling and Francine Clark Art
Institute, Williamstown, Massachusetts.

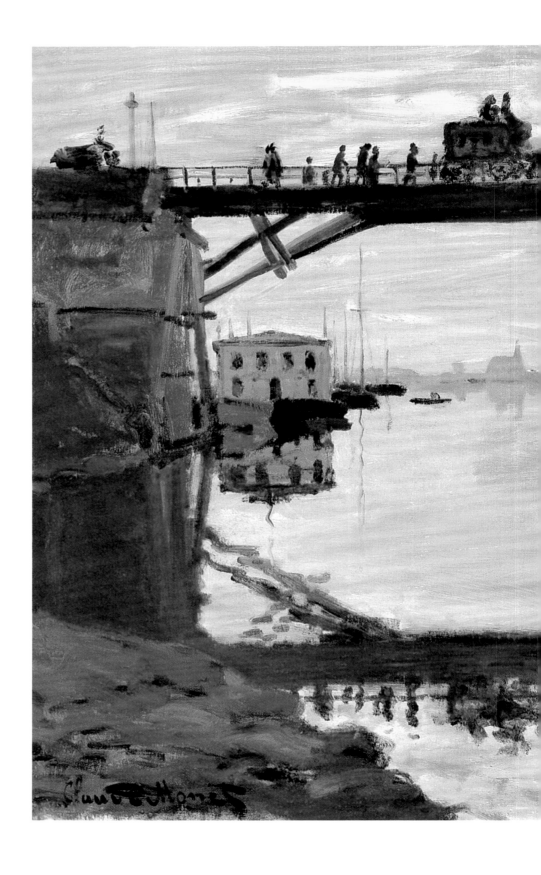

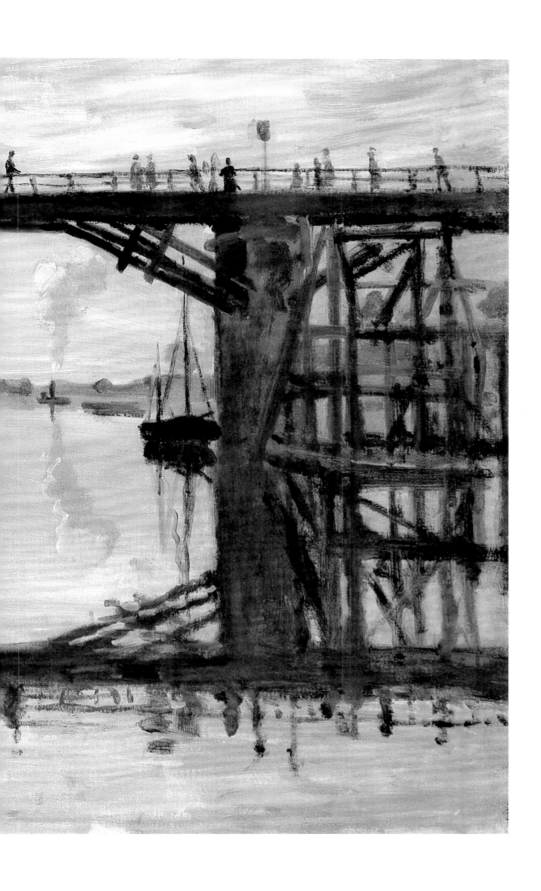

The Wooden Bridge, 1872.
Oil on canvas, 54 x 73 cm.
Dr. Rau Collection, Dayton Art
Institute, Dayton, Ohio.

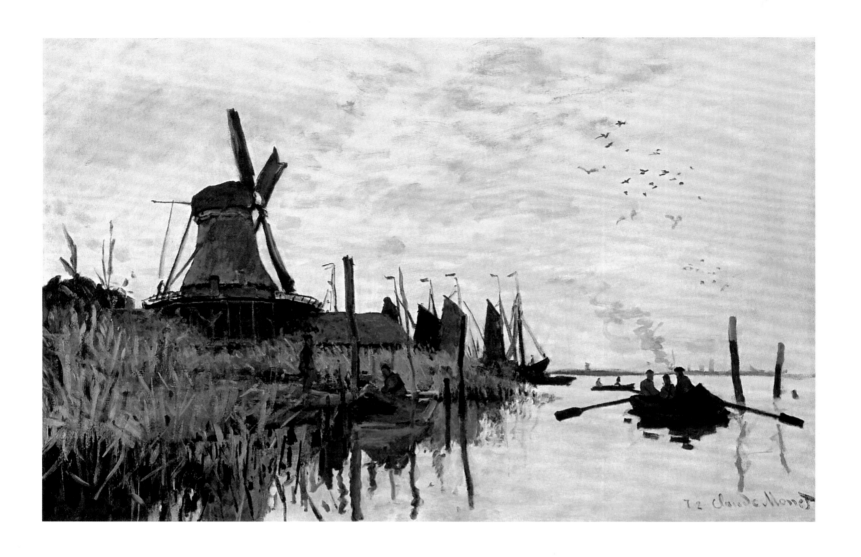

Mill in Zaandaam, 1871.
Oil on canvas, 48 x 73.5 cm.
Ny Carlsberg Glyptotek, Copenhagen.

School, who had pointed French landscape painting towards its own native countryside; Millet and Courbet, who had turned to depicting the work and way of life of simple people; and, finally, Boudin and Jongkind, who had brought to landscape a freshness and immediacy lacking in works by the older generation of Barbizon painters. Monet was to paint alongside several of these masters — Boudin, Jongkind, Courbet (and Whistler, too) — and by watching them at work would receive much practical instruction.

Although Monet did not regard his immediate teacher Charles Gleyre, whose studio he joined in 1862, with great favour, his stay there was by no means wasted, for he acquired valuable professional skills during this time. Charles Gleyre was the only teacher who, in Monet's eyes, truly personified neoclassical painting. Gleyre had just turned sixty when he met the future Impressionists. Born in Switzerland on the banks of Lake Geneva, he had lived in France since childhood. After graduating from the École des Beaux-Arts, Gleyre spent six years in Italy. Success in the Paris Salon made him famous and he taught in the studio established by the celebrated Salon painter,

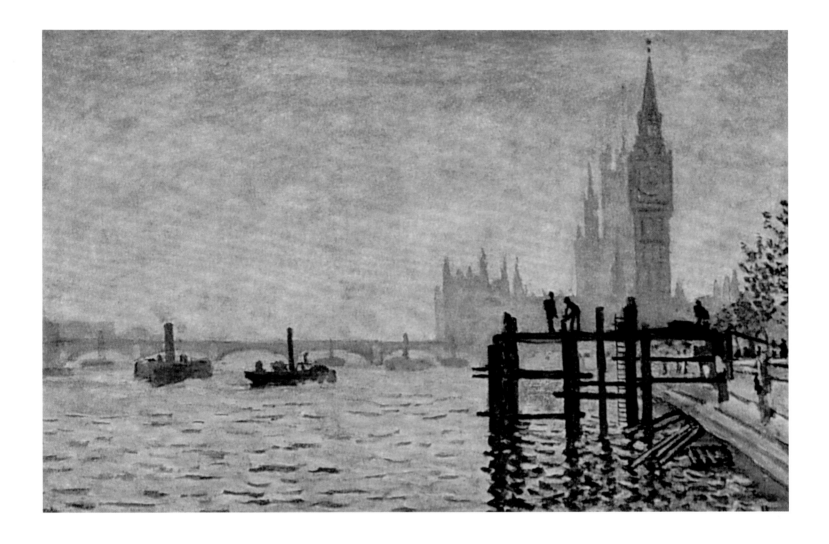

Hippolyte Delaroche. Taking themes from the Bible and antique mythology, Gleyre painted large-scale canvases composed with the clarity and clean lines commonly associated with classical art. The formal qualities of his female nudes can only be compared to the work of the great Dominique Ingres. In Gleyre's independent studio, pupils received traditional training in neoclassical painting, but were free from the official requirements of the École des Beaux-Arts.

Moreover Gleyre, although an advocate of the academic system of teaching, nonetheless allowed his pupils a certain amount of freedom and did not attempt to dampen any enthusiasm they might have for landscape painting. Most important to Monet in Gleyre's studio, however, were his incipient friendships with Frédéric Bazille, Pierre-Auguste Renoir and Alfred Sisley. We know that he had already become acquainted with Pissarro, and thus it can be said that from the earliest stage of his career fate brought Monet together with those who were to be his colleagues and allies for many years to come.

The Thames and the Houses of Parliament, 1871.
Oil on canvas, 47 x 73 cm.
The National Gallery, London.

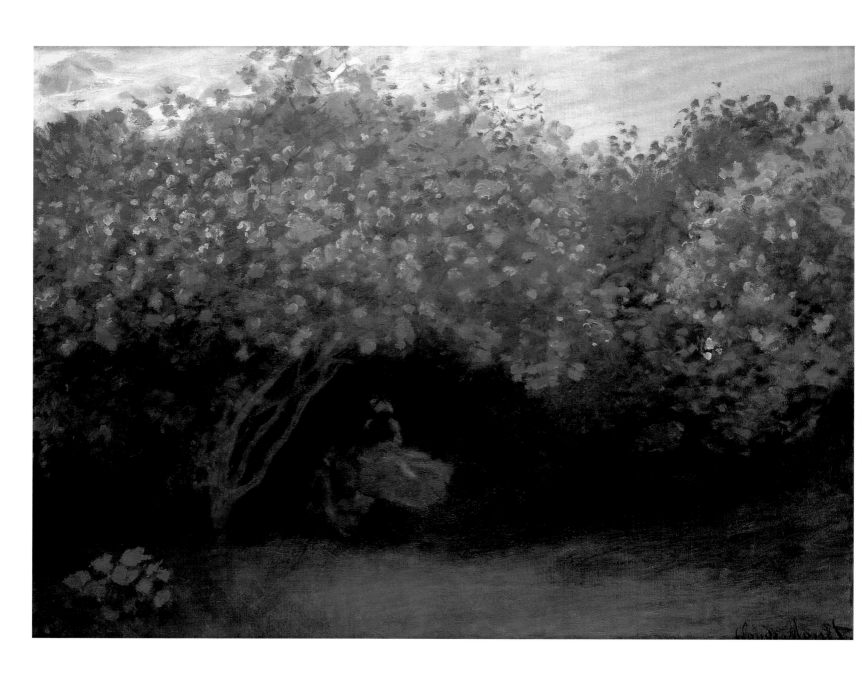

Monet considered it very important that Boudin be introduced to his new friends. He wrote Boudin from Paris that a little group of young landscape artists had formed at the studio, and that they would be happy to meet with him. He also told his friends of another painter he had found in Normandy. This was the remarkable Dutchman Jongkind. His landscapes were saturated with colour, and their sincerity, at times even their naiveté, was combined with subtle observation of the Normandy shore's variable nature. Monet remembered that Jongkind explained to him all the "whys and wherefores" of his style, rounding out the education he had received from Boudin. "From that moment on he was my true master," said Monet. "I owe the final education of my eye to him" (D. Wildenstein, op. cit., p. 14). The Normandy landscape painters Boudin and Johan Jongkind rank among the Impressionists' direct influences.

From the moment they met at Gleyre's studio the young painters moved forward together, casting the weight of the classical tradition off their shoulders. These future Impressionists shared the same objectives and ideas, and together they developed their method of painting. Their contemporaries perceived their painting as a single whole. In 1873, before the first Impressionists' exhibition, the critic Arman Sylvestre wrote about the exhibition at the art dealer Paul Durand-Ruel's gallery: "At first glance one has trouble distinguishing the paintings of M. Monet from M. Sisley, and the latter's style from that of M. Pissarro. After a bit of study one learns that M. Monet is the most skilful and the most daring, M. Sisley is the most harmonious and most timid, and M. Pissarro is the most authentic and the most naïve" (L. Venturi, op. cit., vol. 2, p. 284).

Lilacs in Dull Weather, 1872-1873.
Oil on canvas, 50 x 65.5 cm.
Musée d'Orsay, Paris.

Lilacs in the Sun, 1873.
Oil on canvas, 50 x 65 cm,
The Pushkin Museum of Fine Arts,
Moscow.

They had stopped attending Gleyre's studio, and together they now left to work in the region favoured by the Barbizon School painters, the Fontainebleau forest. Lodgings were only to be had in the small village of Chailly-en-Bière, at the far end of the forest. It had only two hotels: the Cheval Blanc and the Lion d'Or. All four moved into the Cheval Blanc, run by old Paillard. It was a cozy hotel, decorated with the canvases left behind by other painters who had stayed there in years before. The friends set to work with enthusiasm. "The forest is really superb in certain parts,"

Bazille wrote his parents. "We've got nothing like these oak trees in Montpellier. The rocks are not as beautiful, despite their fine reputation" (F. Daulte, op. cit., p. 35). Monet painted broad forest paths, lined with trees and bathed in sunlight. In these landscapes one senses the solid instruction Gleyre had managed to give them, though it may have been against their will. Monet's landscapes of this period inevitably bring the clarity, logic, and order of Nicolas Poussin's paintings to mind. Constructed using the golden ratio, they are harmonious, balanced, and impeccably composed. As in Poussin, there are amply rounded mountain peaks, dense with lush, green trees. Nevertheless it was at that same time, in the Fontainebleau forest, that Monet first had a revelation of the richness of the colour effects created by the sun filtering through the leaves.

Formative Years

During the early and mid-1860s these young painters were still searching for an identity and were still rather uncertain as to where their rejection of academic clichés and Salon painting would lead them; but they were fully prepared to follow boldly in the steps of those who, before their own involvement in art, had begun the struggle for new ideals outside of the artistic establishment. At the outset they were particularly attracted by, in Monet's words, the "naïve giant" Courbet, but by the late 1860s they were beginning to show a preference for Manet, whose pupil, Berthe Morisot, joined their circle. The complete antithesis of the noisy provincial Courbet, Manet was an elegant member of Parisian society, and one of the central figures in the French art world during these years. He struggled constantly in search of an art which was true to life and attracted an ever-increasing number of followers from the ranks of young painters seeking novel means of expression, while often provoking open hostility on the part of official critical circles and the Salon jury. The main stages of this struggle are well-known: *The Luncheon on the Grass* at the exhibition of the Salon des Refusés in 1863, *Olympia* in the 1865 Salon, and his one-man show at the time of the World Fair in 1867. By the end of the 1860s Manet was the recognised leader of the Batignolle group of artists and critics, who met in the Café Guerbois and included Edgar Degas, Henri Fantin-Latour, Armand Guillaumin, Louis Endmond Duranty, Zola and Pissarro, as well as the friends from Gleyre's studio. Manet and Monet knew one another's work long before they were introduced, and although at first very guarded in his attitude to Monet's artistic experimentation, the Batignolle group's leader soon became interested in him and began to follow the development of his work very attentively. As far as Monet was concerned, he did not so much imitate Manet as imbibe the older artist's spirit of delving into the essence of one's subject, gaining the impetus to release the powers latent within him. Monet's development was also influenced by his active contacts with Bazille, Renoir, Sisley

Poppies, 1873.
Oil on canvas, 50 x 65 cm.
Musée d'Orsay, Paris.

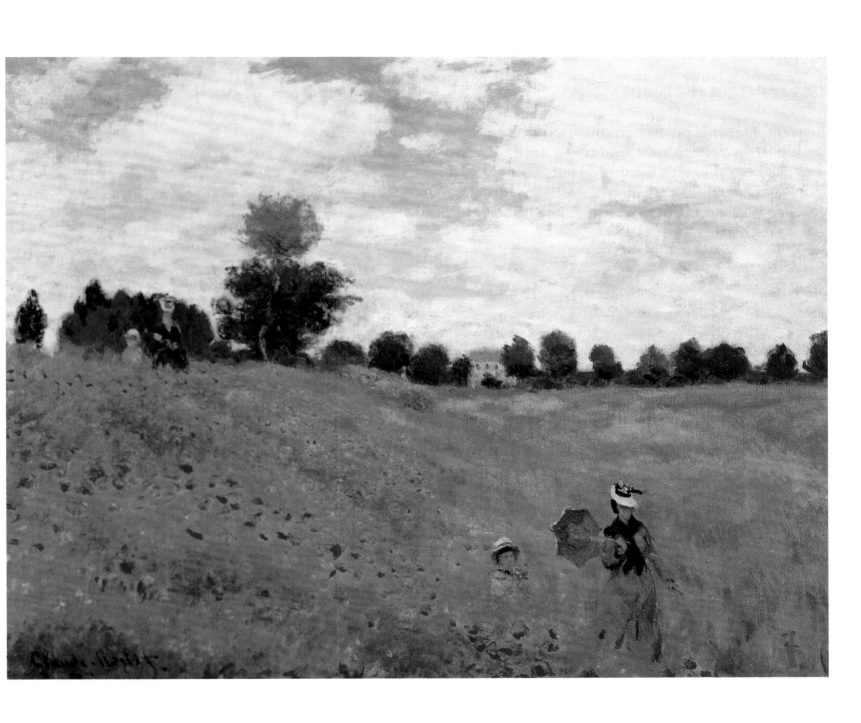

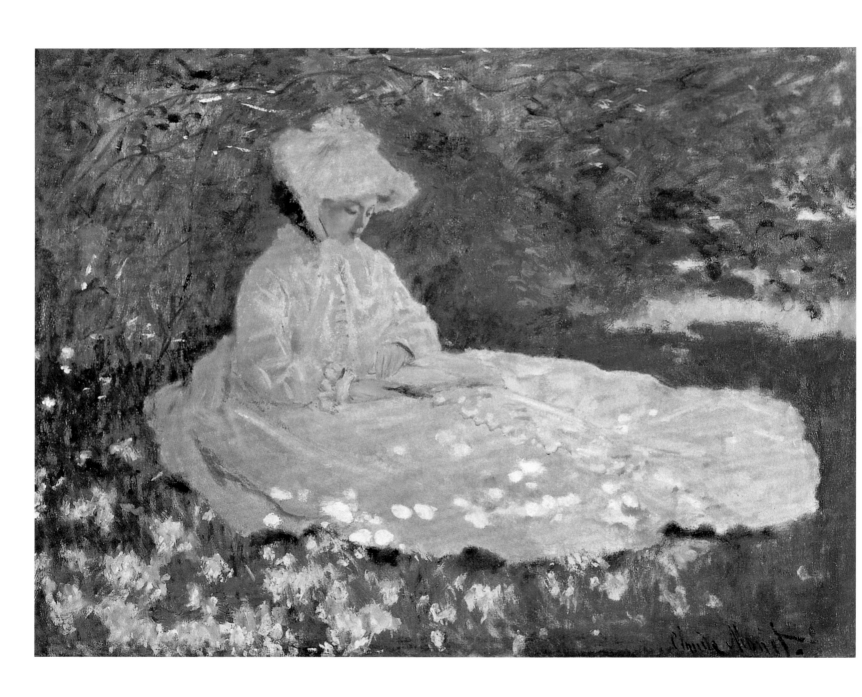

and Pissarro. Discussions, arguments and, most importantly, working together served to sharpen the individual skills of each and facilitated the development of certain general principles.

During the 1860s Monet had not yet determined his personal subject-matter, but he had no wish to turn to historical, literary or exotic subjects as were popular with the Salon's jury. Instead, he made it his priority to serve the truth and to keep pace with the times, and only experienced a slight uncertainty in deciding whether the landscape or rather scenes with figures should be the genre central to his work. During the 1860s Monet occasionally also visited his parents' home in Normandy. He would sometimes go with Bazille to the farm in Saint-Siméon, where a sort of club foregathered in which Courbet and Baudelaire participated. They painted at the little port of Honfleur, which Boudin and all the other Normandy landscapists so loved. "As soon as we arrived in Honfleur we looked for landscape motifs," wrote Bazille to his parents. "They were easy to find, for the country here is paradise. One could not possibly see lusher meadows and more beautiful trees. Everywhere there are cows and horses roaming free. The sea, or rather the Seine greatly widened, provides a charming horizon for these torrents of greenery" (F. Daulte, op. cit., p. 41).

For Monet these were motifs that had been familiar and dear to him since childhood, and he would revisit them throughout his life. Naturally Monet introduced Bazille to his parents. "I have had lunch with Monet's family," Bazille wrote his mother. "They're charming people. They have a charming estate at Sainte-Adresse, near Le Havre (…) I had to refuse their gracious invitation to spend the month of August there" (F. Daulte, op. cit., p. 41). Monet's parents shared this estate with his Aunt Lecadre. Monet knew days of happiness there, but also of sorrow. His disagreements with his family were a source of continual distress for him. In 1864 he wrote Bazille, "What I've been telling you, about the break with my family, is going to happen any day now. Last night at Sainte-Adresse I was asked to leave and not to return anytime soon. I'm even afraid I won't be receiving any more money. With all the effort I'm putting forth now, that would truly be painful" (F. Daulte, op. cit., p. 42).

Camille Doncieux, born in 1847, was seven years younger than Monet, and therefore still in her teens when she met and began modelling for him in 1865. Soon after their meeting, as so often goes the story with artists and their models, Monet fell in love with the dark-haired, dark-eyed Camille.

However, the fact of Camille's humble means (especially when contrasted against Monet's family's relative financial stability) soon became an obstacle in their relationship.

Printemps (Springtime), 1872.
Oil on canvas, 50 x 65.5 cm.
Walters Art Gallery, Baltimore.

Being of different social classes, Monet and Camille might have just enjoyed an acknowledged love affair; however, Monet was enamoured with Camille's intelligence and beauty and insisted on having her as his wife. The family arguments which erupted due to Monet's choice of bride would take an emotional toll on Monet.

In 1867 Monet's father ordered him to spend the summer at Sainte-Adresse under his aunt's surveillance to keep him away from Camille, who was just about to give birth to their first son, Jean. His father threatened to withdraw financial support completely if he married. Monet was in despair, and in such a state of nervous agitation that he even began to lose his vision – the worst misfortune possible for a painter. He was fortunate to find a doctor in Le Havre who would treat him for his anxiety. And yet, all this time Monet was under the spell of Sainte-Adresse, about which he wrote, "It's charming, and I'm discovering things still more beautiful every day. It's driving me mad, there's so much I feel like doing" (L. Venturi, op. cit., vol. 1, p. 21).

He painted a series of landscapes at Sainte-Adresse that brought him one step further towards Impressionism. Indeed, *Regattas at Sainte-Adresse* (The Metropolitan Museum of Art, New York), *Terrace at Sainte-Adresse* (p. 26), and *Woman in the Garden* (p. 25) are all dated 1867. Monet painted a bright blue sea, rippling with tiny waves, with the vast Normandy sky as smooth as a mirror and sprinkled with clouds. Pure colours appear on his canvases, unmixed with one another. Red flowers shimmer in the green grass, coloured pennants flutter in the wind. Sunlight floods his paintings. Monet painted a wonderful, resplendent garden, of the type that is the pride of Normandy. The owners of Normandy gardens rival one another over their horticultural arrangements, which alternate brilliantly coloured beds of flowers with small, scattered flowering trees against a background of a verdant, green lawn. Claude Monet loved these kinds of domestic landscapes, and took his inspiration from the skilful arrangement of nature contrasted with the figures of friends. One gets the impression in these paintings that he has set himself the goal of being a model student of Gleyre's. In *Woman in the Garden* the centre is marked by the red patch of the flowerbed and the vertical axis of the tree, in keeping with all the rules of the classical school. Sunlit shrubs on either side are set in relief against the dark, shadowy greenery of the background. This time he asked his cousin Lecadre's wife to pose. She fills the role of the figure that, in classical paintings, serves to enliven the landscape with a central focus. Standing out against the lush background, the lady in a white dress shades herself under a white umbrella. But in Monet's painting the dress, instead of becoming grey beneath the umbrella, is a very pure sky blue. In 1867 Monet had already begun to analyse the colours he saw and had discovered what Delacroix, in his time, had found. It was that black and white do not exist in nature. There is colour everywhere, one only needs to be able to see it.

Camille at the Window, Argenteuil, 1873.
Oil on canvas, 60 x 49.5 cm.
Virginia Museum of Fine Arts, Richmond.

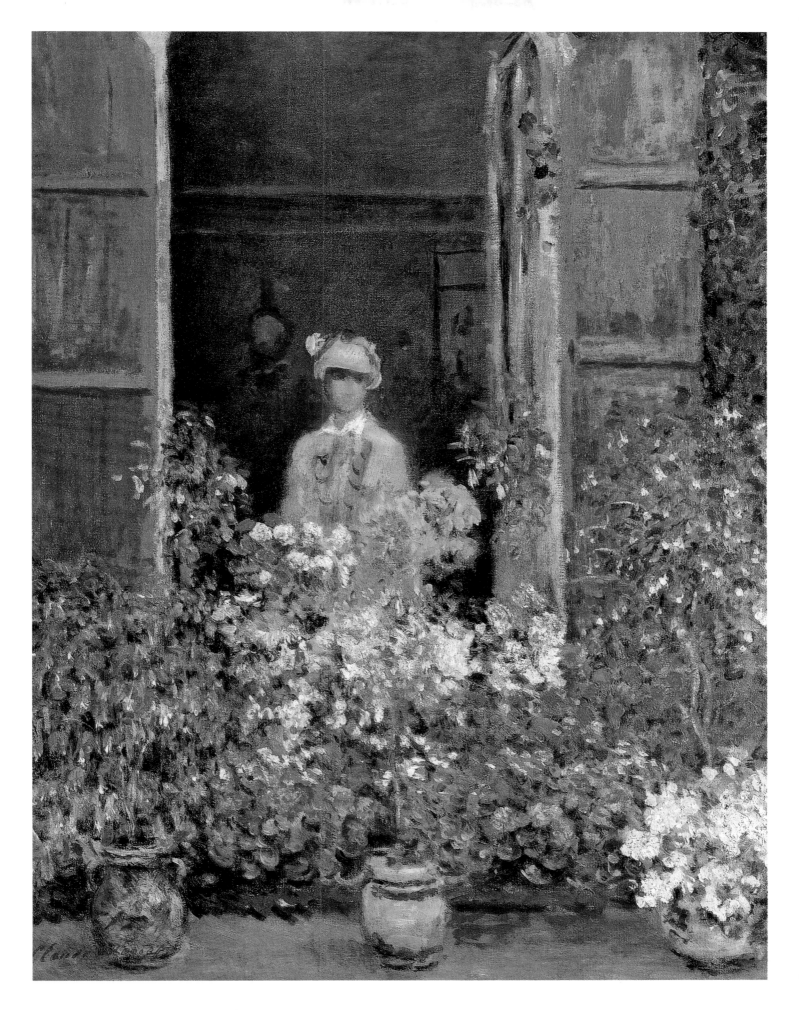

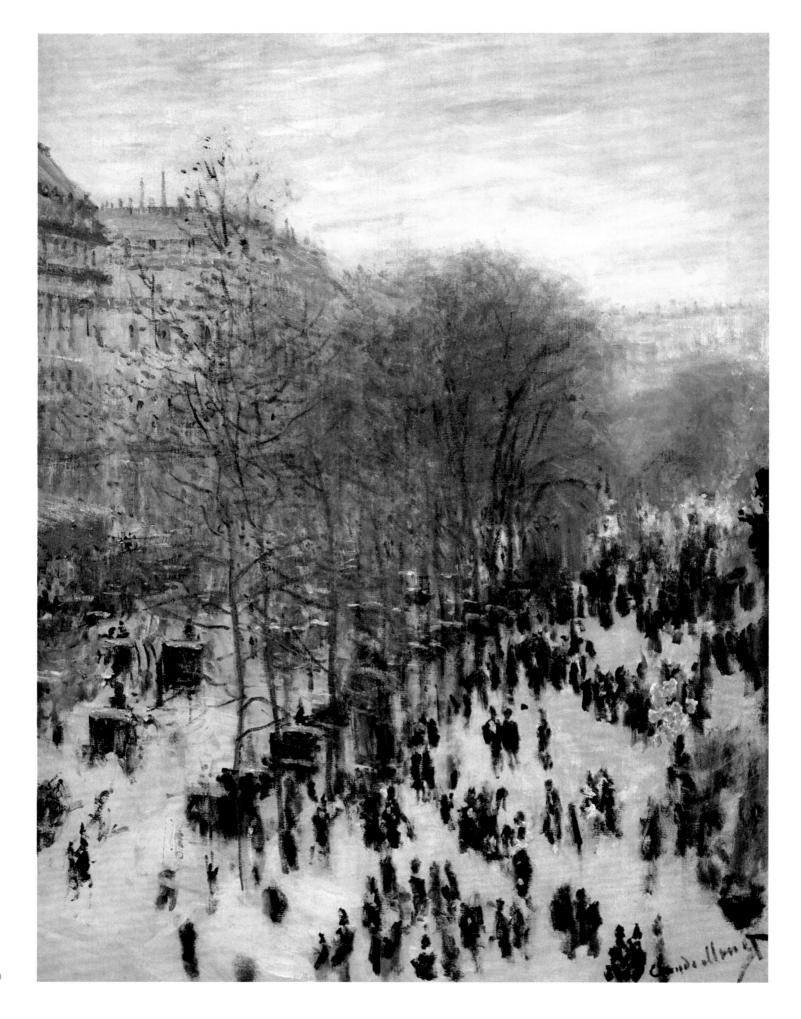

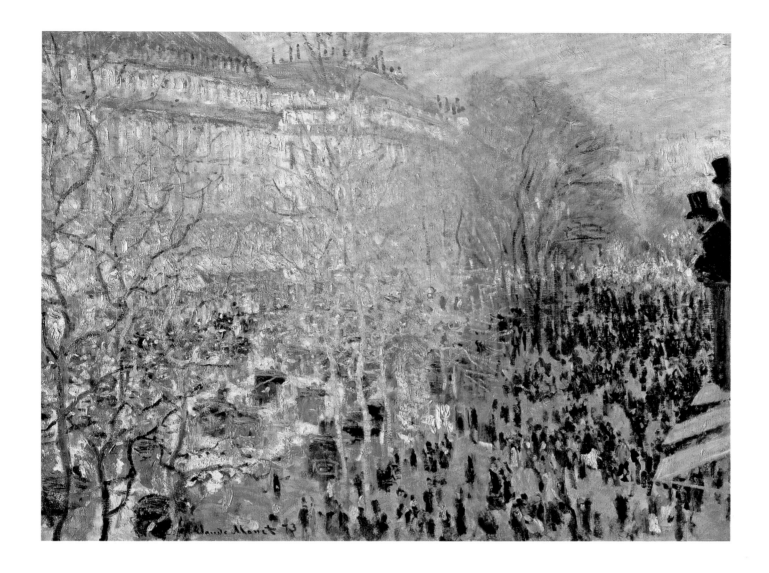

For that purpose it is essential to educate, to train one's eye, and Monet made a start on this difficult task.

The precise dating of this painting to 1867 is based on the style of the lady's dress, which fully conforms to the fashions of that year, and on the title which art-dealer Paul Durand-Ruel prescribed for it on the back: *Une dame au jardin Sainte-Adresse.*

In June 1867 Monet, who was financially supported by his parents, was compelled to obey their demands and leave Paris and his future wife Camille Doncieux (after having feigned a break with her) and go to Sainte-Adresse, where he stayed with his aunt, Mme Lecadre. On June 25 the artist wrote to Frédéric Bazille: "Dear Bazille, for fifteen days already I have been back in the bosom of my family, blissfully happy. They are very nice to me, admiring every brushstroke I make. I am up to my eyes in work, with a score of paintings under way — wonderful seascapes, figures and gardens" (cited: D. Wildenstein, Claude Monet, vol. 1: 1840-1881, Peinture, Lausanne and

Boulevard des Capucines, 1873-1874.
Oil on canvas, 80.33 x 60.33 cm.
The Nelson-Atkins Museum of Art,
Kansas City.

The Boulevard des Capucines, 1873.
Oil on canvas, 61 x 80 cm.
The Pushkin Museum of Fine Arts,
Moscow.

Paris, 1979, pp. 423, 424, letter 33). Among the previously begun pictures that he had either brought with, or had once left behind at Sainte-Adresse (and which have since been rediscovered) was a canvas with two male figures. On this, over the original figures, the *Woman in the Garden* was painted, as demonstrated by x-ray and spectrum analyses. The scene depicted was a corner of the Lecadres' garden and the model was Jeanne-Marguerite Lecadre, the daughter of Alphonse Lecadre, an eminent physician from Le Havre.

She was married to her distant relative Paul Eugène Lecadre, who was Claude Monet's cousin. Jeanne-Marguerite was famed for her elegance and the painter showed her dressed according to the vogue of that year as ascertained from illustrations in a fashion magazine of 1867, or from Edouard Manet's picture *The World Fair of 1867*, in which one of the ladies is also wearing a loose jacket with scallop edging.

This work is notable for its carefully organised composition, which bears some resemblance to landscapes by masters of the classicist tradition. The masses of colour are clearly defined: the bright, blossoming tree in the middle is set against the dark tapestry-like thicket, and stretching in the foreground is the green horizontal strip of the lawn, broken rhythmically by elongated shadows and contrasting with the dazzling reds of the flowerbed.

At the same time, the painting demonstrates Monet's own style of the pre-Impressionist period, particularly in the meticulous treatment of light effects. This painting seems to encompass the precursors to many of the stylistic elements for which Monet would become famous.

In this painting, one can ascertain that the morning sun has not yet lit the dark trees in the background, but that it has flooded the lawn with glittering colours of various hues, glinting off blades of grass and the petals of flowers. The deep blue of the sky over the green trees is counterbalanced by the paler reflections of this colour on the lady's dress, and the parasol has been transformed by the stream of sunshine into a blazing white halo. The first indications of Impressionism are yet more pronounced in the treatment of form, which is cursory rather than detailed. We are given but the indication of the woman, but even in this she is more of a decoy; the true star of this painting is not the human form but the artist's technique. Using light, minute touches, appropriately curved yet giving the impression of a random profusion of colour dashes, Monet modelled the crown of the tree and the flowerbed, aflame with tiny tongues of colour. The present painting is comparable with the canvas *Women in the Garden*, where the shapes of leaves and flowers are still distinguishable, whereas in the 1867 painting *At Saint-Germain-l'Auxerrois*, and *A Cabin at Sainte-Adresse*,

Impression, Sunrise, 1872.
Oil on canvas, 48 x 63 cm.
Musée Marmottan, Paris.

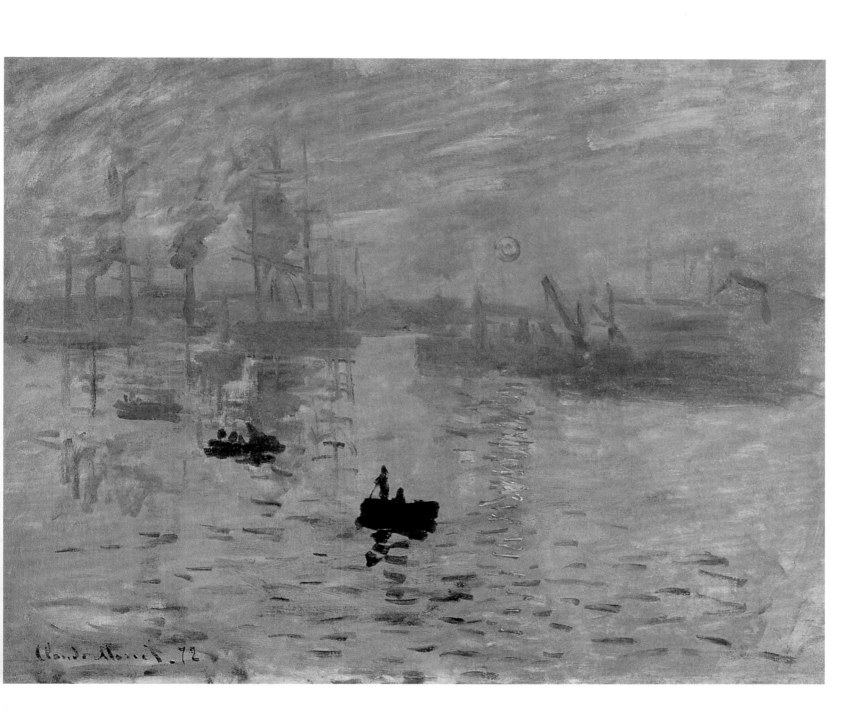

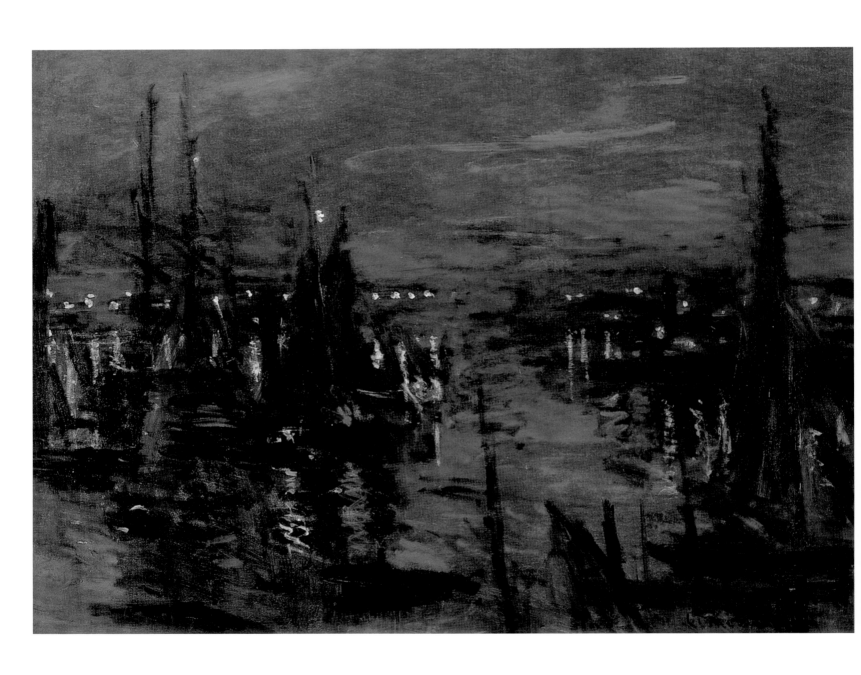

in which the foliage merges into a single mass, and flowers on the flowerbed in the picture *The Terrace at Sainte-Adresse* look like shapeless spots of colour. In this early work one can already trace Monet's favourite device of showing in the background a barely perceptible figure in outline, almost completely dissolved in the shadow. The silhouette which can be discerned on the lady's right, was painted over a male figure buried under a layer of paint.

The careful spatial correlations showing the perception of the scene from a single viewpoint indicate the indubitable influence of photography.

Starting from 1822, when the first permanent photo-etching was produced by Nicéphore Niépce, the process of photography had undergone rapid developments in the mid-nineteenth century due to the invention of numerous chemical processes. By the time that Monet had begun painting, photography's increasingly wide use had come to have a distinct impact on the way that people visualised the world around them. In particular, the role of representative art and the style by which it began to be represented was changing. If technology could now provide a new and more accurate means by which to show reality, what then was the purpose of the artist? It was at this point in art history that technical accuracy in painting became less important than the emotional or intellectual purpose behind the technique and subject matter of a work of art. The newly improved process of photography caught Monet's attention in or around 1867, and can be further evidenced in his work on *Quai du Louvre* and *Jardin de l'Infante*.

At the Fourth Impressionist Exhibition in 1879, where a retrospective of Monet's work was shown, there was a painting listed in the catalogue as *A Garden* (No. 155), with the owner's name and the date of painting specified: "*Un Jardin* (1867), app. à M. Lecadre." There is no doubt that this is the present *Woman in the Garden*. Wildenstein's dating of this painting to 1868 in his comprehensive catalogue of Monet's work appears erroneous. It should also be pointed out that the year 1867 indicated in the catalogue of the Fourth Impressionist Exhibition was certainly provided by Monet himself.

Part of the same scene is shown in the study *Garden in Blossom* (p. 18), which is in the Musée d'Orsay in Paris.

From Figure Painting to Landscape Painting

Like most artists of his generation, Monet evinced no interest in tackling acute social problems. By the time Monet's generation began appearing on the artistic scene,

The Havre Harbour during the Night, 1873.
Oil on canvas.
Private collection.

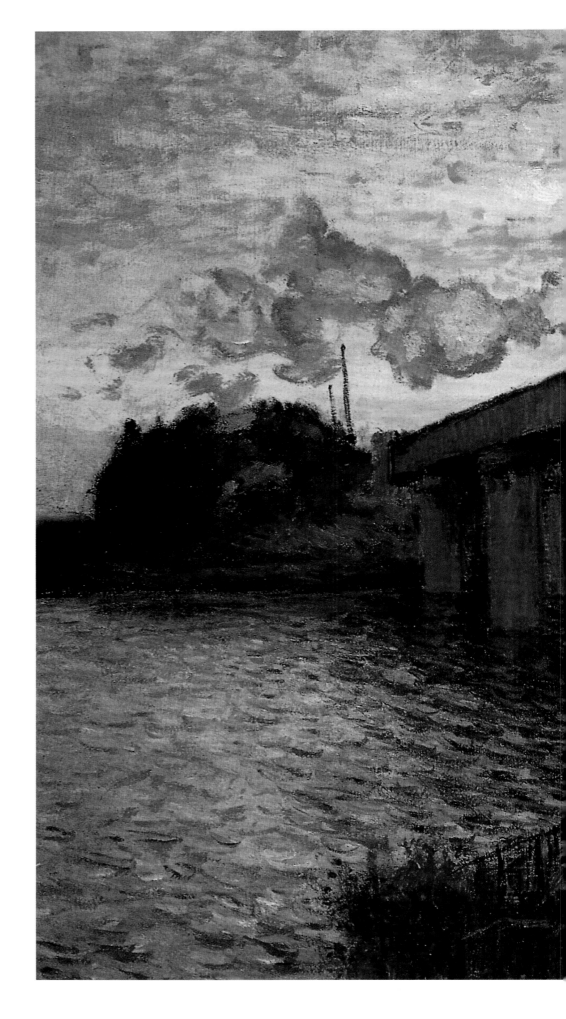

The Railway Bridge at Argenteuil, 1873.
Oil on canvas, 55 x 72 cm.
Musée d'Orsay, Paris.

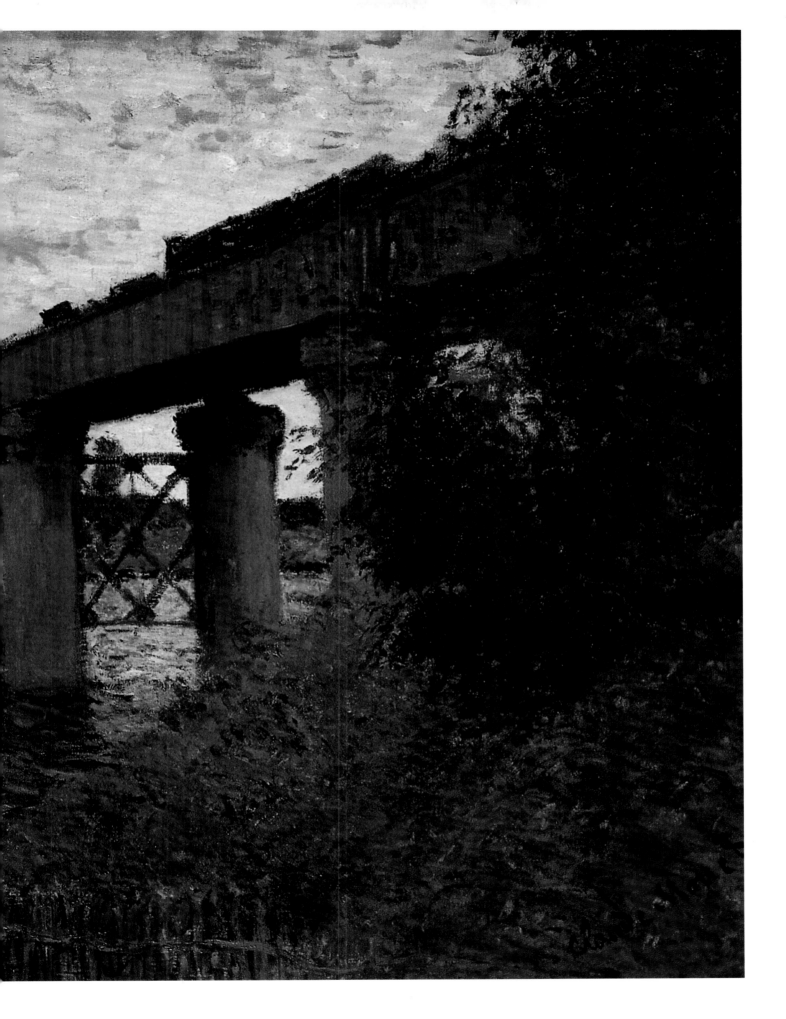

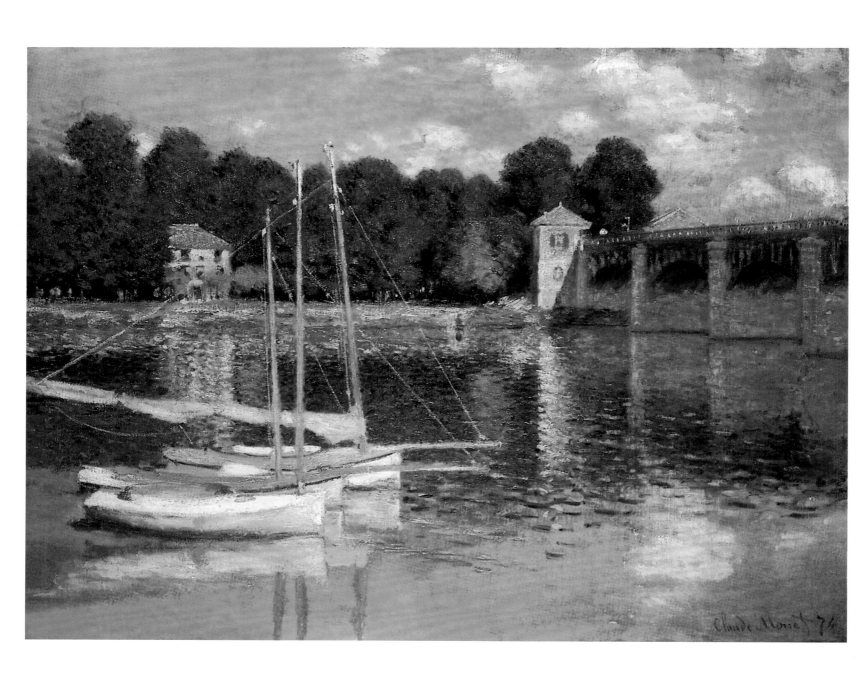

The Bridge at Argenteuil, 1874.
Oil on canvas, 60.5 x 80 cm.
Musée d'Orsay, Paris.

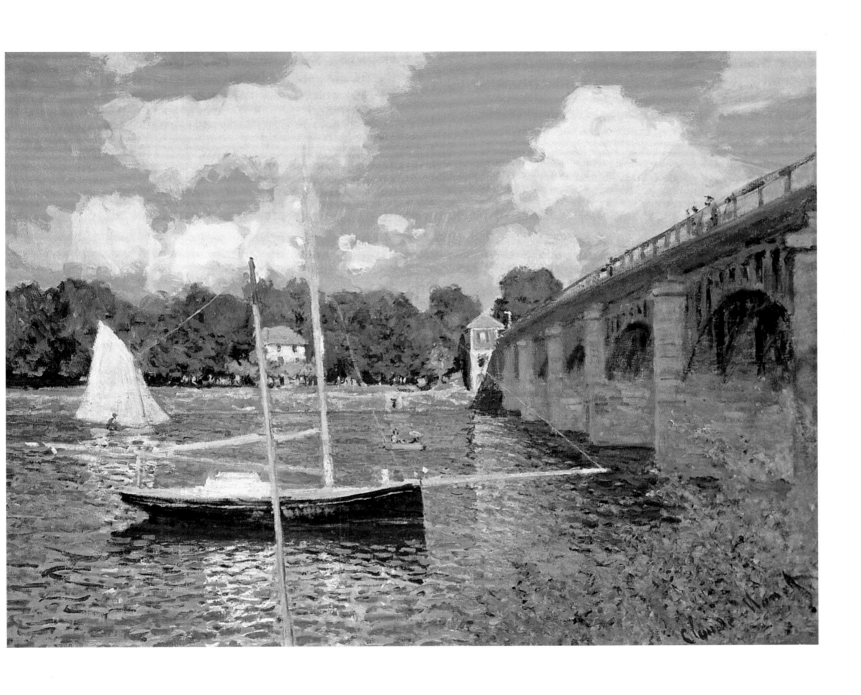

The Bridge at Argenteuil, 1874.
Oil on canvas, 60 x 79.7 cm.
National Gallery of Art,
Washington D.C.

the hopes inspired by the 1848 Revolutions had been shattered. Monet and his friends lived in the apparently unshakeable Second Empire headed by Napoleon III and supported by a bourgeoisie thirsting for wealth and luxury. Progressively minded artists longed merely to dissociate themselves, at least spiritually and morally, from the Empire. The opposition movement, which included the social forces which would come to the fore in the Paris Commune and the ensuing Third Republic, held little interest for Monet, totally immersed as he was in questions of art. His democratic sentiments, in contrast to those of Pissarro, for example, did not presuppose personal involvement in the struggles of the nation. Thus Monet's genre paintings, which played a notable role in the first stage of his career, did not, unlike those of Honoré Daumier or Gustave Courbet, touch upon any vital problems in the social and political life in French society. His figure painting was invariably confined to the representation of his intimate circle of friends and relations. Indeed, he portrayed Camille in a green striped dress and fur trimmed jacket — *Woman in a Green Dress* (p. 33); Camille again with her son Jean at their morning meal — *The Luncheon* (p. 32); and the artist Bazille's sisters in the garden at Ville-d'Avray — *Women in the Garden* (Musée d'Orsay, Paris). Two of Monet's canvases from the 1860s, which currently reside in Russian museums, are of a similar in character — *Luncheon on the Grass* (pp. 22-23) and *Lady in the Garden* (The State Hermitage Museum, St. Petersburg). The first shows a group of friends having a picnic, among them Camille and the artists Frédéric Bazille and Albert Lambron. The second depicts Monet's cousin, Jeanne-Marguerite Lecadre, in the garden at Sainte-Adresse. These paintings might seem to imply that the essence of Monet's talent lies in praise of the intimate and the everyday, and in the ability to recognise their beauty and poetry in spite of the fact that the comfort of friends is commonplace. But Monet conveys these feelings with even greater depth, subtlety and variety when he turns to landscape. Acquaintance with his figure compositions is sufficient to show that he is not attracted by man's inner world or the complexity of human relations. He tends to accentuate the interaction between the figure and the surrounding natural world: where the scene is set in the open air, the play of patches of light on clothing, or even the clothing itself, as in the portrait of *Madame Gaudibert* (p. 33), rather than the expression on a person's face and any internality it might betray. Similarly, the individuality of a model's external appearance and their spiritual world do not inspire Monet; thus in his *Luncheon on the Grass*, which is now in the Pushkin Museum of Fine Arts, Moscow, Monet repeats the figure of Bazille four times. It interests him as one of the elements of the overall composition, but in itself holds little significance in terms of its effect on the painting. This composition had little in common with Edouard Manet's *Le Déjeuner sur l'herbe*, apart from the motif of a picnic on the grass and the charm of an authentic landscape painted in the midst of a natural environment. To judge from the remaining fragments, the canvas was rather dark. The static figures bring the coldness of mannequins to mind. Monet had not yet gotten past the

Le Bateau-Atelier,
(The Studio Boat), 1874.
Oil on canvas.
Kröller-Müller Museum Otterlo,
Netherlands.

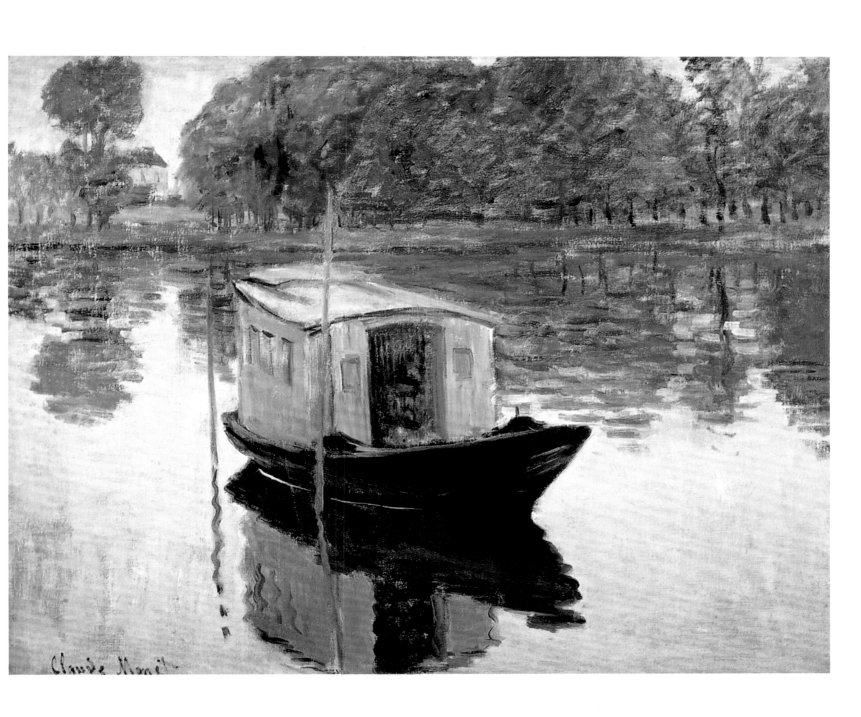

Claude Monet

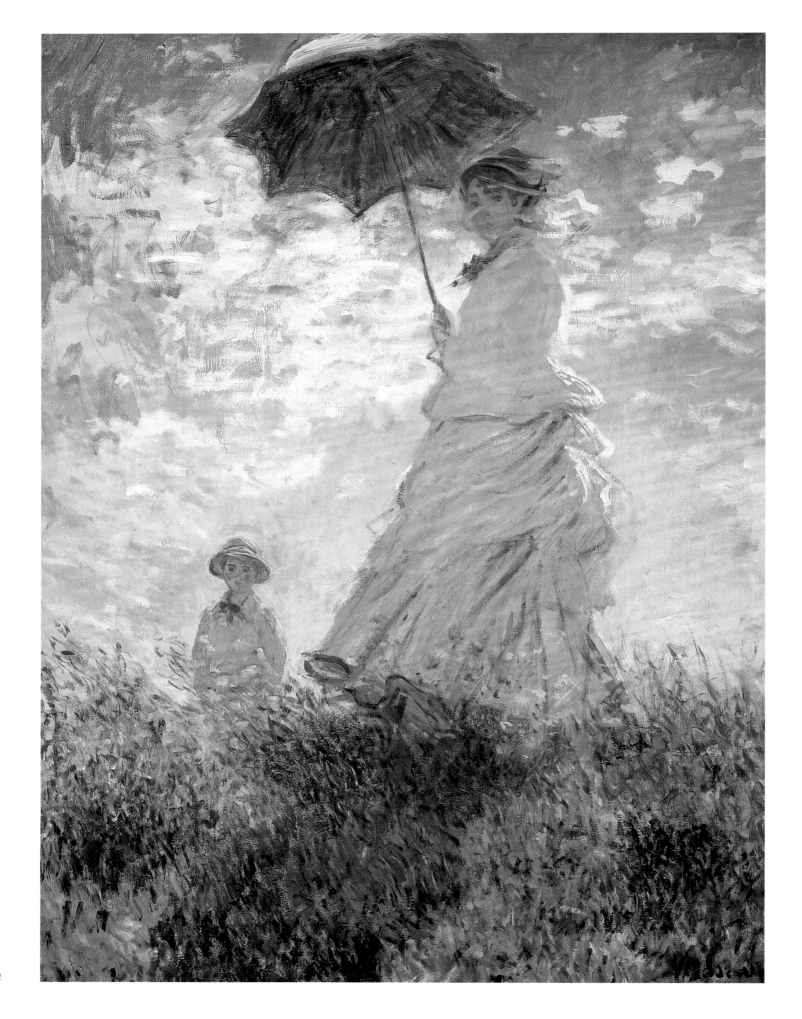

profusion of detail characteristic of genre painting. In this scene, a young girl sets out the dishes on a tablecloth as a dog can be seen running in the foreground. Someone has carved initials and dates on the trunk of a birch tree, and behind it a young man is hiding. But already there is something here that points towards Monet's future: the sun, as it pierces through the greenery of the trees, fragmenting the light into small, juxtaposed patches like a latticed window. Also indicative of Monet's future Impressionism, is the fact that that the shadows of the women's elegant dresses are painted with pure colours, but the studies done at Chatou, near Paris, show an even closer resemblance to the style and technique that Monet would later expand upon in his masterpieces.

Clearly, by the early 1870s, Monet had fully recognised this feature of his talent and figure compositions became less frequent in his work as all his artistic focus was now being devoted to landscape. Nonetheless, these early attempts at figure painting would benefit Monet in the future, for people appear in most of his landscapes — in fields, on roads, in gardens and in boats. True, figures are by that stage not the main, nor even a secondary subject in a picture, but they do seem to be one of the indispensable elements of the changing world, without which its harmony would be disrupted. In this way, Monet appears to be making reference to the conception of Man and Nature often reflected in Poussin's heroic landscapes; however in the great classicist's works, Man and Nature were equally subject to the laws of higher Reason, whereas in Monet's they are equally subject to natural laws.

In 1871-1872 Monet's landscapes were not yet characterised by great richness of colour. Rather, they recalled the tonalities of paintings by the Barbizon artists, and by Boudin's seascapes. He composed a range of colour based on yellow-brown or blue-grey. The rippling of the water and its reflections, such as one finds in his views of Grenouillère, seemed to belong to the past. But this was only a phase in which Monet, in his own way, regathered his momentum after a long interruption which is attributed to the Franco-Prussian war. As he refamiliarised himself with the river, Monet discovered the miracles of colour, and his eye captured its nuances more and more closely. Following Daubigny's example, Monet built a floating studio boat for himself. Since Monet often painted out in the middle of the river, the viewer of the painting seems to find himself situated *inside* the landscape in these paintings. The concrete of one railroad bridge and the ironwork of another introduced an element of modern life into this rural idyll. Monet depicted these bridges many a time from many different angles. At times he also painted the train: its amusing little carriages blending in nicely with the landscape. He painted the Seine at Argenteuil using broken brushstrokes of colour, either pure or mixed with white, rapidly applying paint to canvas and completing the painting entirely in the open air. *Regattas at Argenteuil* (Musée d'Orsay, Paris), a rather small canvas with a dazzling blue sky, a red roof

Woman with a Parasol - Madame Monet and Her Son, 1875. Oil on canvas, 100 x 81 cm. National Gallery of Art, Washington D.C.

and white sails, became a veritable celebration of colour. The painter applied his colours in thick strokes with a brush or a palette knife, giving the impression of reflections gradually fading on the water's surface. It is at this point that Monet's individual style of painting is realised, and truly open-air painting would be designated "Impressionism" the following year.

Another feature of Monet's landscapes in the 1860s and 1870s is that they are often more human than his figure paintings. This tendency can be explained not only by the fact that he was painting facets of nature that were close and familiar to man, but also by his perception of nature through the eyes, as it were, of the ordinary man, revealing the world of his feelings. Each one of Monet's landscapes is a revelation, a miracle of painting; but surely every man, so long as he is not totally blind to the beauty of his environment, experiences at least once in his life that astounding sensation when in a sudden moment of illumination, he sees the familiar world he is accustomed to transfigured. So little is actually needed for this to occur — a ray of sunshine, a gust of wind, a sunset haze; and Monet, as a genuinely creative artist, experienced such sensations frequently. The subject-matter of Monet's early landscapes is typical of his work as a whole. He liked to paint water, particularly the sea-coast near Le Havre, Trouville and Honfleur, and the Seine. He was drawn to views of Paris, the motifs of the garden and the forest road, while his groups of massive trees with clearings and buildings in the foreground were a tribute to the past, a link with the Barbizon group and Courbet (at least in his choice of motif). Indeed, in terms of his painting technique, Monet had not yet fully overcome the influence of Courbet and the Barbizon painters to whom he had aspired in his developmental years. He still applied his paints thickly to the canvas, clearly defining the outlines of every form, although the forms themselves were already being given a rather flattened treatment. Monet's particular interest in the reproduction of light is unmistakable, but even in this respect he did not at first go much beyond his predecessors, particularly Boudin and Jongkind. Although we encounter the use of small, individual patches of colour to convey the vibrancy of light, these tend to be exceptions to the general pattern. And yet while in some ways following a well-trodden path, Monet already displayed originality. By no means all young artists find their distinctive creative personality at an early stage. Some can spend years finding themselves as tradition holds them in thrall, inducing a continual sense of dissatisfaction, and Monet did not completely escape such feelings. On one occasion he took advice from Gustave Courbet and made certain alterations in a painting but, still not pleased with the result, abandoned it and eventually cut the canvas into pieces. If, however, Monet's painting had certain features similar to those of some of his older contemporaries, it coincided in every respect with none of them. The sense of the solidity of natural forms, present in his early landscapes and reminiscent of Rousseau or Courbet, is nevertheless more attenuated, mass being represented with less use of contrast. Compared with Jongkind's seascapes, which are

La Japonaise (Camille Monet in Japanese Costume), 1876.
Oil on canvas, 231.8 x 142.3 cm.
Museum of Fine Arts, Boston.

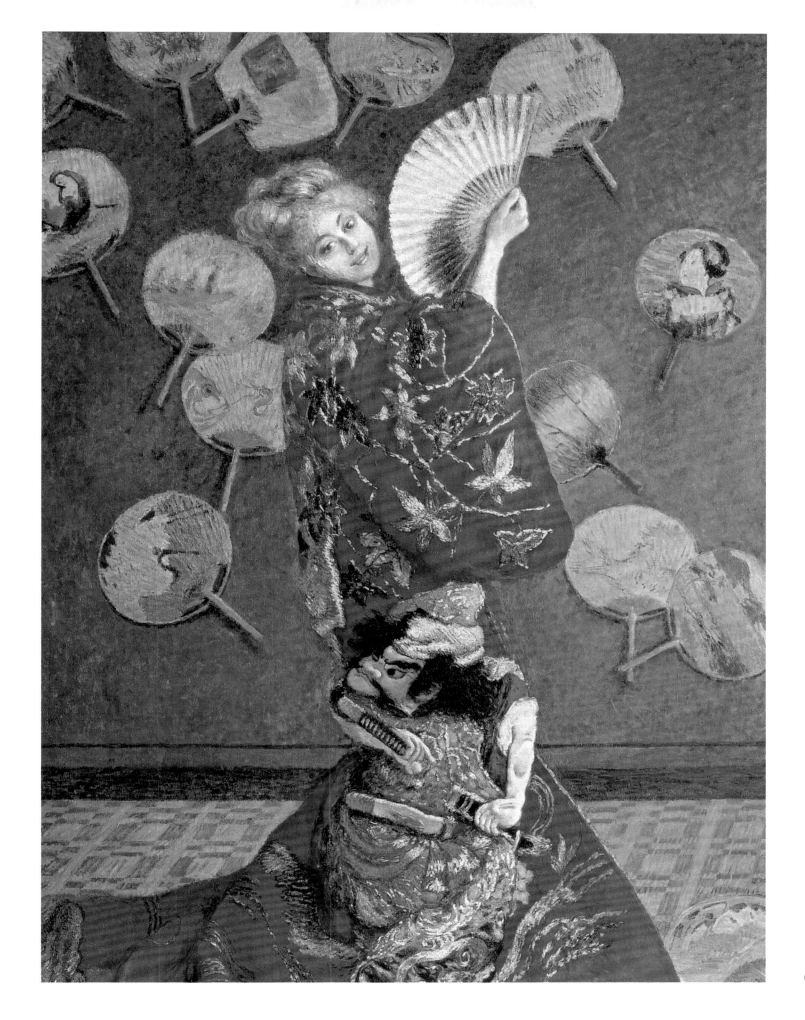

A Corner of the Garden at Montgeron, 1876-1877.
Oil on canvas, 173 x 192 cm.
The State Hermitage Museum,
St. Petersburg.

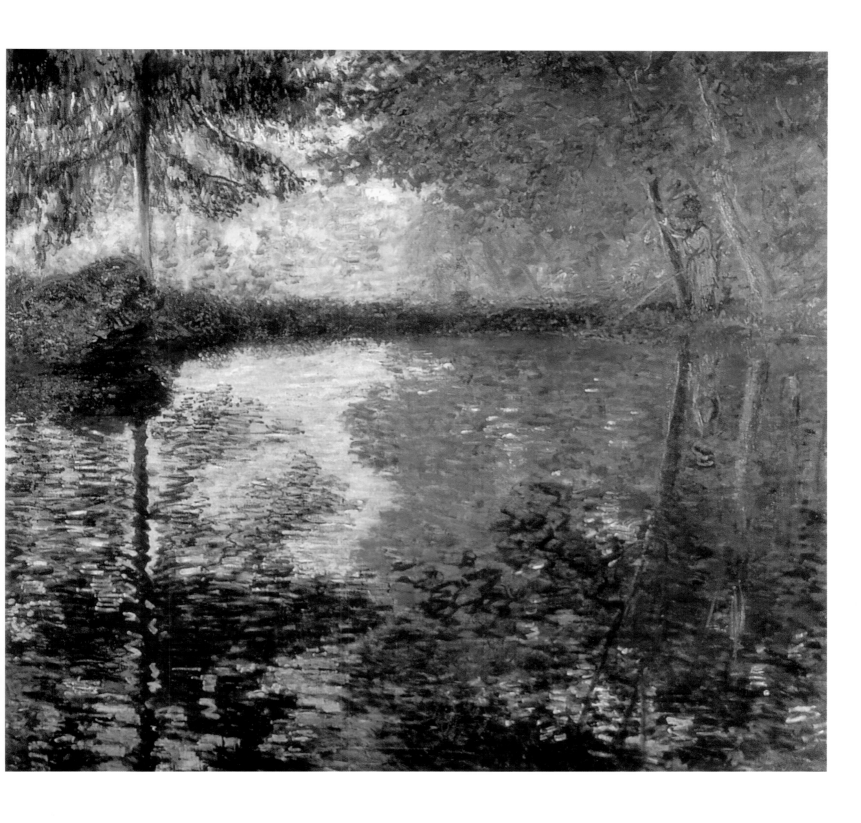

The Pond at Montgeron, 1876-1877.
Oil on canvas, 173 x 194 cm.
The State Hermitage Museum,
St. Petersburg.

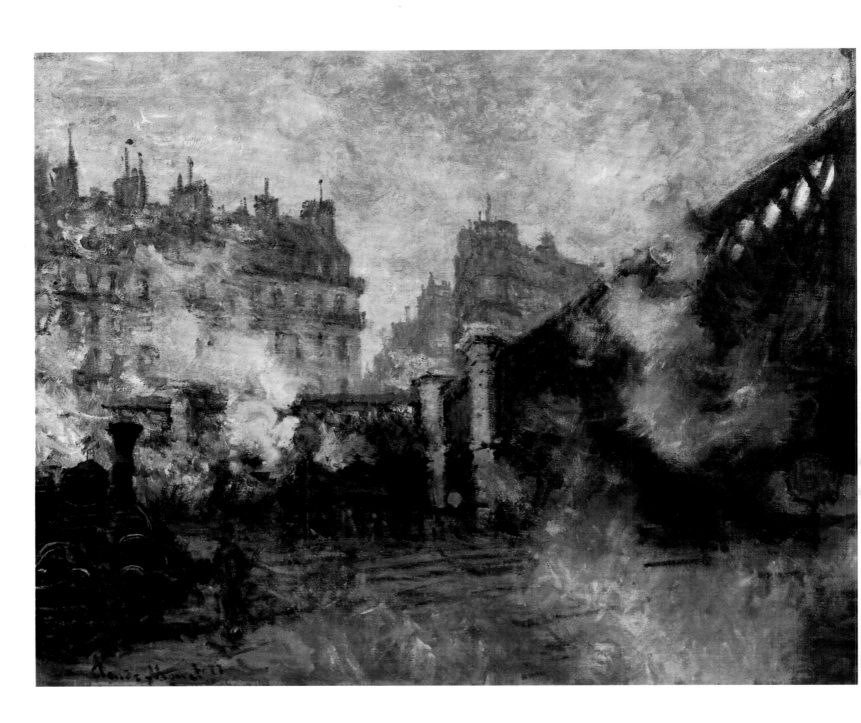

not entirely free from Romantic exaggeration, Monet's marine views are simple and calm. It is apparent that the young Monet was more inclined to develop his own means of expression relying on a sensory experience with nature rather than to imitate the works of other painters.

The First Impressionist Exhibition

For Monet, as for every artist at the beginning of his career, the problem of his public, "his" viewer, was very acute. From the outset painting was his sole source of income and he had to be able to sell his works. And no matter how creatively independent an artist might be, no matter how bold his ideas, the only way for him to attract attention was to exhibit at the official Salon.

Founded in the seventeenth century during the reign of Louis XIV by his prime minister Jean-Baptiste Colbert to display the art of recent graduates of the École des Beaux-Arts, the exhibition was inaugurated in the Louvre's Salon Carré, hence its name. Beginning in 1747, the Salon was held biennially in different locations. By the time the future Impressionists appeared on the stage of art, the Salon boasted a two hundred year history. Obviously every painter wanted to exhibit in the Salon, because it was the only way to become known and consequently, to be able to sell paintings. But it was hard to get admitted. A critical jury made up of teachers from the École des Beaux-Arts selected the works for the exhibition. The Académie des Beaux-Arts (one of the five Academies of the Institut de France) picked the teachers for the jury from among its own members. Furthermore, the teachers in charge of selecting the Salon's paintings and sculptures would be choosing work made by the same artists they had as students. It was not unusual to see jury members haggling amongst themselves for the right to have the work of their own students admitted. The Salon's precepts were extremely rigid and remained essentially unchanged throughout its entire existence. Traditional genres reigned and scenes taken from Greek mythology or the Bible were in accordance with the themes imposed on the Salon at its inception; only the individual scenes changed according to fashion. Portraiture retained its customary affected look and landscapes had to be "composed," in other words, conceived from the artist's imagination. Idealised nature, whether it concerned the female nude, portraiture, or landscape painting, was still a permanent condition for acceptance. The jury sought a high degree of professionalism in composition, drawing, anatomy, linear perspective, and pictorial technique. An irreproachably smooth surface, created with miniscule brushwork almost indiscernible to the eye, was the standard finish required for admission to the competition. There was no place in the Salon for the everyday reality young painters were anxious to explore.

The Pont de l'Europe,
Gare Saint-Lazare (St. Lazare Station),
1877.
Oil on canvas, 64 x 81 cm.
Musée Marmottan, Paris.

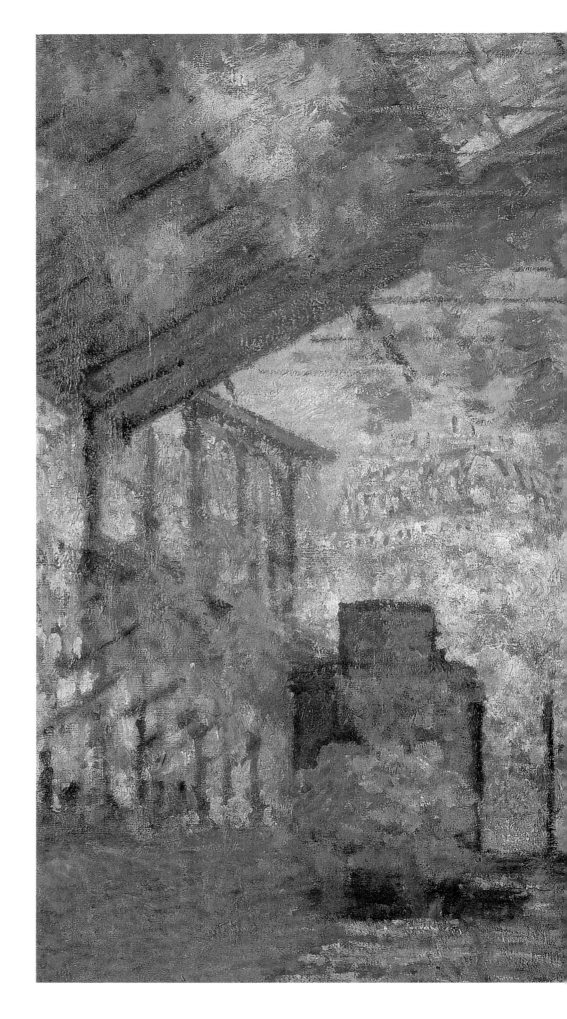

La Gare Saint-Lazare
(St. Lazare Station), 1877.
Oil on canvas, 75 x 105 cm.
Musée d'Orsay, Paris.

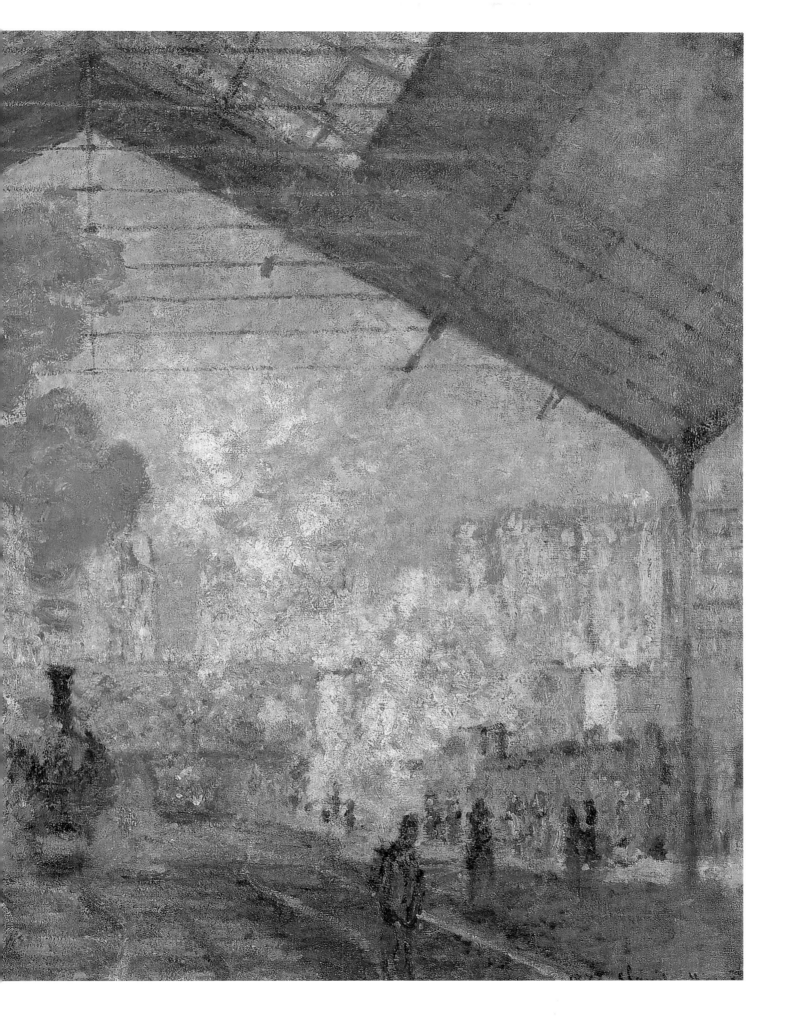

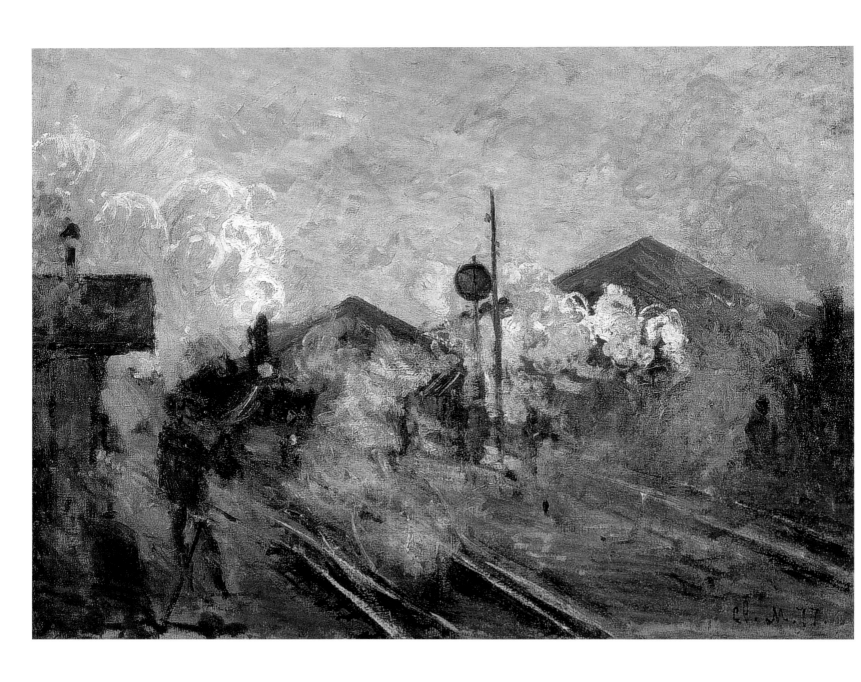

Tracks Coming Out of Saint-Lazare
Station, 1877.
Oil on canvas, 60 x 80 cm.
Private collection, Japan.

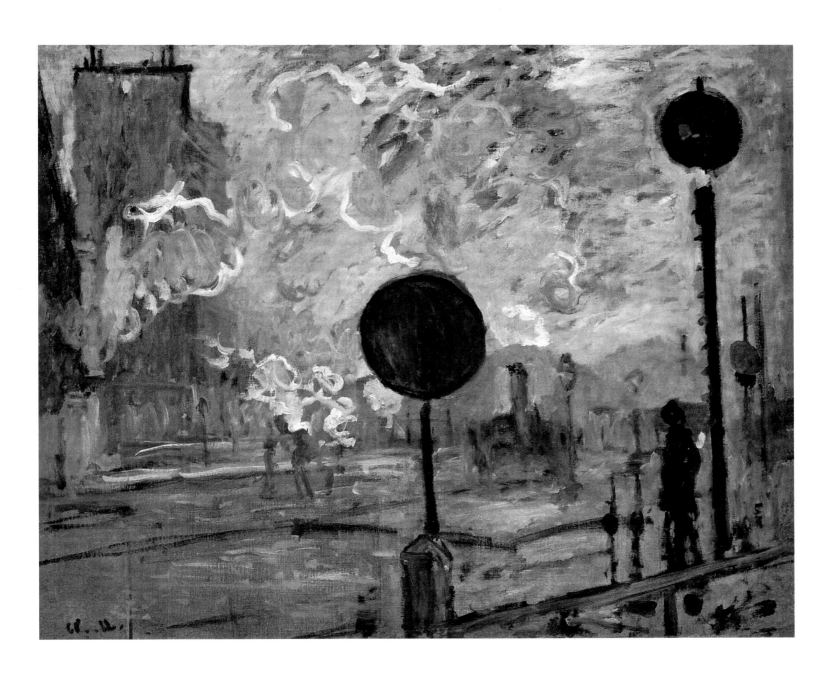

Saint-Lazare Station,
Exterior (The Signal), 1877.
Oil on canvas, 65 x 81.5 cm.
Niedersächsisches Landesmuseum,
Hannover.

The year 1874 was an important date in the history of French art, for it was then that the country's rejected artists began their struggle for recognition, for the right to mount their own exhibitions and make contact with a public whom they would seek to draw towards their ideals and principles, rather than being at the mercy of its tastes and demands. This struggle was unparalleled, for in the entire history of French art up to the appearance of the Impressionists there had actually been no group exhibitions outside the Salon. The Romantics in the 1820s and '30s, and the Realists in the mid-century, for all their shared ideological and aesthetic aims, had never formed new organisations to oppose the existing art establishment. Even the Impressionists' immediate predecessors in the sphere of landscape painting, the Barbizon School painters, although so close to one another both in their lives and in their work, never arranged joint exhibitions. The Impressionists were pioneers breaking down established traditions, and Monet, as always, was at the forefront.

The Salon of 1868 nevertheless showed works by all five future Impressionists: Monet, Renoir, Bazille, Sisley and Pissarro. Even so, all of them felt an increasing desire to exhibit outside of the Salon. The idea of having a separate exhibition probably came from Courbet's example. He was the first to actually do it. In 1865 he hastily set up a shelter on the Champs-Elysées near the Universal Exposition with a sign that read "Pavilion of Realism," sparking strong interest among the public. "People pay money to go to the theatre and concerts," said Courbet, "don't my paintings provide entertainment? I have never sought to live off the favour of governments…I only appeal to the public" (C. Léger, op. cit., p. 57). The future Impressionists wanted to attract attention, too. Even when they found their way into the Salon, their modest little landscapes were only noticed by their close friends. In April 1867, Frédéric Bazille wrote to his parents: "We've decided to rent a large studio every year where we'll exhibit as many of our works as we want. We'll invite the painters we like to send paintings. Courbet, Corot, Diaz, Daubigny and many others…have promised to send us paintings and very much like our idea. With those painters, and Monet, who is the strongest of all, we're sure to succeed. You'll see, people are going to be talking about us" (F. Daulte, op. cit., p. 58).

Organising an exhibition turned out to be no simple matter: it required money and contacts. One month later, Bazille wrote to his father: "I told you about the project of a few young men having an independent exhibit. After thoroughly exhausting our resources, we've succeeded in collecting a sum of two thousand five hundred francs, which is insufficient. We're thus forced to give up on what we wanted to do. We must return to the bosom of officialdom, which never nourished us and which renounces us." (F. Daulte, op. cit., p. 58). In the spring of 1867, Courbet and Edouard Manet each had their own solo exhibitions, after the Salon's jury refused the paintings that they wanted to display there. Inspired by these examples, the future

Snow Effects in Vétheuil, 1878-1879.
Oil on canvas, 52 x 71 cm.
Musée d'Orsay, Paris.

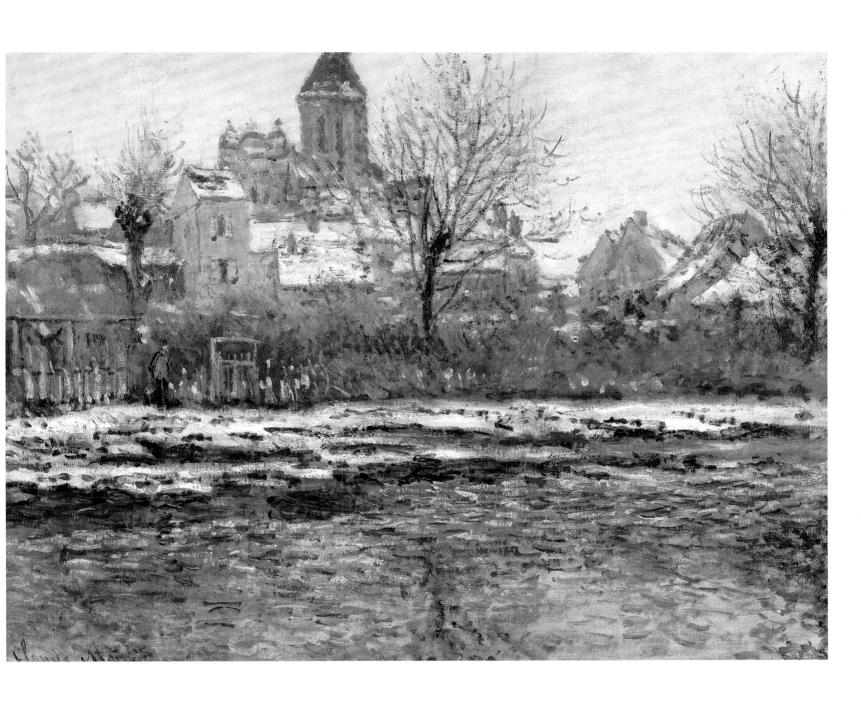

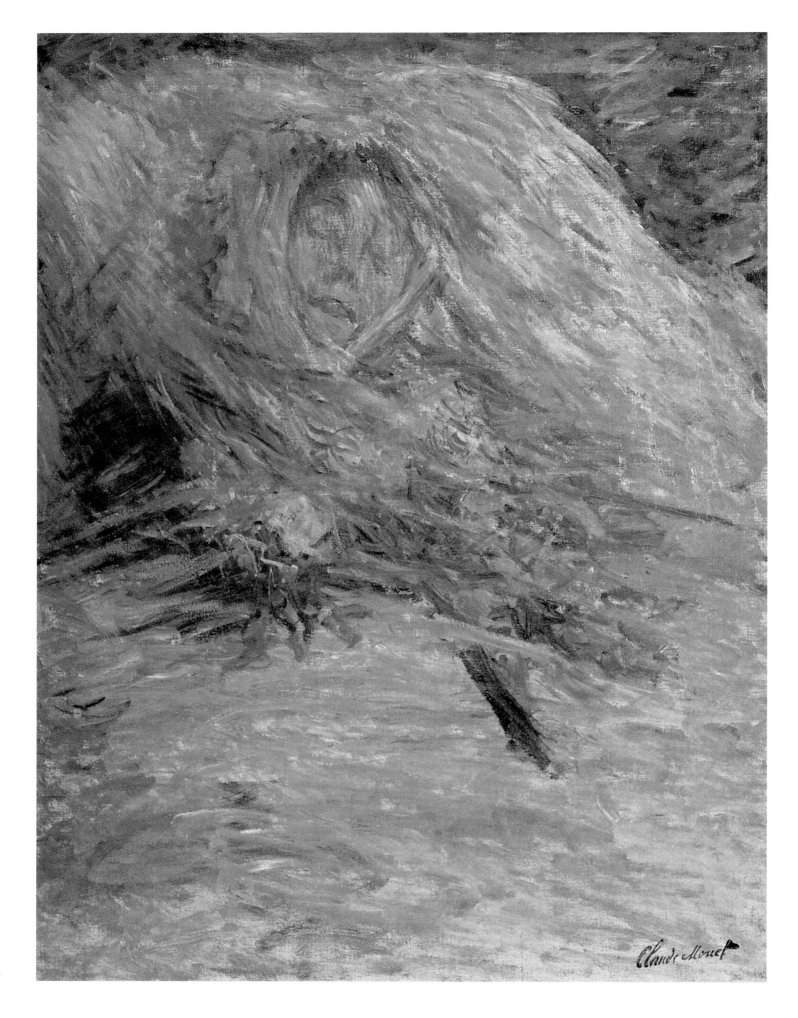

Impressionists never abandoned the idea of an independent exhibition, but left it to slowly ripen as they continued to work. Friends of the artists worried about the consequences of such an exhibit. The famous critic Théodore Duret advised them to continue seeking success at the Salon. He felt that it would be impossible for them to achieve fame through group exhibits: the public largely ignored such exhibits, which were only attended by the artists and the admirers who already knew them. Duret suggested that they select their most finished works for the Salon, works with a subject, traditional composition, and colour that was not too pure: in short, that they find a compromise with official art. He thought the only way they could cause a stir and attract the attention of the public and critics was at the Salon. Some of the future Impressionists did endeavour to compromise. In 1872, Renoir painted a huge canvas entitled, *Riders in the Bois de Boulogne*, which claimed the status of an elevated society portrait. The jury rejected the painting and Renoir displayed it in the Salon des Refusés, which had reopened in 1863. When the time came to organise the first Impressionist exhibit, Bazille was no longer with the group, having died in 1870 in the Franco-Prussian War, so the bold and determined Claude Monet assumed leadership of the young painters. In his opinion they had to create a sensation and achieve success through an independent exhibition, and the others agreed with him.

Exhibiting on their own, nevertheless, was a little frightening and they tried to invite as many of their friends as possible. In the end, the group of artists exhibiting turned out to be a varied bunch. In addition to a few adherents of the new painting, others joined in who painted in a far different style. Edgar Degas, who joined the group at this moment, proved to be especially active when it came to recruiting participants for the exhibition. He succeeded in attracting his friends, the sculptor Lepic and the engraver de Nittis, both very popular Salon artists. Degas also actively tried to persuade top society painter James Tissot and his friend Legros (who was living in London) to join their cause, but was unsuccessful. At the invitation of Pissarro, they were joined by an employee of the Orleans railroad company who was painting plein-air landscapes named Armand Guillaumin. Paul Cézanne travelled to the exhibit from his native town of Aix-en-Provence, also at Pissarro's invitation. The young Cézanne had broken with official painting in his earliest works, but he no longer shared the Impressionists' outlook on art. His participation may have aroused the concern of Edouard Manet, who definitely had been invited. According to his contemporaries, Manet said that he would never exhibit alongside Cézanne. But Manet may have simply preferred a different path. According to Monet, Manet encouraged Monet and Renoir to continue in their attempts to conquer the Salon. Manet found the Salon to be the best battlefield. In Degas's opinion, Manet was prevented from joining them because of vanity. "The realist movement doesn't need to fight with others," Degas said. "It is, it exists, and it must stand alone. A realist salon is needed. Manet did not understand that. I believe it was due much more to vanity than

Camille on Her Deathbed, 1879.
Oil on canvas, 90 x 68 cm.
Musée d'Orsay, Paris.

to intelligence." (Manet, Paris 1983, Éditions de la Réunion des Musées Nationaux, p. 29). In the end, neither Manet, nor his best friend, Henri Fantin-Latour exhibited alongside the young artists. The idea of an independent exhibition also frightened Corot, and although he liked the painting of the future Impressionists, he discouraged the young landscape painter Antoine Guillemet from participating. But Corot was unsuccessful in dissuading the courageous Berthe Morisot, a student of both Corot and Manet, whom at that moment joined the future Impressionists. Finding a location for the exhibit was a difficult problem to solve. It was risky to rent a space to young painters who were not only totally unknown, but who dared challenge the official Salon. "For some time we were automatically rejected by the designated jury, my friends and I," Claude Monet later remembered. "What were we to do? Just painting wasn't enough, we had to sell paintings, we had to live. The dealers wouldn't touch us. Still, we had to exhibit. But where?" (L. Venturi, op. cit., vol. 2, p. 340). An unexpected solution was found. "Nadar, the great Nadar with the heart of gold, rented us the space," recalled Monet (L. Venturi, op. cit., vol. 2, p. 340). Nadar was the pseudonym of Gaspard Félix Tournachon, a journalist, writer, draughtsman, and caricaturist. According to a nineteenth-century historian, Nadar was equally well-known in London and Paris, Australia and Europe. A distinguished photographer, he made photographic portraits of his famous contemporaries, including Alexandre Dumas, George Sand, Charles Baudelaire, Eugène Delacroix, Honoré Daumier, Gustave Doré, Giacomo Meyerbeer, Charles Gounod, Richard Wagner, and Sarah Bernhardt, among many others. But this was not his only claim to fame. He was also a fearless aeronaut. During the Franco-Prussian War, Nadar travelled by balloon over German lines to deliver mail from besieged Paris and it was Nadar in his balloon who got the French war minister, Léon Gambetta, out of the capital in 1871. Nadar was the first person to capture a birds-eye-view of Paris by photographing from the top of an aerostat. He was also the first to photograph the catacombs of Paris, which had opened in the mid-nineteenth century. The second-floor photography studio that he turned over to the future Impressionists, was located in the very heart of Paris, at 35, Boulevard des Capucines. It was unlike the immense galleries that normally housed the Salon exhibitions. "The Salons, with walls covered in dark red wool, are extremely favourable to paintings," wrote the critic Philippe Burty. "They [the paintings] are side-lit by natural light, as in apartments. They are all separated, which sets them off advantageously" (L. Venturi, op. cit., vol. 2, p. 288). Canvases of modest dimensions, lost in the midst of the Salon's huge academic paintings, in Nadar's studio found the optimal conditions for the

La Rue Montorgueil in Paris on June 30th, 1878, 1878.
Oil on canvas, 81 x 50 cm.
Musée d'Orsay, Paris.

La Rue Saint-Denis, 30th of June 1878, 1878.
Oil on canvas, 76 x 52 cm.
Musée des Beaux-Arts, Rouen.

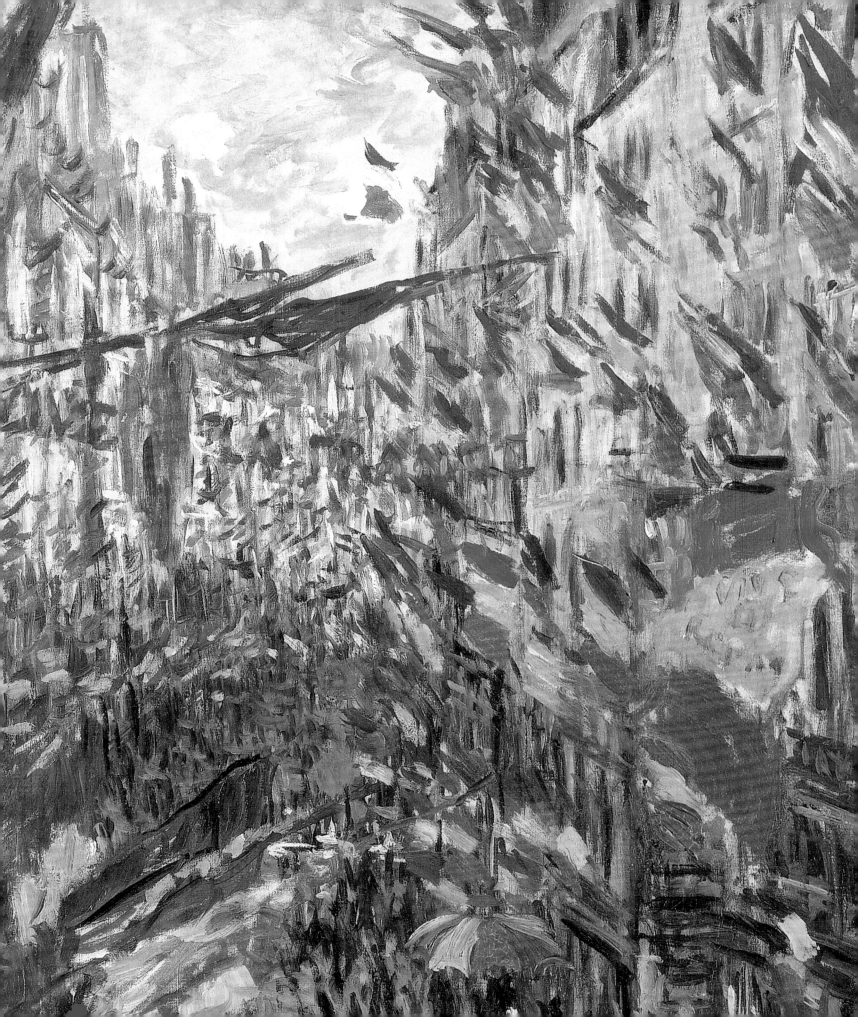

Poppy Field near Vétheuil, c. 1880.
Oil on canvas, 71 x 90.5 cm.
E.G. Bührle Foundation, Zurich.

"free expression of individual talents." (L. Venturi, op. cit., vol. 2, p. 287). One hundred and sixty-five paintings were assembled for the exhibit – the work of thirty rather dissimilar artists. Edgar Degas, Berthe Morisot, and Paul Cézanne exhibited alongside the four Gleyre pupils. The following artists were also represented: the engraver Félix Braquemont; a friend of Edouard Manet named Zacharie Astruc; Claude Monet's oldest friend, Eugène Boudin, landscape painter of Le Havre; and Degas's friend, the sculptor and engraver Ludovic-Napoléon Lepic. Additionally, the extremely fashionable Joseph de Nittis gave in to the exhortations of Degas.

The names of the other participants in the first Impressionist exhibition meant little to their contemporaries and have not remained in the history of art. Degas suggested they call their association "Capucin," after the name of the boulevard, and because it was an unprovocative word that could not be taken politically or assumed to be hostile to the Salon. Eventually they adopted the name *Société anonyme des artistes, peintres, sculpteurs, graveurs, etc.* (The Anonymous Society of Artists, Painters, Sculptors, and Engravers). In the words of Philippe Burty: "Along with their quite obvious individual intentions, the group that thus presented itself for review held a common artistic goal: in technique, to reproduce the broad atmospheric effects of outdoor light; in sentiment, to convey the clarity of the immediate sensation" (L. Venturi, op. cit., vol. 2, p. 288). In fact, only a few of the exhibiting artists expressed both these qualities in their painting: they are the painters that have remained in the history of art under the name of *Impressionists*.

The Artist's Garden at Vétheuil, 1881.
Oil on canvas, 151.5 x 121 cm.
Ailsa Mellon Bruce Collection,
National Gallery of Art,
Washington D.C.

To be fair, we should note that the decision to hold an independent exhibition was not a sudden one. Both on the eve of the 1848 Revolution and shortly thereafter artists were considering various projects for exhibitions outside the Salon, and during the Second Empire such ideas became increasingly popular. But projects, discussions and dreams are a different matter from the realisation of them.

The First Impressionist Exhibition therefore opened on April 15, 1874, at 35 Boulevard des Capucines. Of the thirty participants contributing one hundred and sixty-five works, Monet provided nine, Renoir seven, Pissarro and Sisley five each, Degas ten, and Berthe Morisot nine. The artists exhibited oils, pastels and watercolours — of Monet's works, four were pastels. In the future his contributions would increase in number: for the second exhibition (1876) he provided eighteen works, for the third (1877) thirty, and for the fourth (1879) twenty-nine. He took no part in the fifth (1880) and sixth (1881) shows, but sent thirty-five pictures to the seventh in 1882, and was absent from the eighth (1886).

The importance of any given artist's contribution lay, of course, not only in the number of works exhibited. Their artistic merits, programmatic qualities and conformity to the aesthetic principles of the new movement were vital. In these respects Monet was invariably among the leading figures. At the group's first exhibition viewers saw *The Luncheon* (p. 32), rejected by the Salon jury in 1868; *Boulevard des Capucines*, which now hangs in the Pushkin Museum of Fine Arts, Moscow; and the landscape painted at Le Havre in 1872, *Impression, Sunrise* (p. 53). It was this latter painting that gave Louis Leroy, a critic from the magazine *Charivari*, occasion in his satirical review to dub the participants in the exhibition "Impressionists". As would happen again later with the Fauves, fate had decided that a word thrown at the group in mockery should stick, and the artists themselves, although at first taking the name "Impressionist" as an insult, soon accepted it and grew to love it.

Monet's Le Havre landscape corresponded precisely with the essentials of the movement which would be termed "Impressionism" in the 1880s and 1890s by French critics, and eventually by the critics and art historians of all other countries too. With knowledge of the works by Monet and his friends that were to appear later in the 1870s, this fact

Bouquet of Sunflowers, 1881.
Oil on canvas, 101 x 81.3 cm.
H.O. Havemeyer Collection,
The Metropolitan Museum of Art,
New York.

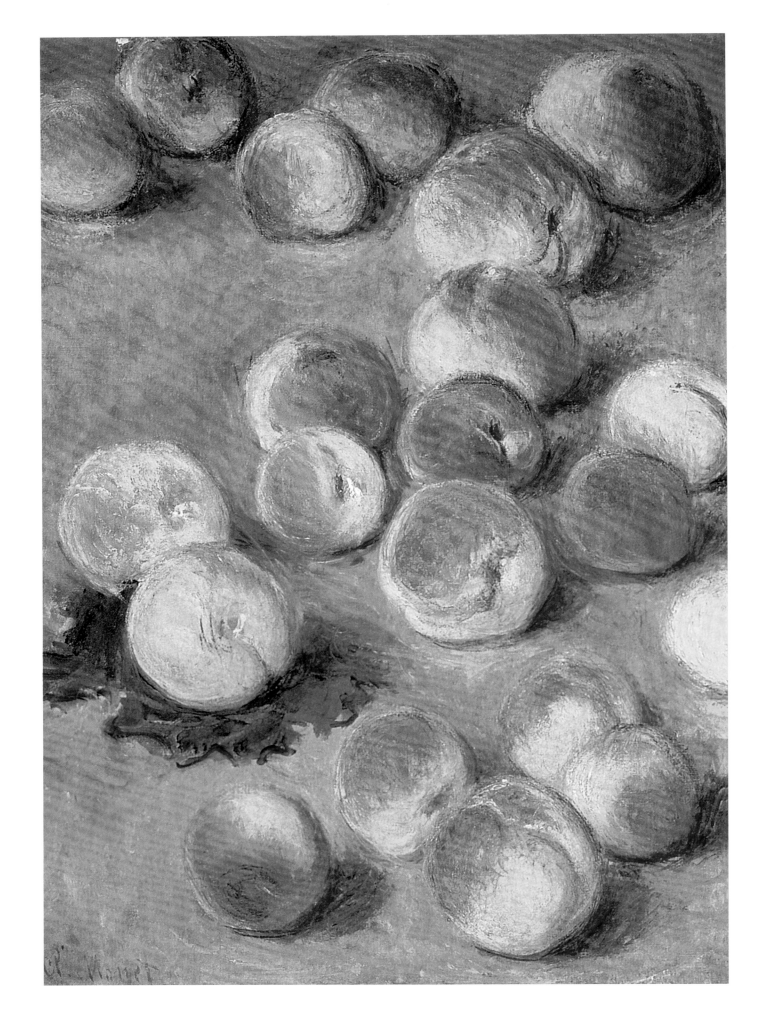

can be asserted with certainty. Two elements are dominant in the landscape: that of water, and that of the sky.

In fact they all merge with one another, forming an elusive blue-grey mirage. The outlines of buildings, smoking chimneys and boats all fade away so that only the vessels in the foreground, represented by sweeping strokes of dark-blue paint, stand out from the morning haze. The pink and yellow tones interact with the dominant cold tones, colouring the sky towards the top of the painting while they touch lightly on the water's surface, announcing the rising of the sun: a red disc suspended in the grey-blue haze. Only the reflections of the sun on the water, suggested by bright, reddish tints, foretell its imminent victory over the early morning twilight.

The picture *Boulevard des Capucines* is no less programmatic, this time demonstrating the Impressionist interpretation of the motif of the city. The artist is looking at the boulevard from an elevated viewpoint, the balcony of Nadar's studio on the corner of the Boulevard des Capucines and the Rue Daunou. He even brings the figures of men on the balcony into the composition, seeming to invite the viewer to stand alongside them and admire the unfolding spectacle. The Boulevard stretches into the distance towards the Opera, pedestrians hurry along, carriages pass by, shadows move across the walls of buildings, and rays of sunlight, breaking through the storm-clouds, sparkle, colouring all in warm, golden tones... Monet gives no attention whatsoever to individual buildings, even those of note (as he did in an early cityscape showing the church of St. Germain-l'Auxerrois in Paris); the city interests him as a unified, mobile organism in which every detail is linked to another. The French capital had been depicted by many artists, including, in the not too distant past, Georges Michel and Theodore Rousseau, who both painted the hill of Montmartre (although Montmartre at that time presented almost a rural scene). Just prior to and contemporaneously with Monet, Paris was painted by Jongkind and Stanislas Lepine. The former's Paris was a bustling and frequently sad city, while the latter could not suppress a rather dry, matter-of-fact approach. But Monet, both in the *Boulevard des Capucines* and in his other cityscapes, affirms the lyrical essence of contemporary urban life and vividly demonstrates the wholly unique light effects that the city provides. This path, or one close to it, would be followed in their cityscapes by Manet, Pissarro, Maurice Utrillo, Albert Marquet and other artists of the Impressionist and Post-Impressionist movements. Both the *Boulevard des Capucines* and *Impression, Sunrise* revealed fundamental changes in Monet's manner. His style had become noticeably livelier, his brushstrokes already quite varied and mobile, and his

Peaches, 1883.
Oil on canvas, 50.5 x 37 cm.
Private collection.

Branch of a Lemon Tree, 1884.
Private collection.

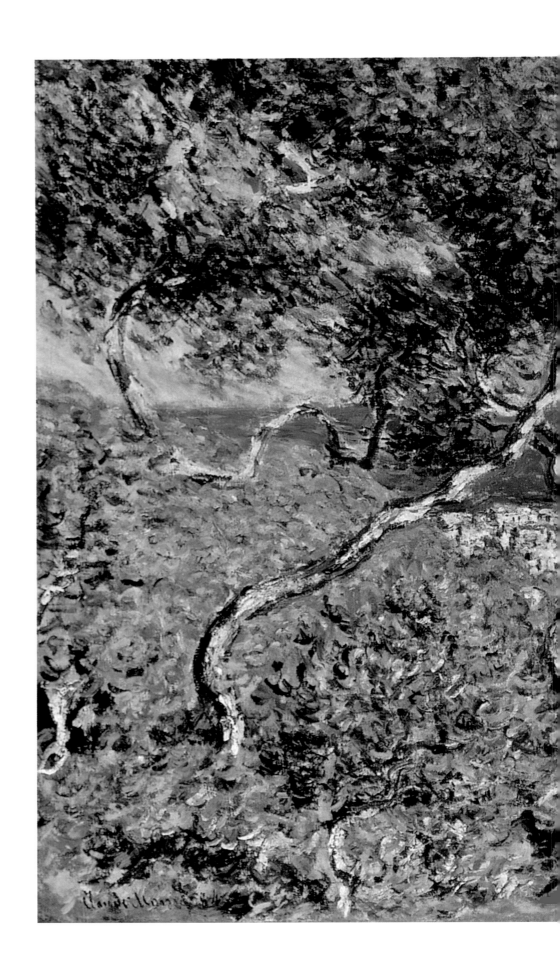

Bordighera, 1884.
Oil on canvas, 64.8 x 81.3 cm.
The Art Institute of Chicago, Chicago.

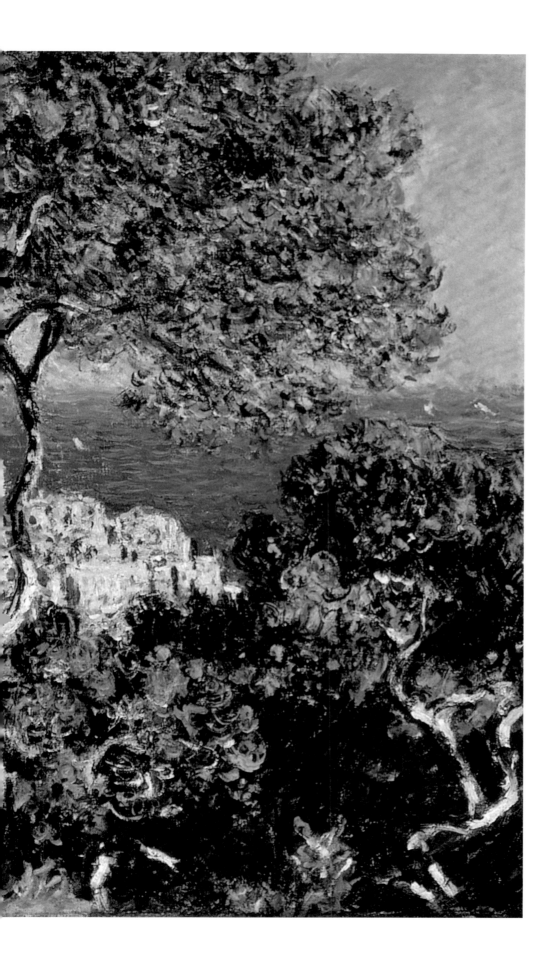

colours had acquired transparency. By now he was representing not only objects but also the atmosphere surrounding them, and influencing both colour and the boundaries of form. Henceforth Monet was convinced that forms could not look as definite as they were painted by, say, Courbet, and that local colour was totally conditional — an object's colour is never perceived in all its purity since it is affected both by light and the air enveloping it. At first hesitantly, and then with increasing freedom and confidence, Monet developed his manner of painting to correspond with his altered artistic perception. In this sense, in the 1870s he achieved perfect balance and harmony. At the Second Impressionist Exhibition Monet displayed landscapes, for the most part of Argenteuil, and the figure composition, *La Japonaise* (p. 65). If *La Japonaise*, which depicted the artist's wife Camille in a kimono, still tended towards Monet's 'old' style – the paint being laid on thickly in broad strokes – the landscapes on the contrary continued the trend indicated by the views of Le Havre in the early 1870s, the *Boulevard des Capucines* and other works in similar vein. From 1872 onwards Monet lived mainly at Argenteuil, a small town on the Seine not far from Paris. Other artists came to visit him there, as though to underline his outstanding role in the establishment of Impressionism. Among them was Manet, who in 1874 painted such well-known pictures as *Argenteuil, Boating, On the Bank of the Seine, Claude Monet in his Studio Boat* and some other works. Edouard Manet consistently singled Monet out from the other Impressionists, and in his reminiscences Antonin Proust recalls the elder artist's words about his younger colleague: "In the entire school of the '30s there is no one who could paint landscape like that. And his water! He is the Raphael of water. He feels its every movement, all its depth, all its variations at different times of the day."

The Argenteuil Period

The foremost theme in Monet's work of the 1870s was Argenteuil. He painted the Seine with boats and without them, reflecting the resonant blue of the sky or leaden grey under wintry clouds. He enjoyed painting the town as well, now powdered with snow, now sunny and green. In fine weather he would go for walks in the surrounding areas of Argenteuil, sometimes with his wife and son, and these strolls gave rise to canvases filled with the intoxicating joy of living. One of these is *The Poppies (A Promenade)* (1873, Musée d'Orsay, Paris). Across a living carpet of meadow grass strewn with the red heads of poppies wander ladies with their children; above them stretches a broad sky with light white clouds. In Monet's interpretation, nature is kind and bright, hospitably drawing to her breast all those who come to her with an open heart and soul. The poppy field theme never lost its attraction for the artist. Before going to Holland in 1886 and elaborating the red

Three Fishing Boats, 1885.
Oil on canvas, 73 x 92.5 cm.
Magyar Szépmüvészeti Múzeum,
Budapest.

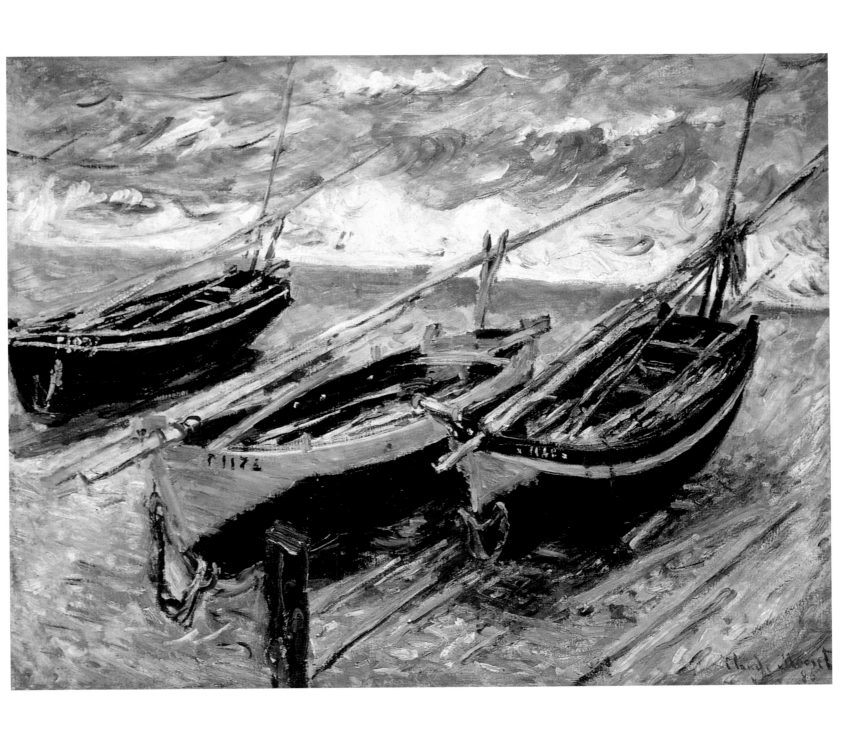

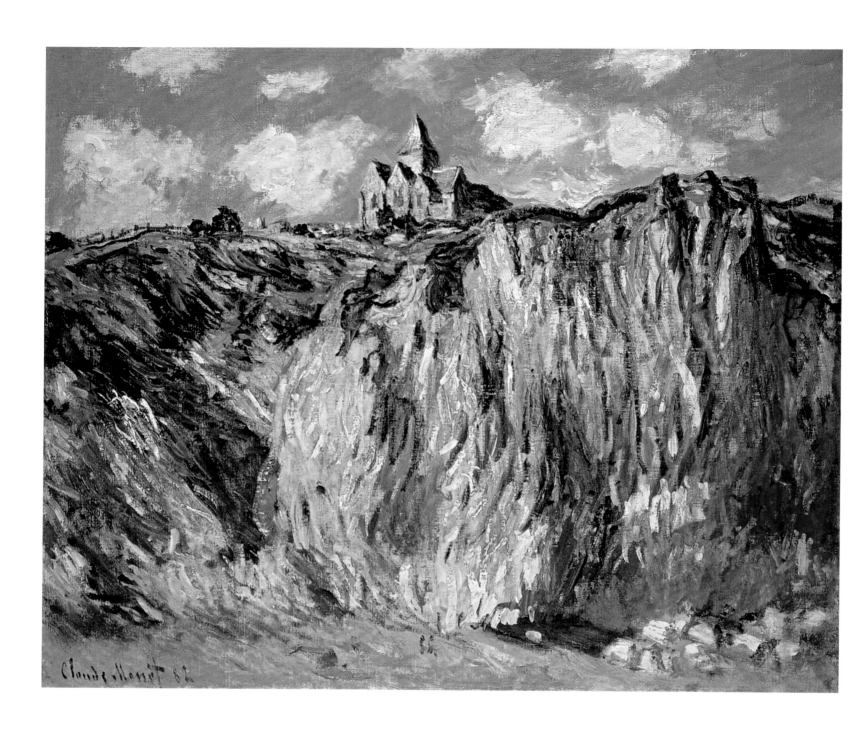

The Varengeville Church,
Morning Effect, 1882.
Oil on canvas, 60 x 73 cm.
Private collection.

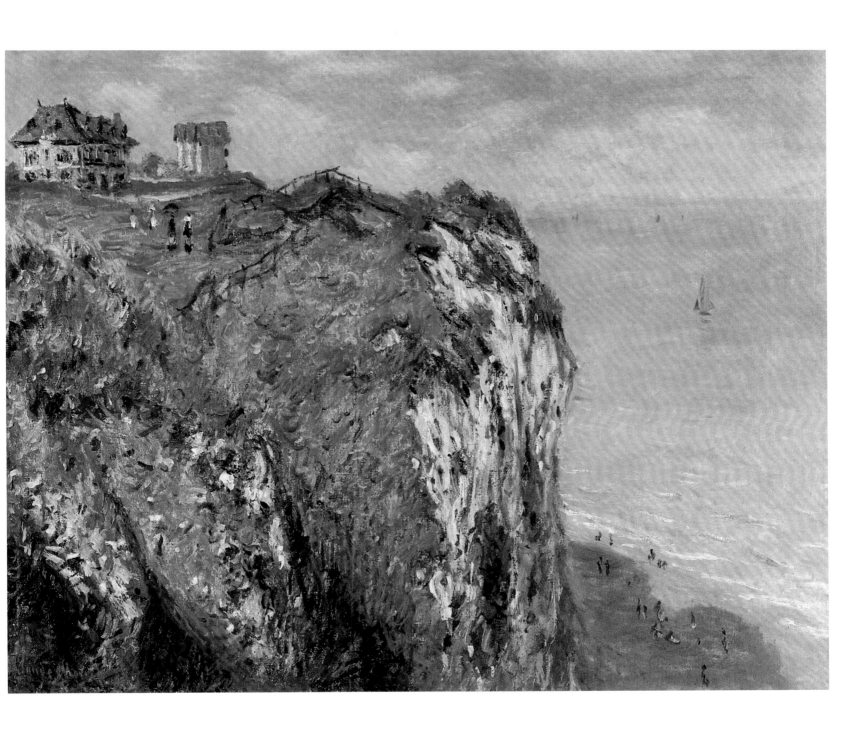

Cliff at Dieppe, 1882.
Oil on canvas, 65 x 81 cm.
Kunsthaus, Zurich.

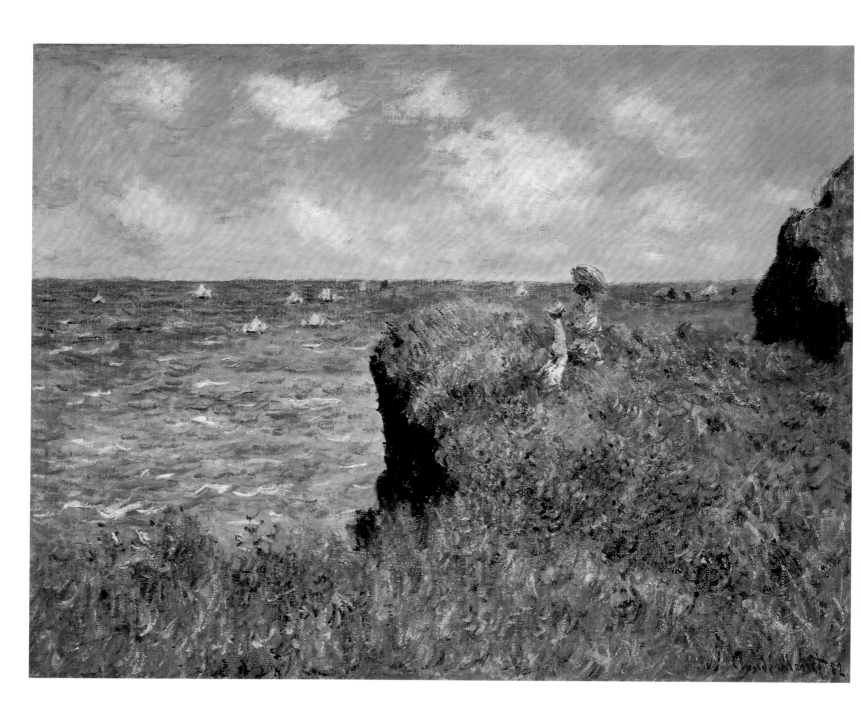

tones of *The Tulip Field*, Monet treated this theme in a way peculiarly his own. More often than not he depicted the golden-green expanse of field with the scarlet flashes of poppies running through it. This is exemplified by *The Poppies (A Promenade)* of 1873 and *The Poppy Field at Lavacourt* of 1881. In pictures on the poppy field motif done after 1886, the artist no longer cares about revealing the actual shapes of the flowers, but dissolves them into a continuous stream of red tones interspersed with greens.

It is precisely in this manner that the Hermitage canvas is executed. Its dating presents great difficulty. Wildenstein assigns the picture to 1890, linking it with a series of four landscapes devoted to one and the same motif (W., III, 1251, 1252, 1253, and 1254, of which two are dated 1890 and 1891 by the artist himself). However, the Hermitage canvas differs from the landscape series in both theme and execution. While in all the landscapes of this series Monet repeatedly depicts the slope of a hill in the right-hand part of the composition, just behind the trees, in the present canvas he unfolds the chain of hills along the entire horizontal of the picture far away from the poplars. A forest massif visible in front of the hills is absent in the landscape series. By its painterly features, the Hermitage canvas shares greater affinity with *Lucerne* and *Poppies* (p. 45), dated 1887 by the artist and showing a locality south of Giverny.

This landscape echoes the Hermitage painting above all in the rendering of the sky covered by small white-edged clouds. The thick, multi-layered texture of brushstrokes typical of the Hermitage canvas can also be seen in other works by Monet dating from 1887, such as *The Boat* and *The Boat at Giverny* (pp. 106-107). Consequently, there is some reason to believe that the Hermitage picture was painted in 1887, when the artist worked on *Lucerne* and *Poppies*.

In his Argenteuil period Monet shows a preference for landscapes that convey wide expanses of space with an uncluttered foreground. This sort of composition lends paintings a panoramic quality, space being developed in breadth rather than in depth, with horizontals expressed by rivers, riverbanks, lines of houses, groups of trees, the sails of yachts turned parallel to the surface of the canvas and so on. Monet's prevailing tendency at this period may be illustrated, for example, by such works as *Barges on the Seine* (1874, private collection, Paris), *Resting Boats at Petit-Gennevilliers* (California Palace of the Legion of Honour, San Francisco), and *Impression, Sunrise.*

The dynamics of the life of nature are captured by Monet in the Argenteuil cycle both in minor, everyday phenomena and in turning-points: the spring blossoming is followed by the time of ripening, in turn followed by the fading of autumn, and then

Clifftop Walk at Pourville, 1882.
Oil on canvas, 66.5 x 82.3 cm.
The Art Institute of Chicago, Chicago.

by winter. Yet even Monet's winter does not signify death, for life still carries on — vehicles move along the roads, people are up and about, a magpie sits on a snow-covered fence, and, most important of all, the changing light and the atmosphere itself live on in his paintings, proclaiming now a thaw, now a fresh snowfall, now another cold spell.

The words of Camille Pissarro, written to Théodore Duret in 1873, can be applied to all the Argenteuil landscapes: "I consider his talent very serious, very pure; he is truthful, only he feels somehow differently; but his art is thoroughly thought through; it is based on observation and on a completely new feeling; it is poetry created by the harmony of true colours."

Monet left Argenteuil occasionally to visit Paris or to stay with Ernest Hoschedé, one of the first collectors to become interested in the new school. On Hoschedé's estate of Montgeron, Monet worked on decorative panels intended for his host. Hoschedé put a large studio not far from the château at Monet's disposal, along with a little fisherman's cabin on the banks of the Yerres River, where he also painted. Monet could work peacefully there, free from everyday concerns. The amateur painter in the family was Alice. She and her husband had at first collected the works of painters of the Barbizon School, and later those of the Impressionists. Monet painted four decorative panels with the park at Montgeron as his subject. Decorative painting was a new field for Monet. These large, almost square canvases are little more than enlarged Impressionist paintings. Because of their dimensions it was impossible to paint out of doors. Monet worked on them in the studio from studies, yet these panels have all the qualities of open-air painting. One has the impression that the painter has transferred a corner of the garden as he saw it in nature directly onto the canvas, with no concern at all for the composition (*A Corner of the Garden at Montgeron*, p. 66). The flowering shrubs are cropped by the lower edge of the canvas, and the bright blue of a part of the pond can be glimpsed. A style of composition that was not classical, but seemed instead to be chosen at random, was one of the methods used by the Impressionists. The roses are painted with juxtaposed brushstrokes of white lead and red which, through an optical phenomenon, give the viewer the impression of fresh flowers suffused with morning dew. The light blue haze of a hot summer's day softens the colours in the background. Monet's painting celebrates the beauty of nature, alive and unaffected. Another of Monet's panels begins with a pond shadowed by trees that takes up two thirds of the height of the canvas (*Pond at Montgeron*, p. 67). A bank of damp mist conceals the human figures. The eye can barely make out one lady with a fishing rod standing in the shadow of a tree, another reclining in the grass, and two figures walking away. Only in the background do the trees part, leaving the field open to the warm, golden sunlight.

The Cliff, Étretat, Sunset, 1883.
Oil on canvas, 60.5 x 81.8 cm.
North Carolina Museum of Art,
Raleigh, North Carolina.

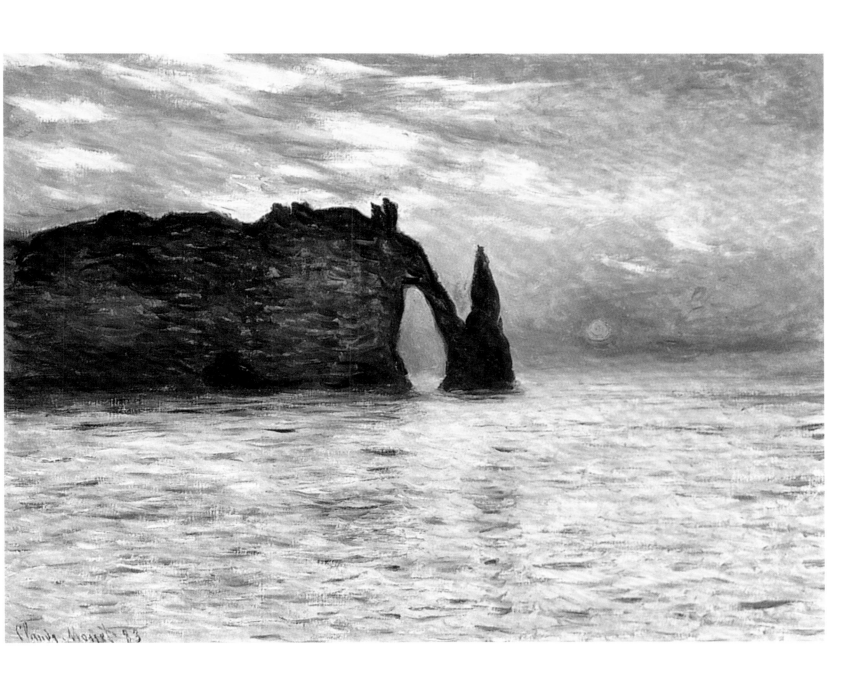

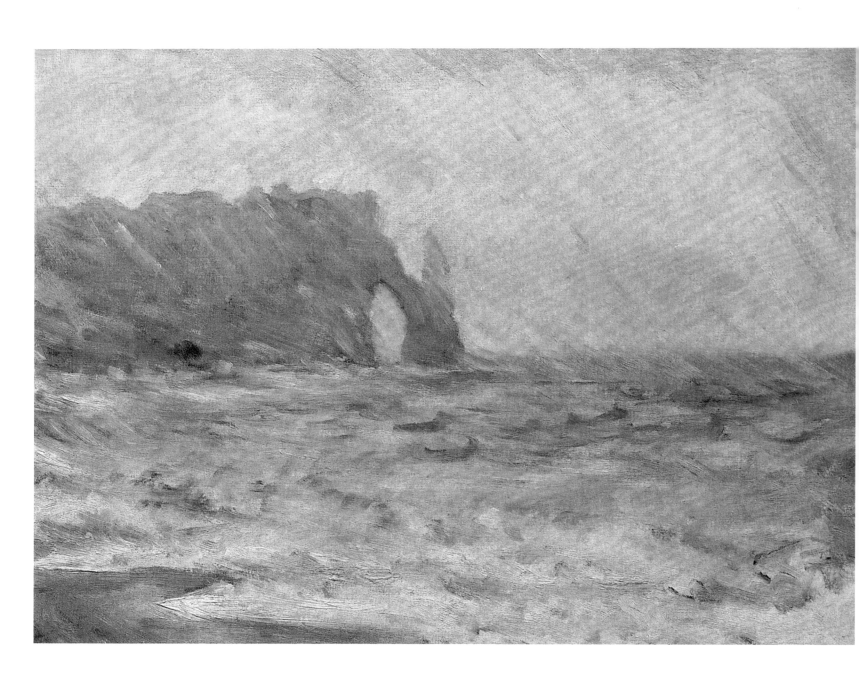

Étretat, The Rain, 1885-1886.
Oil on canvas, 60.5 x 73.5 cm.
Nasjonalmusjeet, Oslo.

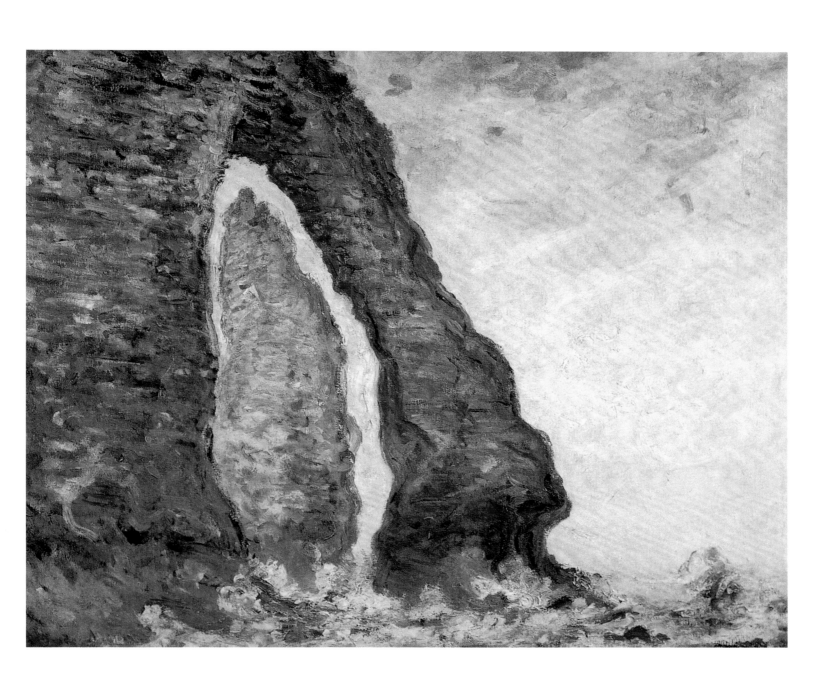

The Needle Seen through the Porte d'Aval, 1885-1886.
Oil on canvas, 73 x 92 cm.
Private Collection, USA.

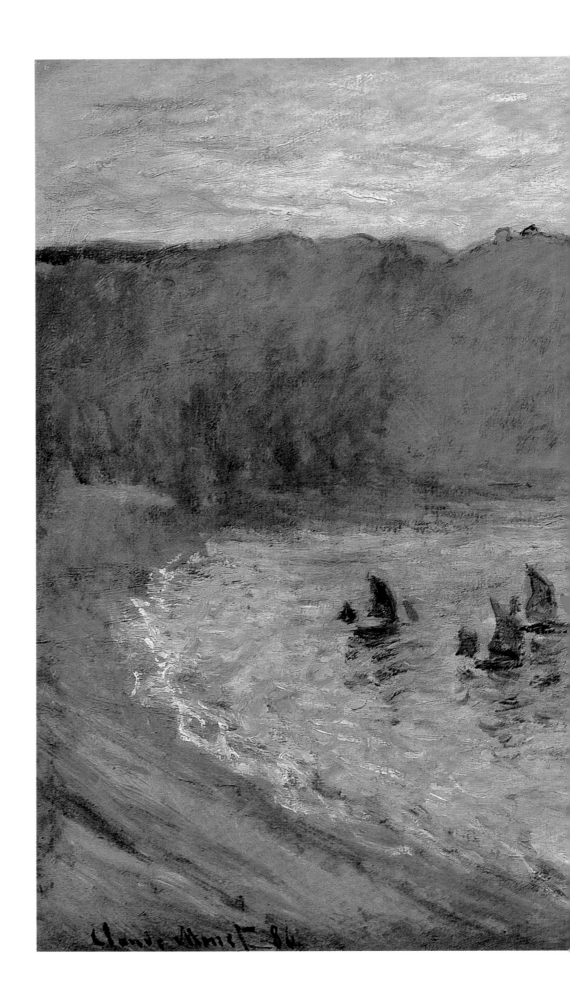

Cliffs at Étretat, 1886.
Oil on canvas, 65 x 81 cm.
Pushkin Museum of Fine Arts, Moscow.

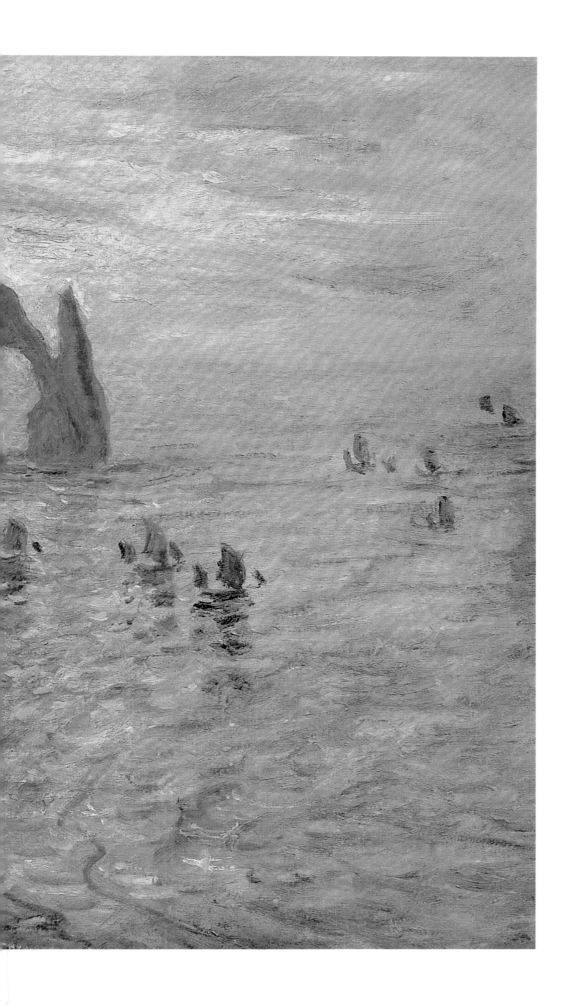

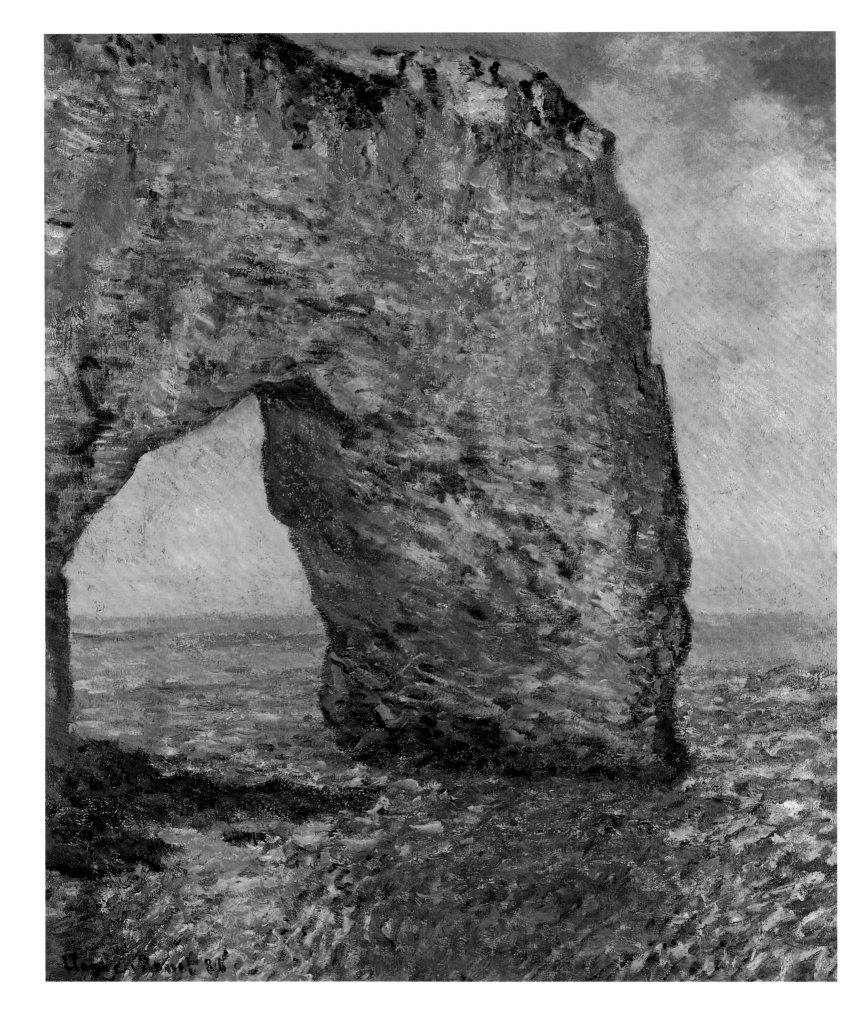

Two of these, sold by the bankrupt Hoschedé in 1878, are now in the State Hermitage Museum in St. Petersburg. They are *A Corner of the Garden at Montgeron* and *The Pond at Montgeron*. Monet's characteristic taste for the decorative is given free rein in these works, particularly in the former. In the Argenteuil series Monet tended most often towards small canvases and a horizontal format; here the format is considerably larger and almost square

In 1907 Ivan Morozov bought a large, rolled-up canvas from the dealer Ambroise Vollard, paying for it merely 10,000 francs, because it was badly soiled and the varnish damaged. Morozov had it restored in Paris and called it *The Riverside*, in accordance with Vollard's receipt. It almost coincided in size with the *A Corner of the Garden at Montgeron*, part of Monet's series of decorative panels executed in 1876-1877. Either *The Pond at Montgeron* or a study for it appeared at the *Third Impressionist Exhibition* among the eleven Monets from the collection of Ernest Hoschedé — probably under the title *La Mare à Montgeron*. This is difficult to establish today, but the following description by G. Rivière in his review of the 1877 exhibition pertained indisputably to the composition of *The Pond at Montgeron*, whether it was the present painting from the Hermitage or a study for it, *A Corner of the Pond at Montgeron*: "...the side of a pond in the dark-blue waters of which huge trees are reflected". This description provided grounds for altering the title given by Vollard. The peculiarities of texture handling are explained by the decorative effect sought by Monet. This kind of brushwork with paint applied in bold broad strokes was not altogether characteristic of Monet. The painting is made up of streams of yellows, greens and blues, yet the colours do not lie in chaotic disarray. Applied in patches and staggered zigzags, they give a sensation of an undulating mass inbued with life. Using the surface of the pond as a mirror, the artist juxtaposed the actual scene with its inverted reflexion. Owing to this symmetrical disposition, the tree trunks, which seem to extend down into the water, emphasise the picture's two-dimensional quality and give stability with their vertical lines to the quivering surface of the pond. *The Pond at Montgeron* may have appeared in the sale of Hoschedé's collection in 1878 as one of four nameless pictures by Monet, unlisted in the catalogue and sold at nominal prices. This supposition is based on the following considerations: in 1968 M. Bodelsen published the records of the 1878 Hoschedé sale in *The Burlington Magazine*, which she had discovered in the archives, and which listed many Monets. Recorded as items 6, 7, 15 and 16 were nameless paintings by Monet, not included in the sale catalogue. Two of them were bought by G. Petit for seventy-five and thirty-eight francs, one by J.-B. Faure for fifty francs and one by De Bellio for thirty-five francs. The present writer believes that the canvas purchased by J.-B. Faure is *The Pond at Montgeron*, now in the Hermitage. When Morozov purchased it from Vollard, the dealer had it in a roll and its varnish was soiled, thus, like the other three pictures, it had probably appeared at the Hotel

The Manneporte (Étretat), 1886.
Oil on canvas, 81 x 65 cm.
The Metropolitan Museum of Art,
New York.

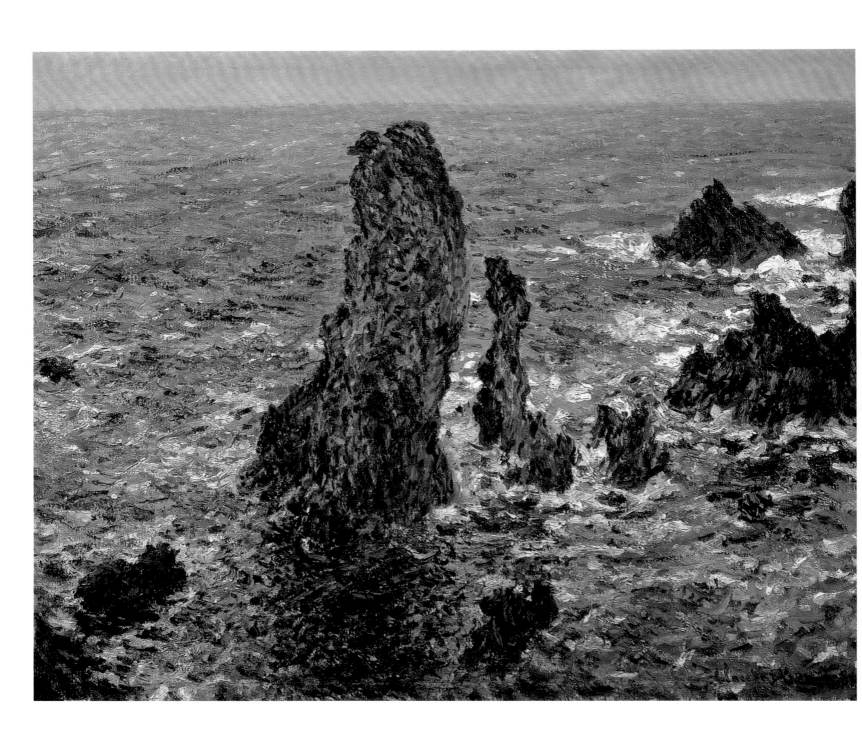

The Rocks at Belle-Île, 1886.
Oil on canvas, 65 x 81 cm.
Pushkin Museum of Fine Arts, Moscow.

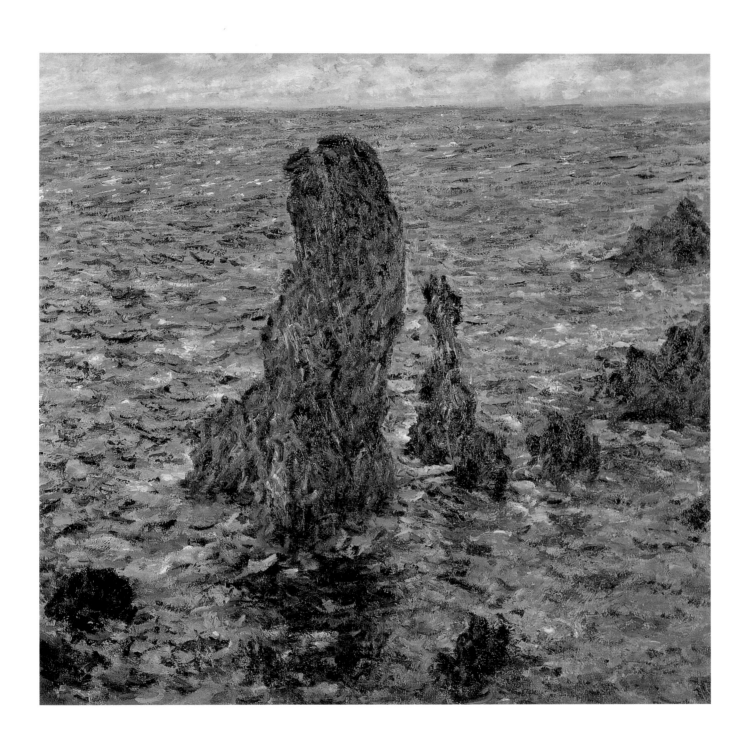

The Port Coton "Pyramids", 1886.
Oil on canvas, 65.5 x 65.5 cm.
Dr. Rau Collection, Cologne.

Drouot rolled up. Not examined prior to the sale and not included in the catalogue, it sold for a much lower price than did Monet's other works.

When Monet was in Paris he could most often be found in his favourite district on the right bank near the railway station of Saint-Lazare. These were familiar haunts for Monet as he used to arrive here from Le Havre and leave from here when travelling out into the environs of Paris. What, one might wonder, could he find of interest in the halls of the station, in the cheerless platforms, the criss-cross pattern of the railway lines and the bridges suspended above them? And yet Monet never tired of admiring the confident little steam-engines with their tall, protruding funnels, the fantastic pattern of the rails and the iron girders supporting the glass roof, and, above all, the clouds of blue-white steam and grey smoke that poured through the expanses of the station. He covered canvas after canvas here creating the first cycle of his career, *La Gare Saint-Lazare*.

The theme of the railway was not a new one in European art. In 1843, in one of his graphic series Monet's compatriot Honoré Daumier took a lighthearted look at the misadventures of Parisians who had taken to the railway. Then in 1844, William Turner depicted a courageous steam-engine moving steadily forward through rain and steam; and a few years later the German Adolph von Menzel depicted the railway line between Berlin and Potsdam.

So what did Monet bring to this subject, already taken up by other artists? Neither Turner's nor Menzel's work could be deemed an urban landscape, the former being something of a phantasmagorical vision, the latter a rural setting being forcibly encroached upon by new technology. Monet's stations, however, are a continuation of his urban theme, his joyous poem of the contemporary city with all the distinctive signs of the time. The views of Saint-Lazare station and his landscapes of Montgeron were Monet's major contributions to the *Third Impressionist Exhibition*, but neither the public nor the critics took them seriously. About one of the decorative Montgeron canvases entitled *The Turkeys at the Chateau de Rottembourg, Montgeron* (distinguished by its marvellously rhythmic structure), it was written that Monet had simply scattered white blobs with necks attached on a green background, and that the painting lacked air and that as a whole it created a ridiculous impression. Thus the gulf between the artist and the public was by no means closed, assuming that the latter gleaned its information from the periodical press. But at the same time, the Third Impressionist Exhibition was in a sense the culmination of the entire movement. For example, Renoir displayed *Dancing at the Moulin de la Galette*, *The Swing*, portraits of Jeanne Samary and Madame Henriot, and other significant works; and Pissarro and Sisley were represented by such highly typical paintings as *Harvesting at Montfoucault* and *Floods at Port-Marly* respectively.

The Rocks at Belle-Île
(The Savage Coast), 1886.
Oil on canvas, 65 x 81.5 cm.
Musée d'Orsay, Paris.

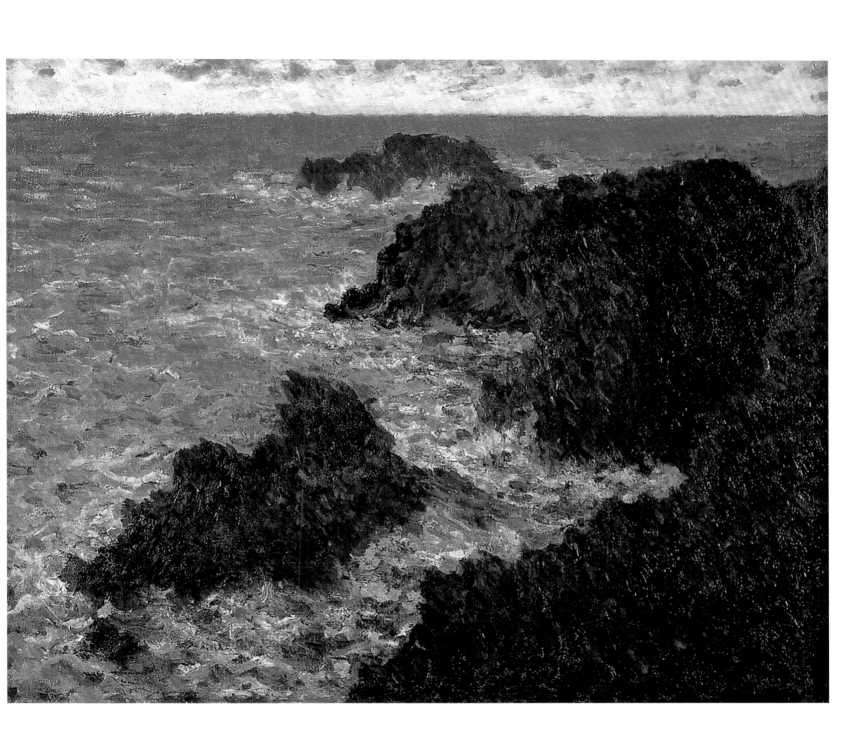

The Boat at Giverny, c. 1887.
Oil on canvas, 98 x 131 cm.
Musée d'Orsay, Paris.

Study of a Figure Outdoors
(facing right), 1886.
Oil on canvas, 130.5 x 89.3 cm.
Musée d'Orsay, Paris.

Study of a Figure Outdoors
(facing left), 1886.
Oil on canvas, 131 x 88 cm.
Musée d'Orsay, Paris.

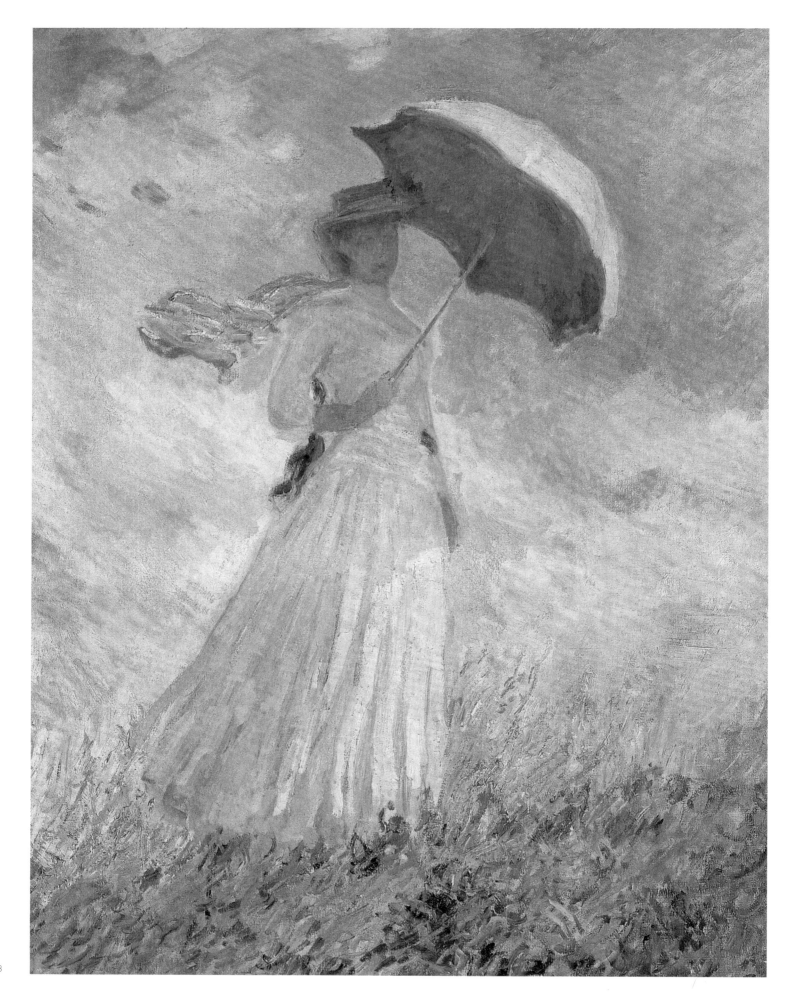

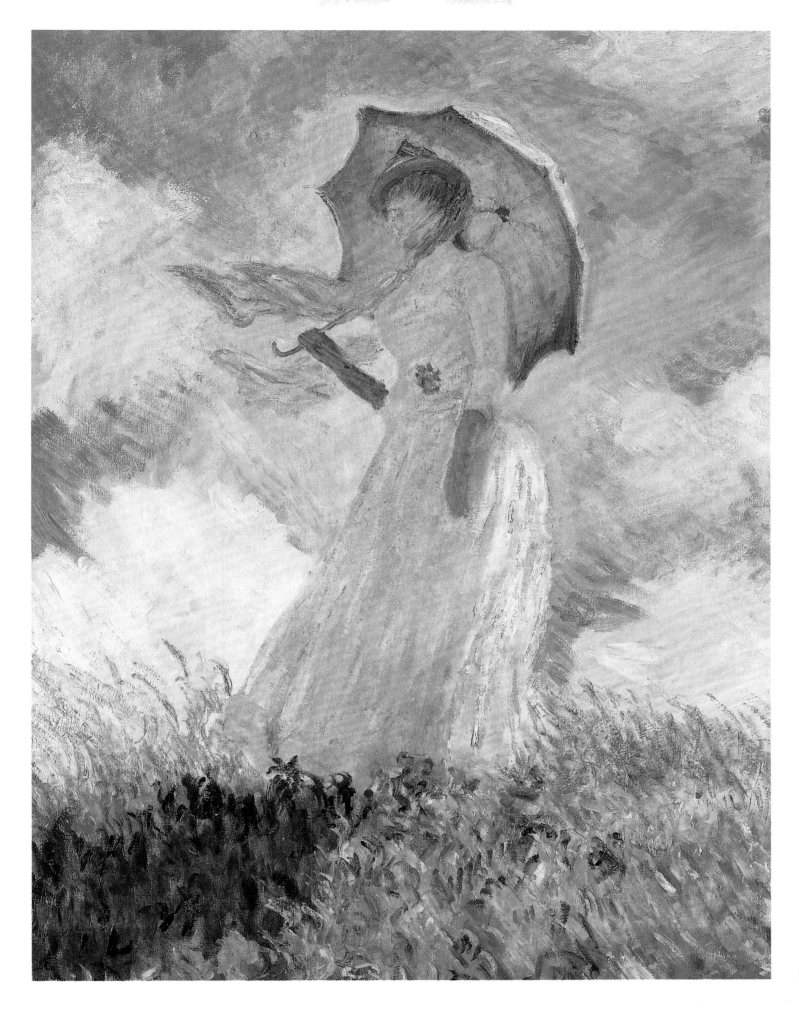

The fourth exhibition was somewhat less varied, for Renoir, Sisley and Berthe Morisot were all absent. However, the contributions from Monet and Pissarro continued to affirm the central role of the landscape in the Impressionist movement. The main attacks from the critics were provoked by Monet's *La Rue Montorgueil in Paris on June 30th, 1878* (p. 78) and *La Rue Saint-Denis, June 30, 1878* (p. 79). The review by the influential critic Albert Wolff of *Le Figaro (The Barber)* newspaper, while remarking on the exceptional position of Monet among the Impressionists, and even admitting a certain liking for some of his landscapes, comes to the categorical conclusion that "…he has now fallen so low that he will never be able to rise again." Wolff continues — with Pissarro in mind as well as Monet:

> The speed of these artists' work indicates how little they need to be satisfied. Monet sends thirty landscapes, all completed, one must assume, in a single day. Pissarro daubs a dozen pictures before breakfast and exhibits forty such works. These adroit gentlemen really do work remarkably quickly! Two or three haphazard strokes of the brush any old how, a signature — and a painting is finished.

This was written of artists who spent enormous amounts of time and energy on the creation of landscapes; artists constantly plagued by self-doubt.

The cityscapes shown by Monet at the fourth exhibition reveal changes in his treatment of the urban theme and changes in his style as a whole. The streets of Montorgueil and St. Denis had been decorated for the World Fair. To produce the paintings, Monet adopted a viewpoint similar to that he had chosen for the *Boulevard des Capucines*, looking down from a balcony, only now the compositions are given no indication of the position from which the pictures were painted. The artist immediately plunges the viewer into the expanse leading into the depths of the streets, filled with flags fluttering in the breeze — the cheerful interrelationships between these hosts of flickering red, white and blue flags tend to distract one from the motif of the street as such. In the *Boulevard des Capucines* it was possible to distinguish the essential features from which the impression of the city was built up — the buildings flooded with sunlight, the trees of the boulevard, the carriages and figures of pedestrians; but now the viewer has almost no chance of spotting such details, for everything, from the roofs of the buildings to the shop-windows at pavement level, is bedecked with innumerable flags. Thus the commentators who ignore the rather long titles given to these paintings at the exhibition, replacing them with a short one, *Flags*, are not entirely unjustified. The views of the Saint-Lazare station displayed new developments in the character of Monet's painting. It is painted with powerful brushstrokes which at times "fragment" the object being depicted. Similarly, in *Flags*, the comma-like strokes have become frenzied; energetic marks of the brush literally lash the surface of the canvas and the

Poppy Field in a Hollow near Giverny, 1885.
Oil on canvas, 65 x 81 cm.
Museum of Fine Arts, Boston, Massachusetts.

colours, especially the various shades of red, ring out loudly and confidently. Always preoccupied with the problems of rendering light and air, Monet had thus, by the late 1870s or early 1880s, achieved a heightened expressiveness of colour and a powerful and dynamic brushstroke.

In 1880, at the age of forty, Monet had come to the end of his first consistently Impressionist decade. He had behind him dozens of works that were to become classics of Impressionism, and his creative method had been defined — including the approach of painting landscapes in the open air shared by other Impressionists.

There is nothing surprising about the simple fact of his painting outdoors, for many generations of artists had already executed drawings, watercolours and sketches in oils directly from nature. More often than not, however, these works constituted supplementary material used towards the creation of the final, completed canvas. The Impressionists, and Monet more than anyone, wanted to transform nature herself into a workshop and to erase the distinction between the sketch, the result of direct observation, and the picture, the synthesis of the whole creative process. Thus Monet's correspondence abounds in complaints about changes in the weather. He is brought to despair by rain, winds and inconsistent light, all of which hamper his work, and yet at the same time it is nature's very changeability that is so attractive to him. How can one convey by means of paint the grass swaying in the wind or the ripples on the surface of water? How can one transfer onto canvas the fluffiness of newly-fallen snow or the crackling fragility of melting ice as it flows downstream? It was Monet's firm conviction that all this can be achieved by tireless observation and so, dressed in comfortable clothing suitable to the weather, the artist would go out to work every day, morning, afternoon and evening. Sometimes he was even obliged to lash his canvas to his easel and an umbrella to his own body in order to protect himself and his work from the tempestuous elements. In the 1870s Monet's aesthetic attitudes took quite definite shape. The ordinary world that surrounded man in his everyday life appeared in his canvases transformed, no longer sadly humdrum, but invariably joyous, for nature never inspired gloomy, burdensome ideas in Monet.

This optimistic view of the world was matched by his palette which, once freed of conventional sombreness, began to glow with bright, sunny colours. The expanses re-created in his paintings were filled with light and air, which demonstrated his astonishing ability to perceive nature as a combination of many variable elements.

The texture of his paintings became particularly diverse, created by multitudes of mobile and vibrant strokes. By this time everything about Monet proved that a vivid and original landscapist had appeared in French painting. What were the tangible results of the decade that had just closed? How was Monet regarded by his contemporaries — not

Haystack at Giverny, 1886.
Oil on canvas, 61 x 81 cm.
The State Hermitage Museum,
St. Petersburg.

Poppy Field, c. 1890.
Oil on canvas. 60.5 x 92 cm.
The State Hermitage Museum,
St. Petersburg.

Poppy Field (Giverny), 1890.
Oil on canvas, 61.2 x 93.1 cm.
Mr. and Mrs. W.W. Kimball Collection,
The Art Institute of Chicago, Chicago.

the friends and colleagues who were thrilled by his art, but the public, and the press which shaped public opinion? With rare exceptions, the critics spoke of Monet in the most disparaging terms. The situation of his family, now consisting of two children and a sick wife (Camille died in 1879 after a painful illness), was catastrophic indeed, as extracts from his letters attest.

In 1875 he wrote to Manet: "Since the day before yesterday, our position becomes worse and worse; we have not got a penny, and cannot have credit either with the butcher or the baker. Although I have not lost faith in the future, the present, as you can see, is very hard." A second letter, from 1877, is addressed to Zola: "Can you and would you do me a great favour? If I haven't paid by tomorrow night, Tuesday, the sum of 600 francs, our furniture and all I own will be sold, and we will be out on the street… I am making a last attempt and I am turning to you in the hope that you may possibly lend me 200 francs. This would be an installment which may help me obtain a delay. I don't dare to come myself; I would be capable of seeing you without daring to tell you the real purpose of my visit." It was very difficult to write such letters, but Monet turned to others besides Manet and Zola. He suffered, sought a way out, and worried about his family, but all his troubles were forgotten when he was alone, with his canvases and paints, one to one with Nature; not a trace of disillusionment or sorrow remained, and no doubt cast its shadow on the joyous essence of being. After spending several years at Vétheuil on the Seine, Monet settled down in 1883 at Giverny, henceforth his main place of residence, although he did a good deal of travelling in the 1880s. In the spring of 1883 he worked on the Normandy coast, at Le Havre and Étretat, and in December of that year he set out with Renoir for the Riviera. In 1884, after Bordighera and Menton, he returned to Étretat, where he also spent several months during the following summer. The year 1886 was memorable for trips to Holland and Brittany; from January to April 1888 he lived on the Mediterranean coast at Antibes, before moving on to London and

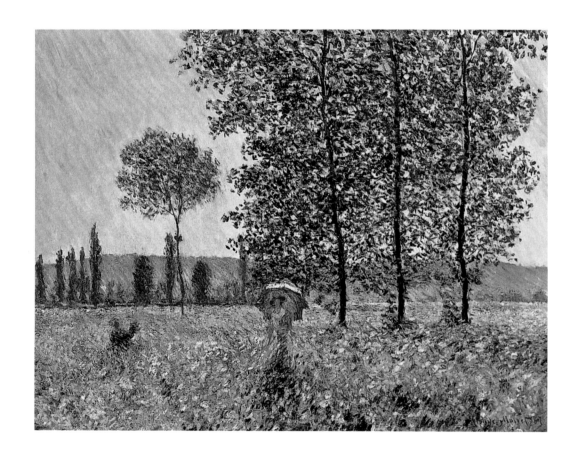

Under the Poplars, Sunlight Effect,
1887.
Oil on canvas, 74.3 x 93 cm.
Staatsgalerie Stuttgart, Stuttgart.

thence back to Étretat. These journeys were undoubtedly efforts to find new sources for his work, new and inspiring motifs. Nevertheless, in all his wanderings, Monet remained resolutely faithful to the central principle of his art, trying to penetrate deep into nature, to apprehend her secrets and convey them through vivid and direct perception. After his arrival in Bordighera and exposure to the exotic nature of the south, he wrote to his second wife Alice: "My work is progressing, but I am experiencing difficulty; these palm-trees are a torment to me, and apart from that it is very hard to pick a motif and get it down on the canvas — there are such thickets all around." In Brittany he was moved by the region's singularity and severity, writing to Durand-Ruel: "I am doing a lot of work; this place is very beautiful, but wild, yet for all that the sea is incomparable, surrounded by fantastic crags."

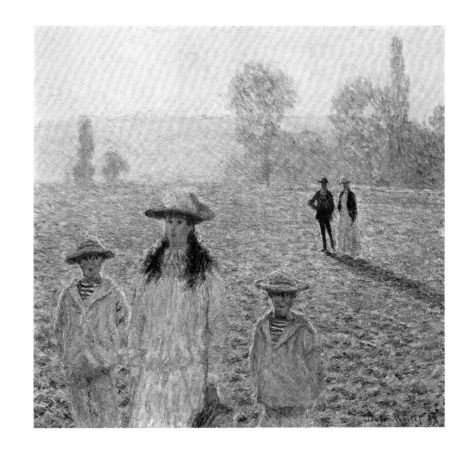

The impression evoked by the picture *On the Cliffs near Dieppe* corresponds rather closely with the description of the scene given by the writer Eugène Fromantin in his novel *Dominique* in 1862: "One had to strain one's eyes to see where the sea ended and the sky began — so much alike were they in their turbid paleness, their stormy trepidation and their boundlessness, and border line between them obliterated." Monet was the first nineteenth-century landscape painter in France to give expression to this infinity and to the merging of the two elements. The cliffs, sea and sky are shrouded in a morning dew mist, which blurs all the outlines. The artist's main concern is to render the most minute colour fluctuations in the atmosphere. The picture displays features characteristic of a whole period of Monet's work, for example, a composition not dependent for support on vertical lines and a fluidity of form, here brought out particularly by the austere curve.

This fascination with the subtlest effects of light and air, with scenes suffused with haze, was to bring Monet, two years later, to the banks of the Thames.

In 1898 this canvas was apparently exhibited, along with a large series of Norman landscapes, at the George Petit Gallery. In 1900 the artist informed Paul Durand-Ruel in his letter of January 23, that he was sending him, among other

The Stroll at Giverny, 1888.
Oil on canvas, 80 x 80 cm.
Private collection.

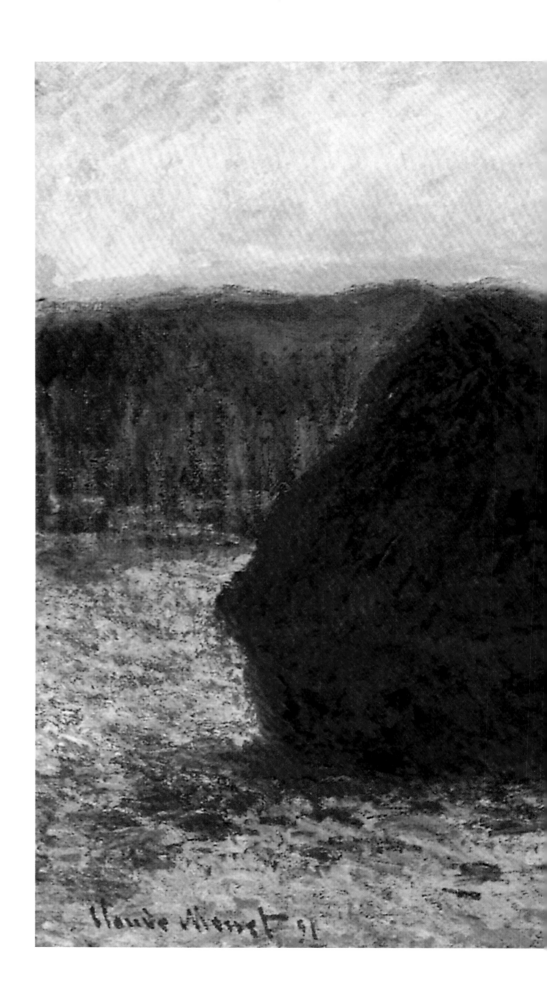

Haystack (Thaw, Sunset), 1890-1891.
Oil on canvas, 64.9 x 92.3 cm.
The Art Institute of Chicago, Chicago.

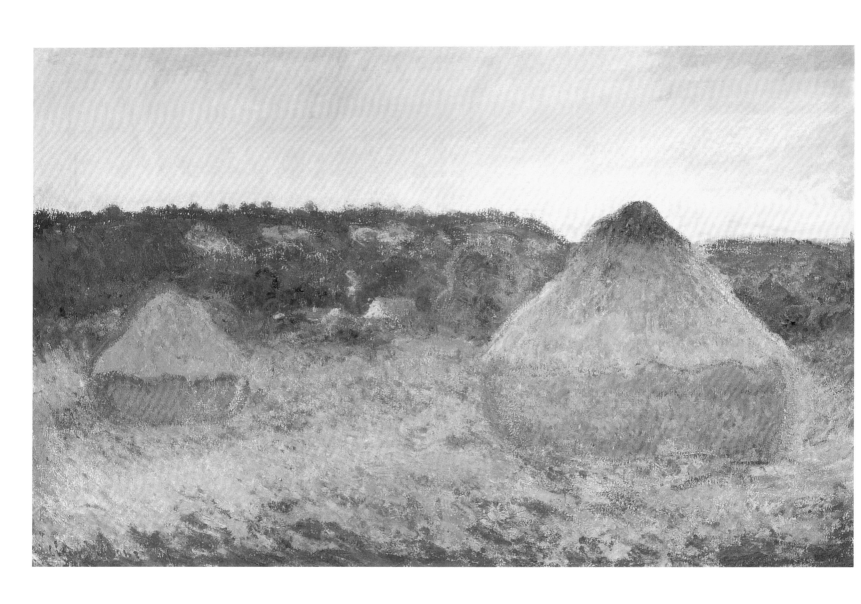

Stacks of Wheat (End of Day, Autumn),
1890-1891.
Oil on canvas, 65.8 x 101 cm.
The Art Institute of Chicago, Chicago.

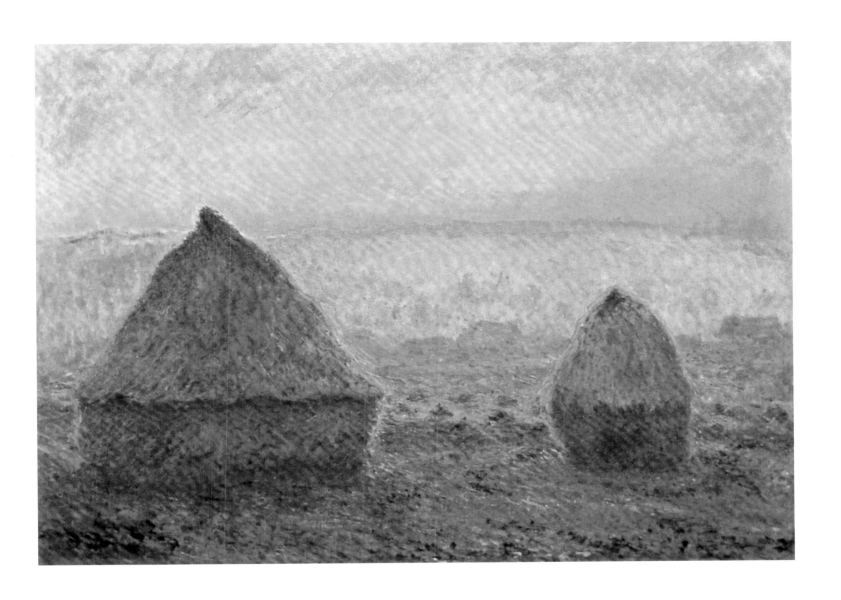

Haystacks at Giverny, Sunset,
1888-1889.
Oil on canvas, 65 x 92 cm.
Saitama Museum of Modern Art,
Urawa-Shi.

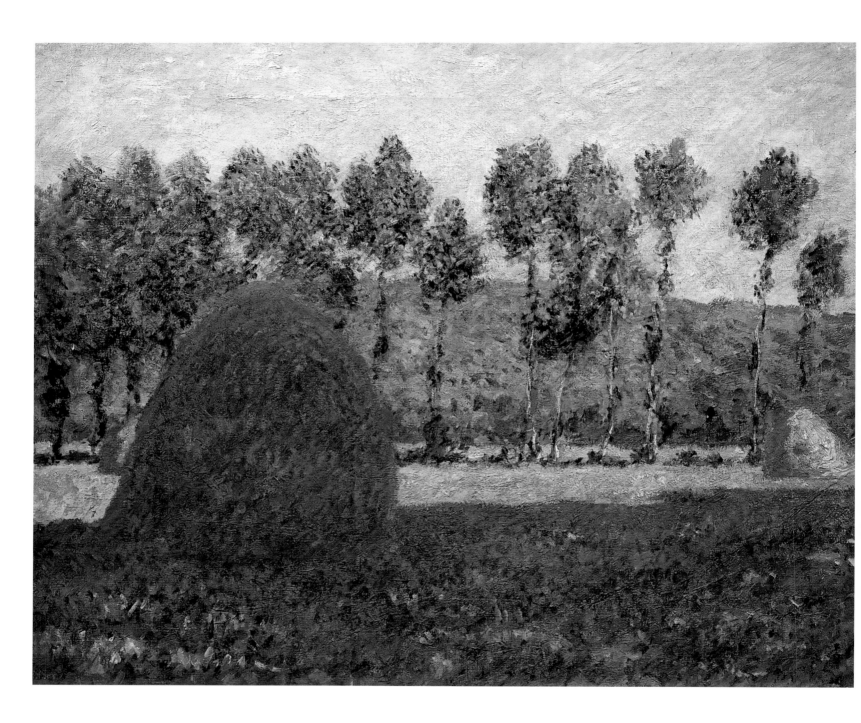

landscapes, the picture *On the Cliffs near Dieppe*. There is a drawing from Monet's notebook of the 1880s, which depicts a very similar motif, in the Musée Marmottan in Paris.

As a result of his daily contact with nature Monet gained insight into her peculiarities, and he created landscapes in which concretely observed, unique features are combined with attempts at generalisation. One such work is the landscape *The Rocks at Belle-Île* (p. 102), in which he depicts the jagged, windswept crags of the Brittany coast, the white crests of the foaming water, and, beyond, the boundless sea, which seems almost to flow into the sky at the horizon. This is indeed Brittany, but not only Brittany — it is the sea in general, its endlessness, its eternal battle with dry land. The painting is executed in varied, sensitive strokes, strictly following the form of the object portrayed — in this case, the cliffs. Monet set himself a rather different task in a landscape painted in that same year of 1886, *The Rocks at Étretat* (Pushkin Museum of Fine Arts, Moscow). Here too, the viewer is presented with a wide expanse of sea, bounded to the left by the line of the shore which rises up into blue cliffs. How different the treatment of these cliffs is, however! The crags are removed from the foreground, and the shoreline in front of them is quite without substance; all sense of the solidity of the rocks is lost.

The water has none of the mobility and weightiness which are so masterfully brought out in the other paintings. The artist's attention is concentrated on representing the atmosphere and the vibrations in the air which is itself filled with the play of golden-yellow light. The brushwork is matte and pale, with the strokes playing a dematerialising role rather than serving to create form. Alongside the landscapes of Normandy, Brittany and the Mediterranean, the motif of Giverny appears in Monet's work of the 1880s, returning the artist to the landscapes of the Île-de-France so dear to his heart.

In fact, he had never really parted with them, but they had become noticeably less frequent. In Russian museums there are two paintings depicting haystacks at Giverny; the Hermitage canvas is dated 1886, while that in the Pushkin Museum of Fine Arts dates from about 1889. "I am always in the fields, am often travelling, and always just passing through Paris," Monet wrote to Boudin in 1889. Always in the fields... In the Hermitage painting the fields seen from a hill alternate with solid, squat houses along the roadside and trees planted at regular intervals. Although there is a haystack positioned in the foreground it does not play the central role in the composition, for the background details, which are given considerable solidity, tend to attract the viewer's gaze. This is not true of the landscape in the Moscow collection. The lilac-red haycock haystack standing in

Haystack near Giverny, 1889.
Oil on canvas, 64.5 x 81 cm.
The Pushkin Museum of Fine Arts,
Moscow.

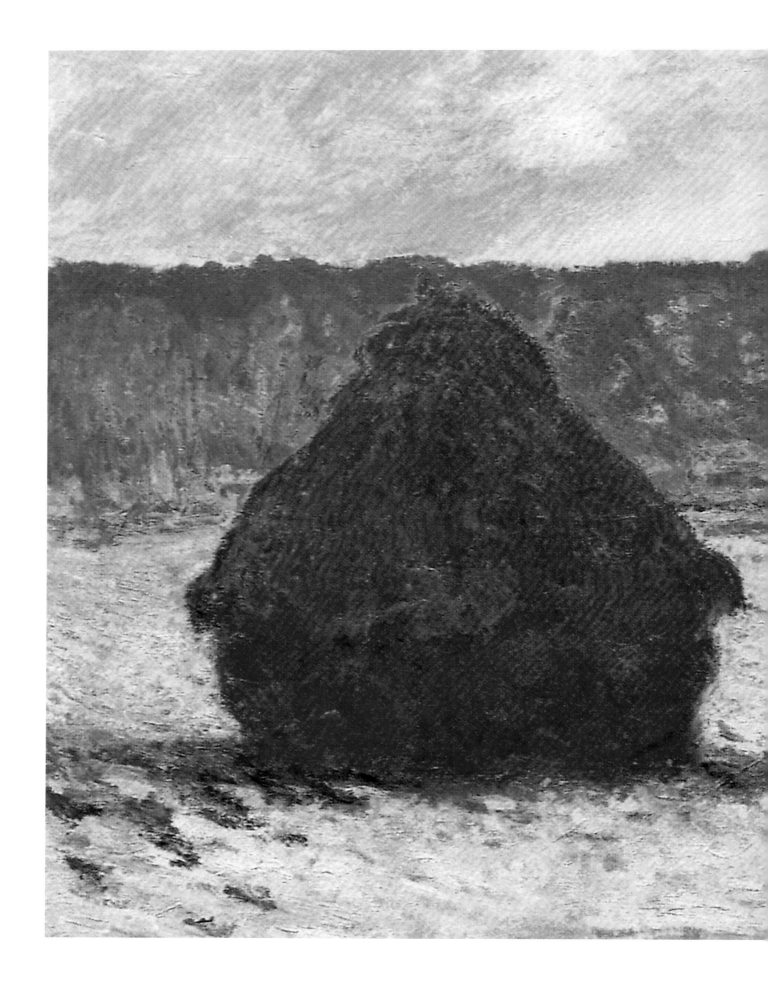

Stack of Wheat (Snow Effect, Overcast Day), 1890-1891.
Oil on canvas, 66 x 93 cm.
Collection Mr. and Mrs. Martin A.
Ryerson, The Art Institute of Chicago,
Chicago.

Poplars on the Bank of the Epte River,
1891.
Oil on canvas, 100.3 x 65.2 cm.
The Philadelphia Museum of Art,
Philadelphia.

Poplars, 1891.
Oil on canvas, 93 x 74.1 cm.
The Chester Dale Collection,
The Philadelphia Museum of Art,
Philadelphia.

the shade is the pivot of the composition, and the two haystacks on its right and left still further stress its importance. The background is pushed into the distance by a row of poplars cutting across the brightly-lit part of the meadow, which contrasts sharply with the shaded section. Even before this picture, Monet used to introduce elements which gave regularity to his landscapes. In *The Poppies (A Promenade)*, for instance, the line of dark-green trees, interrupted by a building, runs parallel to the bottom edge of the canvas. Now, however, Monet was attracted by the expressiveness of strictly linear rhythms, and his treatment of form became increasingly a matter of planes. Monet's landscapes of the 1880s reflect not only experimentation, but also contradictory stylistic tendencies. Some of these arose from an attempt on his part to reach a certain compromise. In March 1880 he wrote to Theodore Duret that he was "grooming" his painting in a desire to exhibit it in the Salon. He also remarked on his decision to show his works at the international exhibitions of the art-dealer Georges Petit. "I am doing this," Monet explained, "not out of any personal inclination, and I am very sorry that the press and the public would not respond seriously to our small exhibitions, far superior as they were to the official marketplace. But, well, you have to do what you have to do." Still it was less the search for a compromise that pushed Monet towards changes than an inner, as yet subconscious sense of the crisis of Impressionism. During the 1880s this feeling was experienced in one way or another by all the creators of the Impressionist method; Pissarro, for example, became closer to Seurat and Signac, and turned sharply towards Divisionism, while Renoir felt a new enthusiasm for Ingres and the Renaissance masters.

Rouen Cathedral in Full Sunlight:
Harmony in Blue and Gold, 1893.
Oil on canvas, 107 x 73 cm.
Musée d'Orsay, Paris.

Rouen Cathedral at Noon, 1894.
Oil on canvas, 101 x 65 cm.
The Pushkin Museum of Fine Arts,
Moscow.

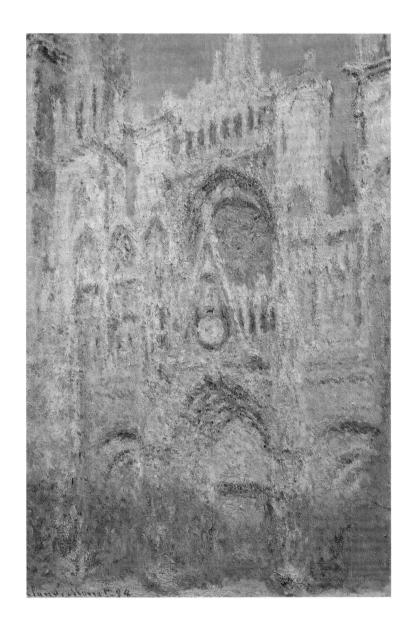

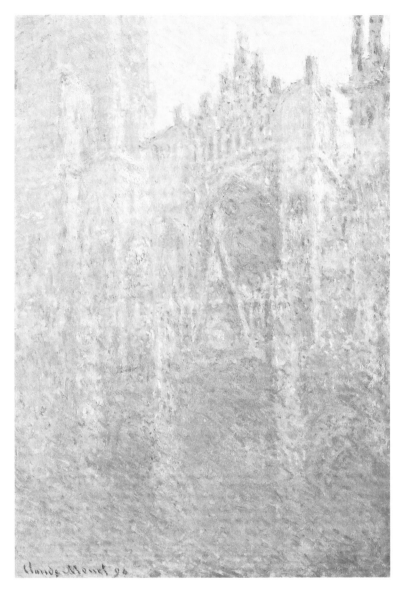

Rouen Cathedral, 1892.
Oil on canvas, 100 x 65 cm.
Private collection, France.

Rouen Cathedral in Light Fog, 1894.
Oil on canvas, 101 x 66 cm.
Museum Folkwang, Essen.

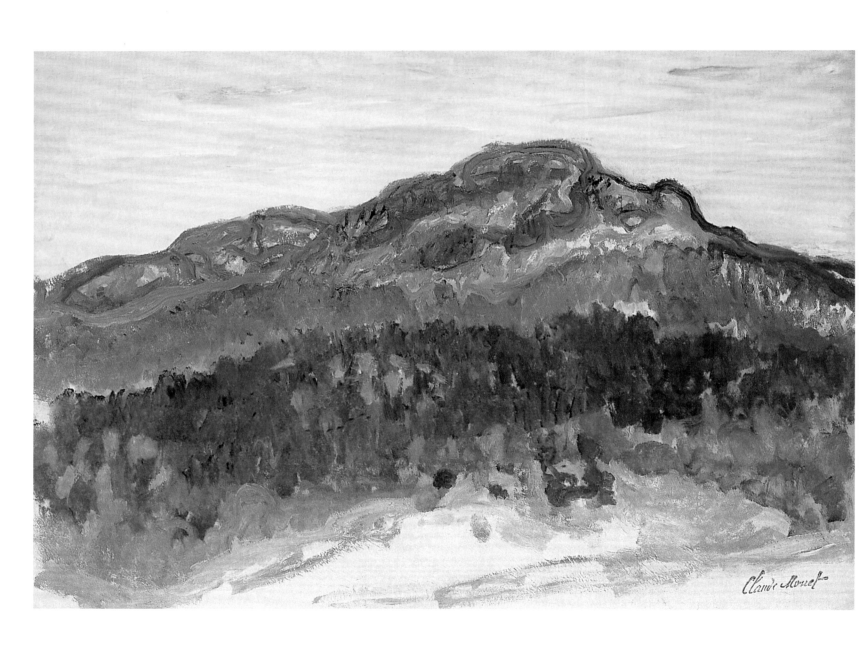

Unlike them, Monet turned towards no extraneous influence, experienced no impulse from without, but rather followed the logic of his own artistic development, which drove him to a continual intensification of his own experimentation. This tendency had always been characteristic of Monet, but his perception of nature as a unity had remained constant, always maintaining a harmonious equilibrium as he represented its particular characteristics.

In the 1890s and 1900s, however, Monet's experiments with light and colour frequently became almost an end in themselves and, as a result, his harmonious perception of nature began to disappear. It is indicative that during this period he was already working in isolation. Although this did not mean breaking off personal contacts with the friends of his youth, creative contact with them was lost. There were no more joint exhibitions, no exchanges of opinion, no arguments. In the 1890s Pissarro moved away from Divisionism, and this marked a broad return to his old sphere of work, although his new pictures were no mere repetition of what he had produced before. Sisley, who had always remained rather in the shade, and who, in contrast to the other Impressionists, had not experienced any great creative turmoil, fell seriously ill and died in 1899. In the mid-1880s Renoir informed his correspondents that he was once again painting in his former soft and gentle manner and although, as with Pissarro, this was by no means a complete regression, Renoir's art, nonetheless, regained its old verve, emotional power, and ingenuousness. It was, however, the career of Claude Monet that demonstrated with truly classic clarity not only how Impressionism arose and flourished, but also how, when it lost the lyricism at its heart, it slowly died.

One of the central problems tackled by Monet at the end of the nineteenth and beginning of the twentieth century was that of serial work. The principle of work in series had been used by artists before Monet, especially in the field of graphic art, with cycles of several sheets devoted to a single event, hero, town and so on. Artists were particularly prolific with series depicting the seasons of the year, some of them relying on the language of conventional allegory, others depicting rural labour at different times of the year. Before Monet, however, no one in European art had created series devoted to a single motif such as haystacks, a row of poplars, or the façade of a cathedral. Monet's forerunners in this respect were Japanese artists, in particular Katsushika Hokusai, the creator of numerous series, including the celebrated *36 Views of Mount Fuji*. Like all painters of his time, Monet was enthusiastic about the Japanese woodcuts which truly enchanted French art lovers during the latter half of the nineteenth century.

His enthusiasm was at first rather superficial, as evinced, for example, in *La Japonaise* (p. 65), which depicts Camille in a kimono against the background of a wall decorated with Japanese fans. This element of fancy-dress gave way to a more

Kolsaas Mountain, 1895.
Oil on canvas, 65 x 92 cm.
Private collection, USA.

profound grasp of the aesthetic of Japanese art, although here, too, Monet did not merely follow the lead of other artists, and was swayed more by inner impulse than outside influence. Throughout Monet's series the basic subject remains unchanged but the lighting varies. Thus as the eye becomes accustomed to looking at one and the same object, it gradually loses interest in the thing itself and, like the artist, the viewer is no longer attracted by the subject as such, but rather by the changing light playing on its surfaces. Hence it is light that becomes the "hero" of each painting, dictating its own laws, colouring objects in various ways, imparting either solidity or transparency, and altering contours by either rendering the boundaries of forms uncertain, or making them perceptible only as sharp silhouettes. A few paintings of haystacks at Giverny suggested to Monet the idea of creating a whole series on this theme. He began in 1890 and by 1891 he was already able to show his *Haystacks* at Durand-Ruel's — fifteen variations with a glowing or darkening sky, bright green or ashen-grey meadow, haystacks shot with red, yellow or lilac, and the multicoloured shadows they produced.

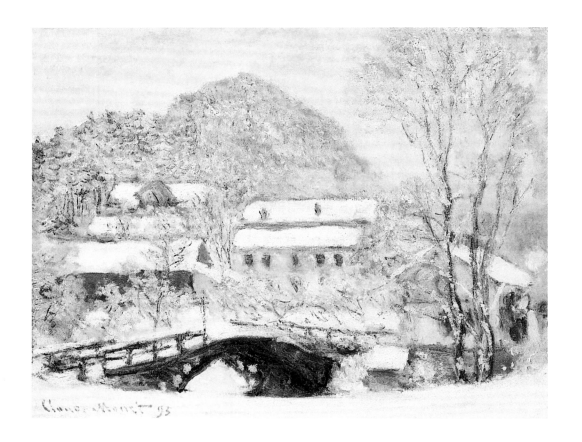

In critical works on Monet it is frequently suggested that in all his series the artist strove only for objective recording of optical impressions. Monet did indeed set himself this task, but that did not prevent him from remaining an involved, creative artist, conveying his own emotional state to the viewer. Moreover, in his first series the lyrical impulse was still strongly in evidence.

Anatoly Lunacharsky remarked: "Claude Monet made countless pictures of a single object, for example, a haystack, painting it in the morning, at noon, in the evening, in the moonlight, in the rain and so on. One might expect these exercises — which link Monet with the Japanese — to produce something like a set of scientific colouristic statements about the celebrated haystack, but instead they prove to be miniature poems. The haystack is at times majestically proud, at times sentimentally pensive, or mournful…"

Sandvika, Norway, 1895.
Oil on canvas, 73.4 x 92.5 cm.
Private collection.

Winter Landscape (Sandviken), 1895.
Oil on cardboard, 37 x 52.5 cm.
Private collection.

*At Val Saint-Nicolas near Dieppe in
the Morning*, 1897.
Oil on canvas, 65 x 100 cm.
Private collection.

Steep Cliffs near Dieppe, 1897.
Oil on canvas, 65 x 100.5 cm.
The State Hermitage Museum,
St. Petersburg.

It is justifiable to ask whether in *Haystacks,* and his other series of the 1890s, Monet was deviating from Impressionism. The answer would seem to be that he was not. He was simply paying attention primarily to the rendering of light, one of the cardinal problems of Impressionism. This was how painters and critics close to Monet understood his new works, acknowledging the talent they revealed.

When Durand-Ruel exhibited the *Rouen Cathedral* series (pp. 128, 129) in 1895, the friends of Monet's youth accepted it, albeit not without certain reservations. Pissarro wrote to his son: "The Cathedrals are criticized by many, but praised by, among others, Degas, Renoir and me. I so wanted you to see them all together, for I find in them the magnificent unity towards which I myself so aspire." Shortly before this, Pissarro had informed his son that Cézanne liked the Cathedrals.

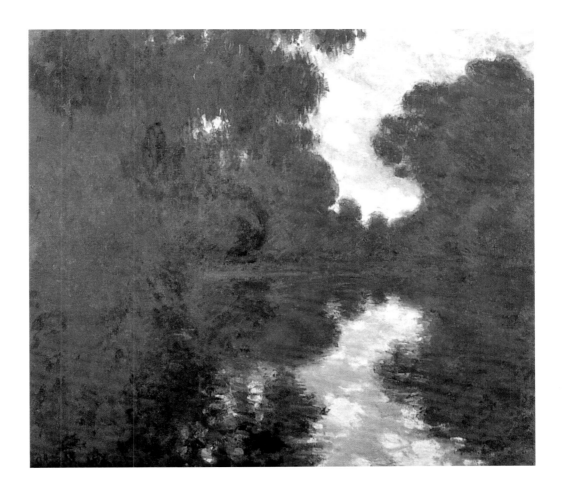

From the Single Painting to the Series

The idea of creating the series came to Monet in 1892 while he was staying in Rouen, where, enchanted by the cathedral, he lodged directly opposite it. From the window of his room he could see not the whole building but only the portal, and this determined the composition of the canvases in the first part of the cycle. In these the artist's field of vision is invariably limited to the portal and the patch of sky above it. It is a "close-up" composition with a part of the cathedral, transformed by the skilled hands of mason and sculptor into stone lacework, occupying the entire area of the canvas. Previously, looking from a cliff, a hill or the window of a room, he liked to impart a sense of space by leaving the foreground free.

Now the subject was approached at almost point-blank range, and yet its proximity did not help to elucidate its nature, for light hardly reduced it.

Morning on the Seine (The Branch of the Seine near Giverny), 1897.
Oil on canvas, 82 x 93.5 cm.
Hiroshima Museum of Art, Hiroshima.

Morning on the Seine, Clear Weather, 1897.
Oil on canvas, 81 x 92 cm.
Private Collection, USA.

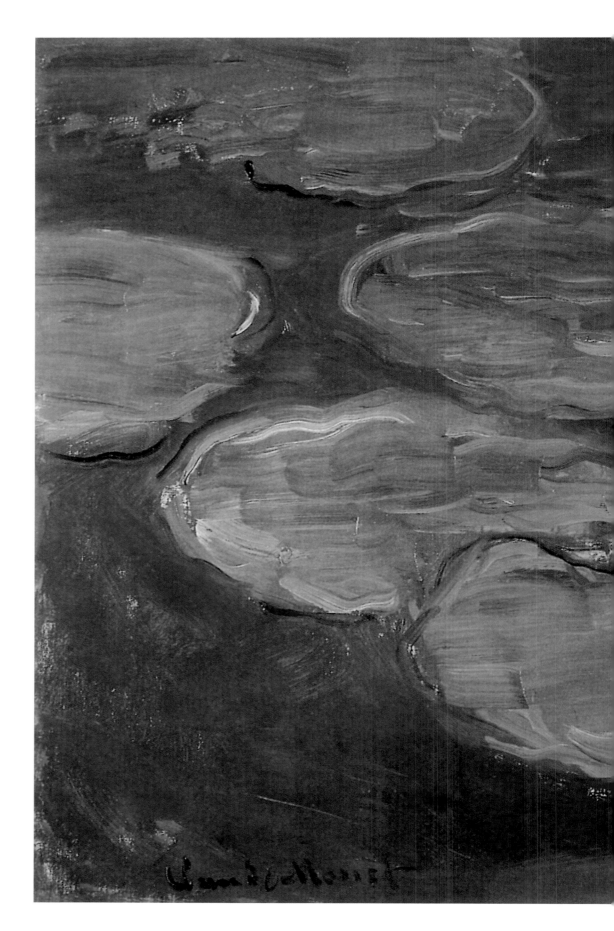

Nympheas (Water-Lilies),
c. 1897-1898.
Oil on canvas, 66.04 x 104.14 cm.
Los Angeles County Museum of Art,
Los Angeles.

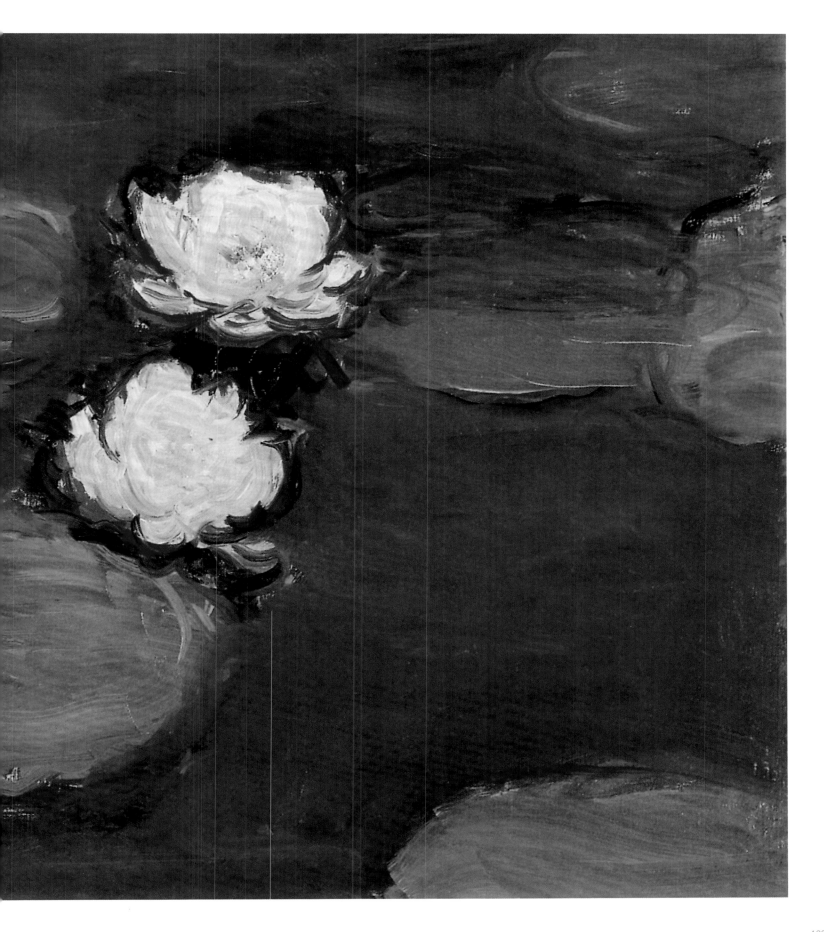

The other part of the cycle was produced in 1893 during a second visit to Rouen, when Monet took with him the canvases he had already executed, intending to add the finishing touches to them. He again studied the movement of light across the portal and, when he saw the effect he wanted, finished the work he had begun a year earlier; where the moment from the past did not recur, he took a fresh canvas and started again from scratch.

During this second visit Monet did not only paint the cathedral from the viewpoint he had used in 1892; he rented another apartment as well, one which enjoyed a slightly different view of the building.

From here a considerable portion of Saint-Romain's tower was visible to the left of the entrance, and also some houses situated close to the tower. On both his first and second visits Monet turned to his Cathedrals with an enthusiasm which bordered on frenzy. "I am worn out, I can't go on," he wrote to his wife in 1892. "And, something that I have never experienced before, I have spent a night filled with nightmarish dreams: the cathedral kept falling on me, and at times it seemed blue, at others pink, at others yellow."

The following words come from a letter dated 1893: "I am painting like a madman, but no matter what you all say I am quite played out and am now good for nothing else."

What is known of the creation of the Rouen Cathedral series and other pictures of these years makes it clear that Monet could now not only paint on the spot, but could continue work in his workshop, then return to paintings on location, and then again add finishing touches in the studio. Monet had worked in the studio previously — although to all questions put to him on this point he invariably replied that nature was his workshop — but with the years, work in the studio became increasingly important for the artist.

Purple Water-Lilies, 1897-1899.
Oil on canvas, 65 x 100 cm.
Galleria Nazionale d'Arte Moderna, Rome.

Water Lilies and Japanese Bridge, 1899.
Oil on canvas, 90.5 x 89.7 cm.
Princeton University Art Museum, Princeton.

White Water Lilies, 1899.
Oil on canvas, 89 x 93 cm.
Private collection.

It is unlikely that the canvases executed in Rouen in 1892 remained untouched in Giverny, and it is certain that after his return from the second visit to Rouen he was still bringing them to perfection.

One cannot disagree with Pissarro's judgement that the Cathedrals series must create its strongest impression when all twenty canvases are collected together — alas, a spectacle almost unrealisable today, since the paintings are scattered among numerous museums and private collections throughout the world. Best endowed in this respect is the Musée d'Orsay in Paris which holds five paintings: *The Cathedral in Cloudy Weather*, *The Cathedral in the Morning* (*Harmony in White*),

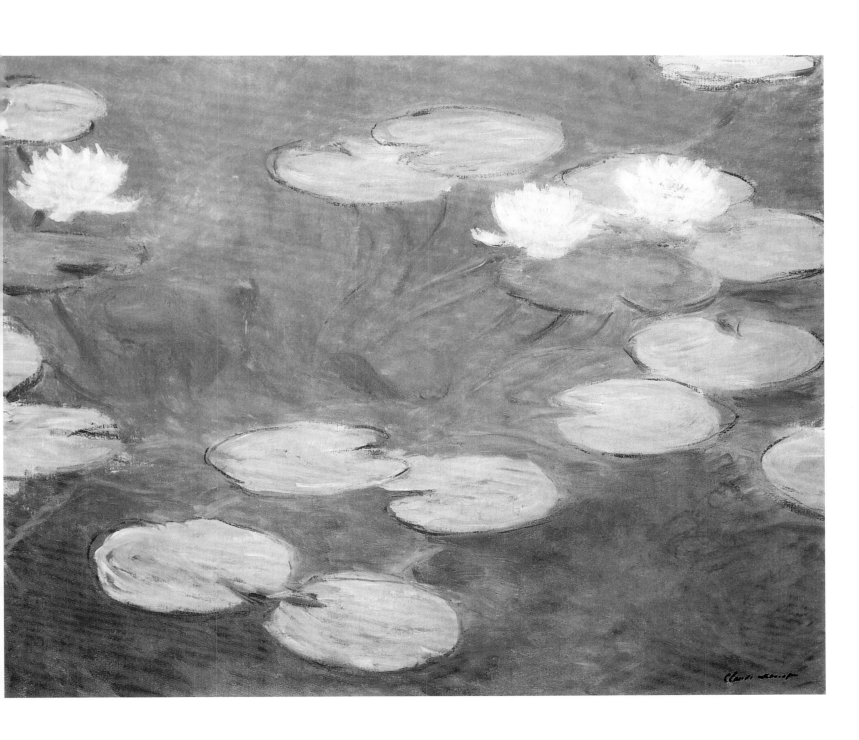

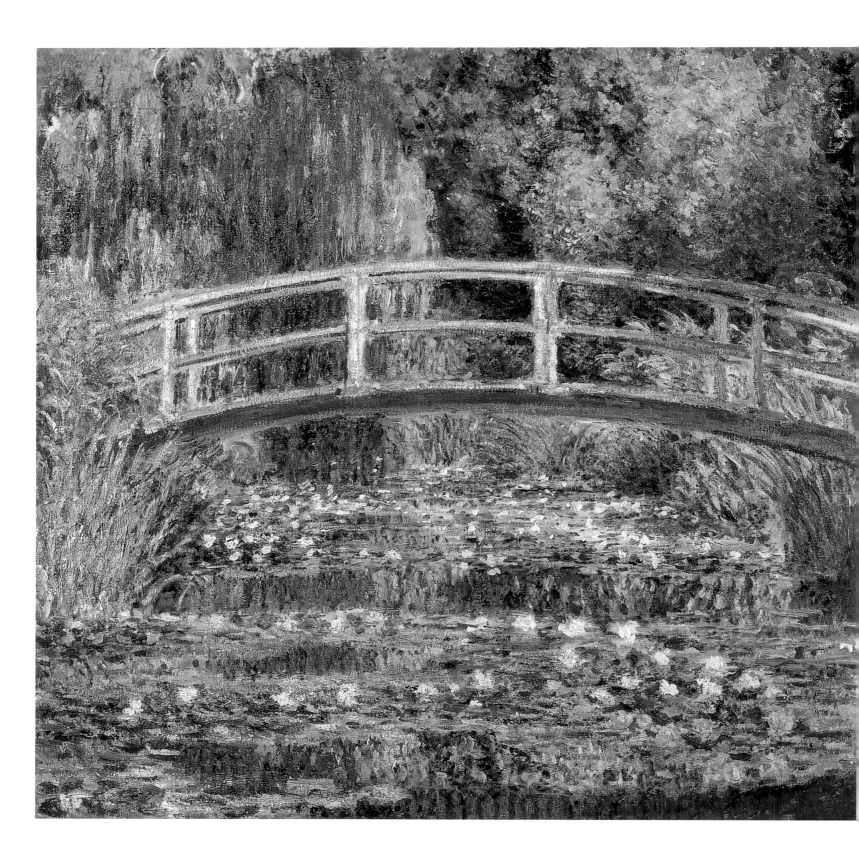

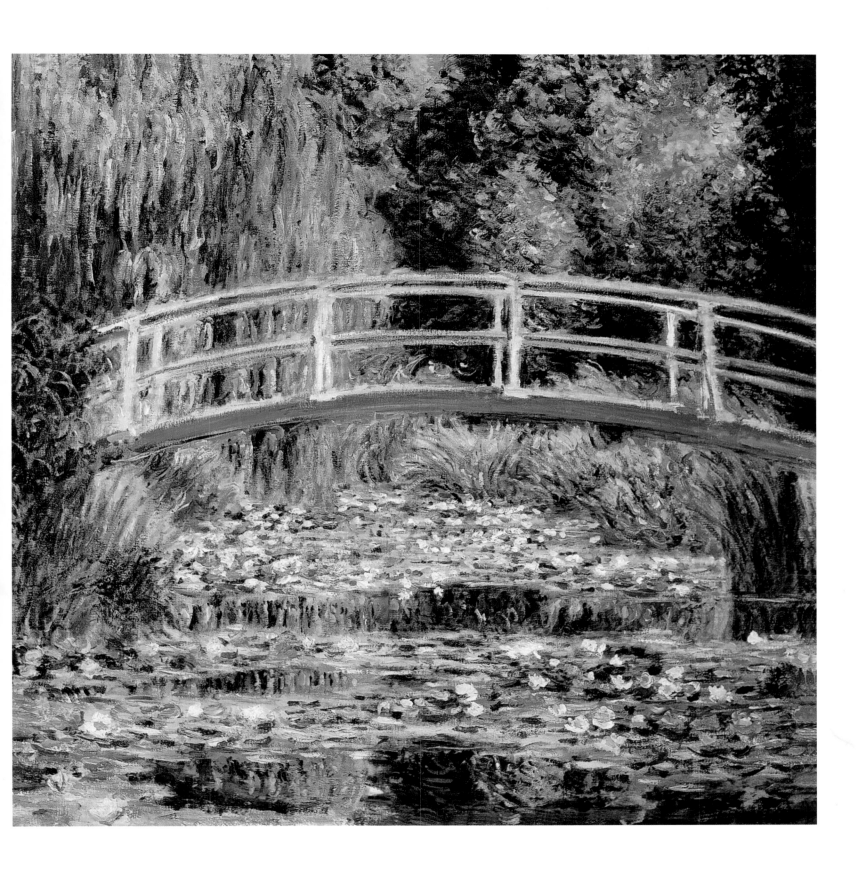

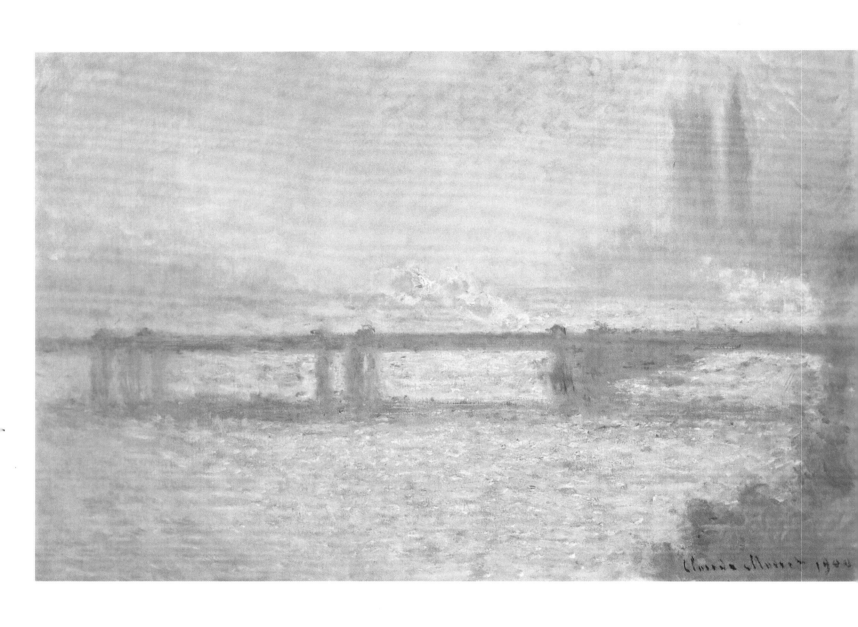

Rouen Cathedral in Morning Sunlight: Harmony in Blue, Rouen Cathedral in Full Sunlight: Harmony in Blue and Gold (p. 128), and the cathedral without indication of the time it was painted, a work known as *Harmony in Brown*. The gaze of the visitor to the museum passes quickly from one picture to the next, then returns and runs again across the uneven surface of the canvases, studying the changes of light. The repeated motif of the portal, painted, moreover, on vertical canvases of approximately uniform dimensions, recedes, in proportion to the length of time spent in contemplation, further and further into the background, until the viewer is wholly enthralled by the astonishing skill of the painter.

In the collection of the Pushkin Museum of Fine Arts in Moscow there are two paintings from the series, *Rouen Cathedral at Noon* (p. 128) and *Rouen Cathedral in the Evening*. The intense blue of the sky above, the dark-blue and violet shadows below, and between them a scattering of golden, pink and slightly lilac tones, alternating with light sprinklings of pale blue — these are the colours Monet used to reproduce the façade of the cathedral in the evening.

Darker blue and lilac tones are distinctly more evident in the second painting, where pinks are almost extinguished and gold is shot with orange and red.

While on the Riviera in 1888 Monet wrote to Rodin: "I am arming myself and doing battle with the sun... Here one ought to paint with pure gold and precious stones." These words could be related to the Rouen Cathedral series as well, for here too, Monet was waging war with the sun, and the surfaces of the canvases really are reminiscent of a scattering of precious stones being played upon by rays of sunlight. By the time the *Cathedrals* were being created, the nervousness of Monet's brushstrokes and the intensity of his colour combinations had lessened noticeably, and he was now more concerned with shades and nuances of colour.

O. Reuterswärd has perceptively noted that one of the most remarkable features of the series lies in the variations of values: "...spots of paint, both strong and weak in terms of light, interlacing in ever-new combinations of tones, the vivid play of colours conveying almost imperceptible light effects." Critics within Monet's circle, Mirbeau and Geffroy among them, greeted the *Rouen Cathedral* series ecstatically.

The greatest impression was, however, made by the review of Georges Clemenceau, a close acquaintance of Monet's since the 1860s. Briefly abandoning questions of politics, the leader of the radicals took up his pen and published an enthusiastic article in *Justice*. Upon reading the article, Monet wrote to Clemenceau: "If one sets aside modesty and my person, then everything is said beautifully."

Charing Cross Bridge (Overcast Day), 1900.
Oil on canvas, 60.6 x 91.5 cm.
Museum of Fine Arts, Boston.

Waterloo Bridge, London, 1900.
Oil on canvas, 65 x 100 cm.
Hugh Lane Municipal Gallery of Modern Art, Dublin.

145

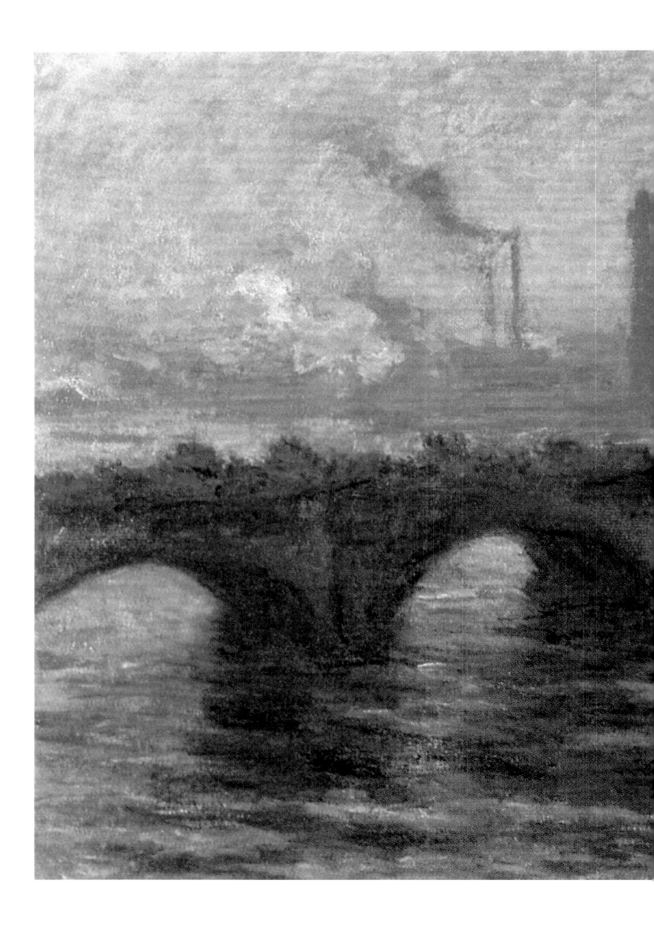

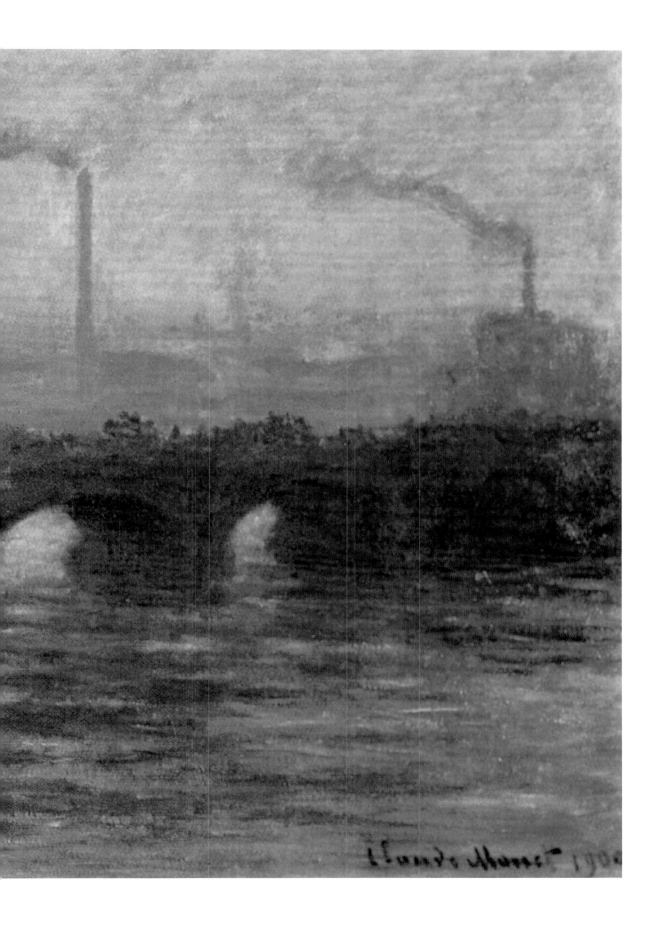

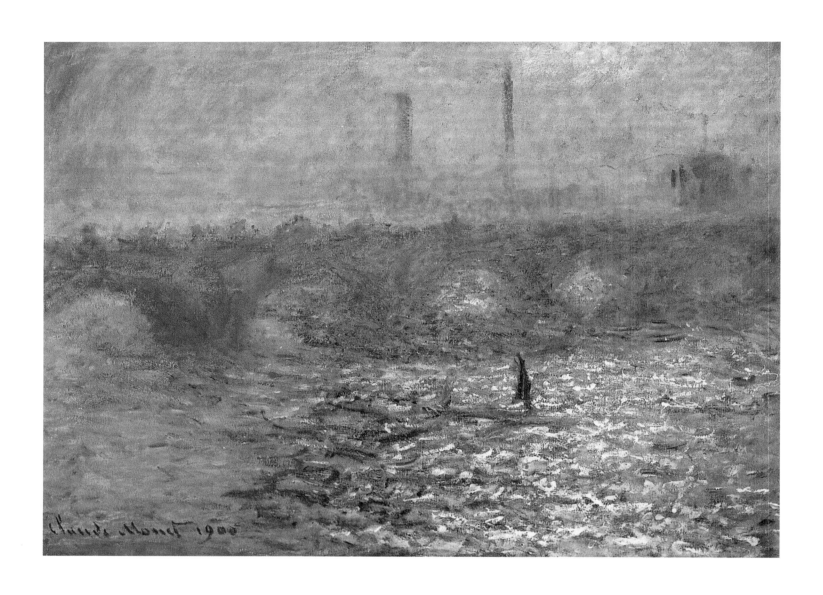

Waterloo Bridge, 1900.
Oil on canvas, 65.4 x 92.7 cm.
Santa Barbara Museum of Art,
Santa Barbara, California.

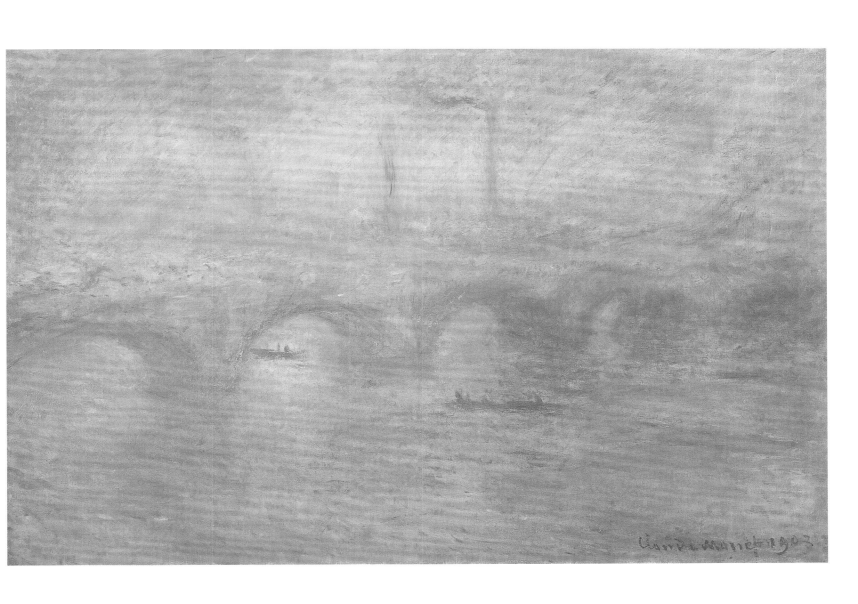

Waterloo Bridge, Effect of Fog, 1903.
Oil on canvas, 65.3 x 101 cm.
The State Hermitage Museum,
St. Petersburg.

This delight was by no means shared by all artists and critics. The opposition's opinion was most laconically expressed by the aging Gérôme, himself crowned with all the laurels and distinctions of the official art world, when he called the Cathedrals and all Monet's other works of this period "rubbish". The following years saw no fundamental changes in Monet's career, though the artist continued to experiment in spite of his age.

The meadows of Giverny always remained his favourite motif. In the luxuriantly flowering grass with its poppies exploding in tiny flames, Monet's practiced eye, trained by years of work, could distinguish a vast number of graded nuances. He created an extremely delicate mosaic on the canvas, composed of tiny brushstrokes of colour. Paul Cézanne, who had criticised Monet for copying unthinkingly from nature, said of him one day, "He's nothing but an eye." But, quickly catching himself, he added "But what an eye!" (Camille Mauclair, Claude Monet, Paris, 1924, p. 51). These meadows became his permanent workplace. When a journalist, who had come from Vétheuil to interview Monet, asked him where his studio was, the painter answered, "My studio ! I've never had a studio, and I can't see why one would lock oneself up in a room. To draw, yes – to paint, no" (L. Venturi, op. cit., vol. 2, p. 340). Then, broadly gesturing towards the Seine, the hills, and the silhouette of the little town, he declared, "There's my real studio" (D. Wildenstein, op. cit., p. 38). He painted a field of poppies, and created the impression of wind not only with the rippling shapes of the trees, but also in the way the painting itself was executed. Brushstrokes of pure colour – red, blue, and green – are applied to the canvas with apparent randomness. The tangle of these colours renders the effect of the grass.

As before, the central role in his art was played by series which he displayed to the public periodically: in 1904 showing views of the Thames at Durand-Ruel's; in 1909 the cycle of *Water Lilies* at the same venue; and in 1912 views of Venice at Bernheim-Jeune's. Two of the London landscapes are held by Russian museums — *Waterloo Bridge* (p. 149), and *Seagulls*.

In both paintings Monet uses the effect of a mist hanging over the Thames to transform the bridge and buildings into ghostly visions. How far removed these new works are from the views of London painted in 1871 – paintings which opened the period of Monet's creative maturity!

Houses of Parliament, Effect of Sunlight in the Fog, 1900. Oil on canvas, 81 x 92 cm. Musée d'Orsay, Paris.

But at the same time how clearly linked they are, for in the later works Monet developed and took to extremes what was already present in embryonic form in *The Thames* and the *Houses of Parliament*.

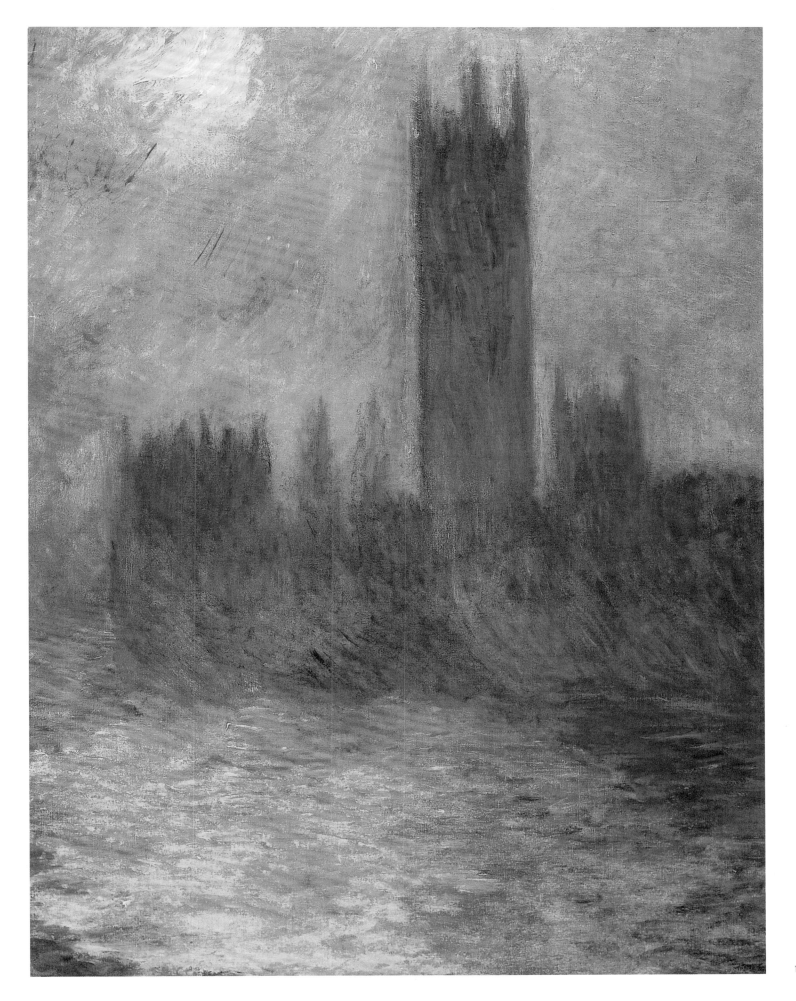

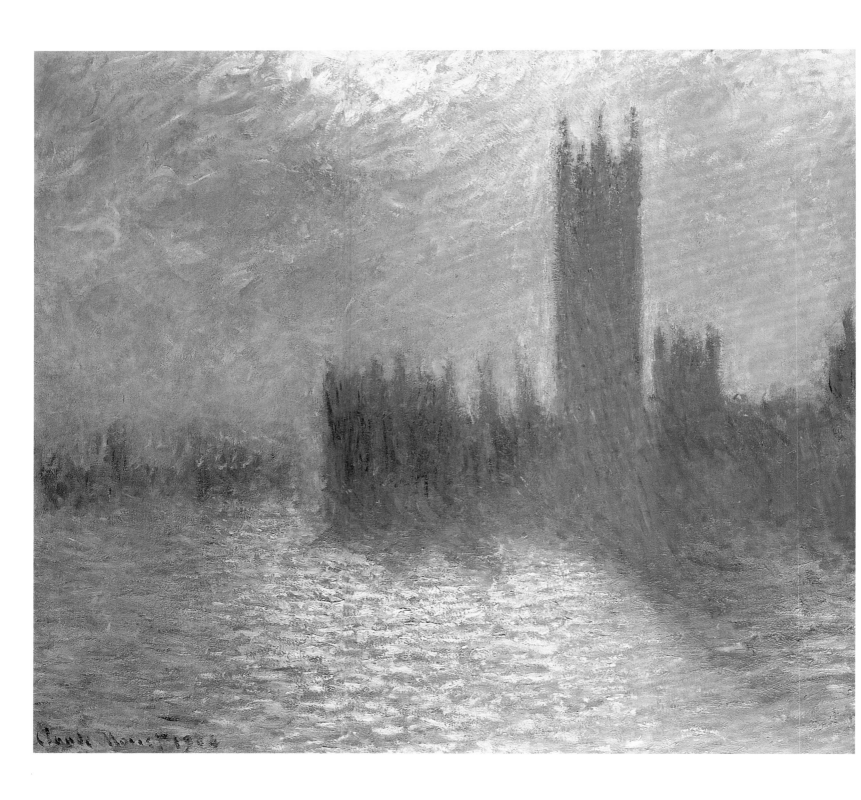

London, the Houses of Parliament,
Effects of Sunlight in Fog, 1904.
Oil on canvas, 81 x 92 cm.
Private collection.

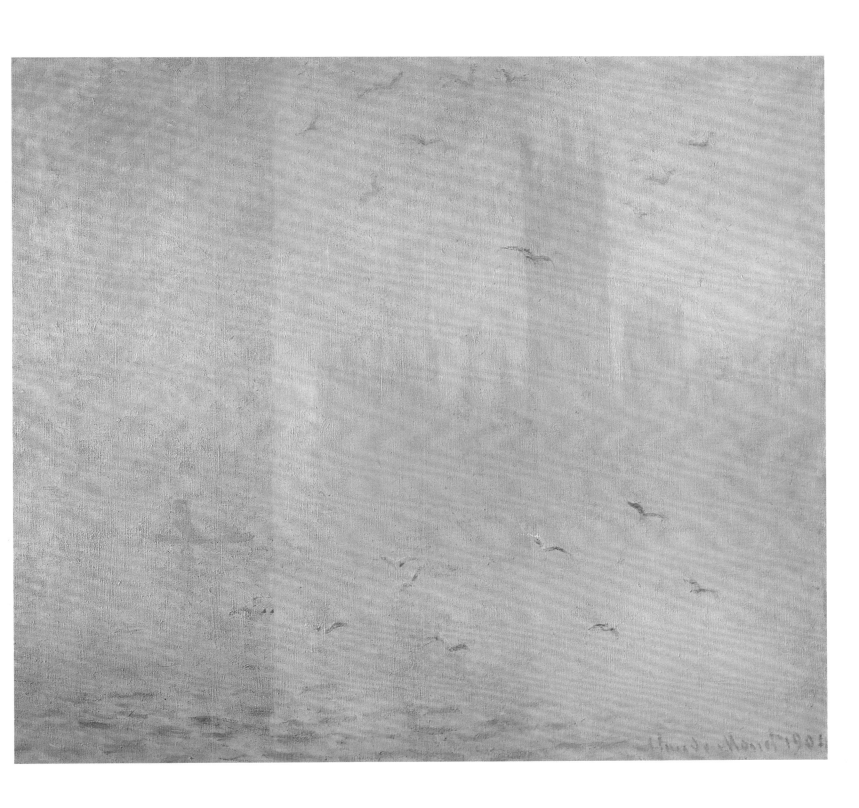

Seagulls over the Houses of Parliament, 1904.
Oil on canvas, 82 x 92 cm.
The Pushkin Museum of Fine Arts,
Moscow.

The canvases of the London series, like Monet's other works of these years, might well be compared with musical variations. The nineteenth century as a whole provides many vivid examples of cross-currents and mutual enrichment between different art forms and genres, and Impressionism is no exception to this tendency. If it is acceptable to speak of "pictorial" qualities and of a capacity to paint by means of sounds in relation to the *Nocturnes, The Sea and Moonlight* by Debussy, then musical terminology is equally applicable in characterising Monet's paintings in the 1890s and 1900s. For his now increasing, now diminishing colour modulations attune the viewer to a particularly musical wavelength and create a sort of "melody in colour".

Perhaps the most notable of all Monet's later series are his *Water Lilies*, if only because he laboured over it for several decades right up until his death. Monet conceived the idea of the series in 1890: "I have set about truly impossible things," he wrote to Geffroy, "water with grass that sways in the depths. It is something to wonder at endlessly, but how difficult it is to convey!"

At that time the artist made several sketches on the theme of Reflections but returned to them only at the end of the 1890s. Work on the *Water Lilies* proper took place in two stages. The first cycle includes canvases of comparatively small dimensions executed between 1898 and 1908; the second stage coincided with the later years of Monet's life, from 1916 to 1926, and includes the huge canvases presented by the artist to the French state in 1922 which now hang in the Orangerie des Tuileries in Paris. Monet's interest in the motif of water lilies is most revealing in terms of his mature period.

The images of wild crags and expanses of sea that had previously captivated him had already disappeared from his art, and the meadows of the Île-de-France with their waving grass and the busy stretches of the Seine were also by now rarely encountered. Instead, he liked to paint misty London, or Venice reflected in the waters of the lagoon. But above all, he was drawn to the bright and beautiful face of his own garden. He threw himself into the creation of his garden at Giverny, as he had thrown himself into the creation of serial paintings. Adjacent to his house was a large plot of land covered with beds of pink, yellow, and purple flowers. There had been a brief period in his life when he painted bouquets of flowers: now he painted the garden born of his own imagination. He argued passionately with Alice in defence of his projects. Finally, despite his wife's objections, he replaced the cypresses with slender metal arches covered in winding, climbing roses. "He adored his garden, which he created entirely himself, because it had only been a simple orchard before," Blanche Hoschédé-Monet recounted. "He planted and watered his plants himself. He always loved flowers and surrounded himself with them.

The Artist's Garden at Giverny, 1900.
Oil on canvas, 81 x 92 cm.
Musée d'Orsay, Paris.

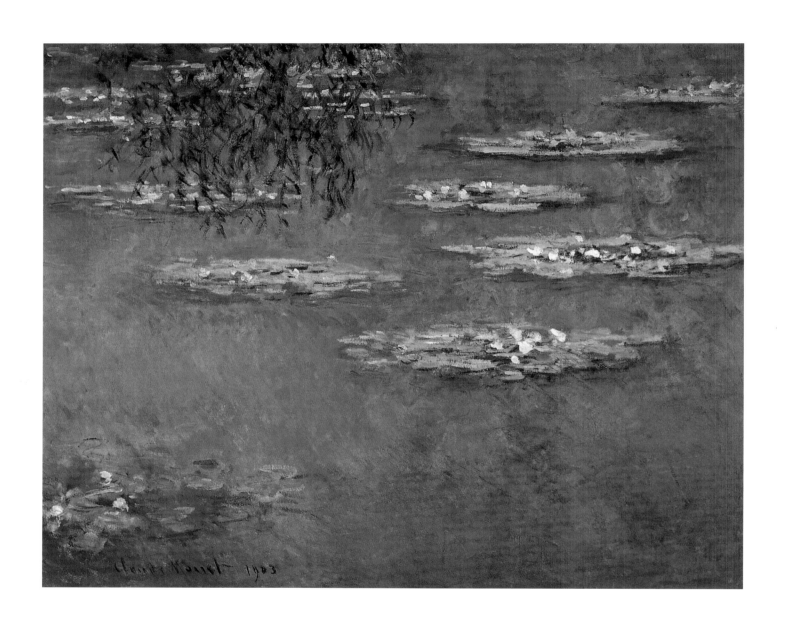

Water Lilies, 1903.
Oil on canvas, 81.2 x 101.6 cm.
Dayton Art Institute, Dayton, Ohio.

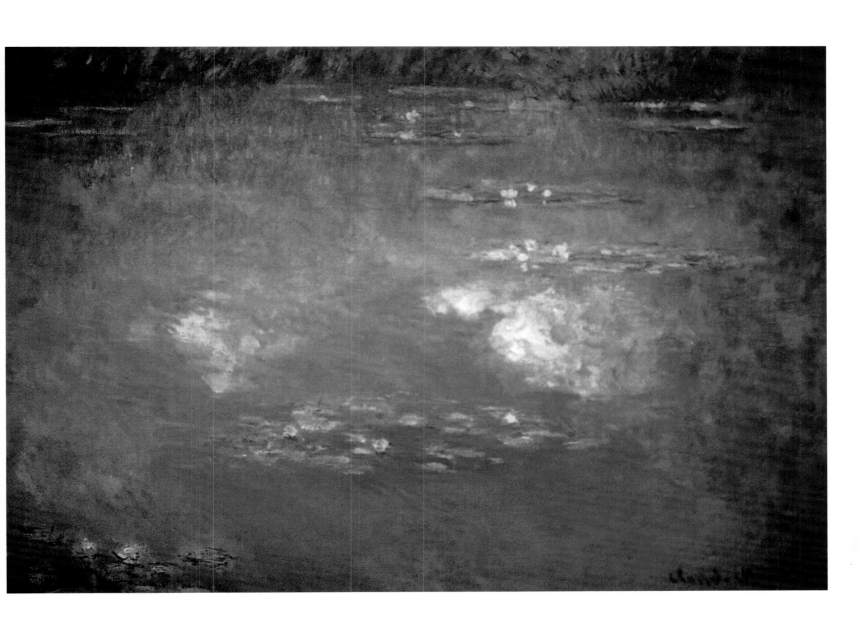

Water Lilies. Water Landscape, Clouds, 1903.
Oil on canvas, 73 x 100 cm.
Private collection.

Later, with his financial success, he was able to make this wonderful garden and pond, something he had hoped for and dreamt of accomplishing" (J.-P. Hoschédé, op. cit., t. 1, p. 162).

Monet himself drew the shape of the pond and the little bridges that crossed it, which afterwards served as motifs for his landscapes. Jean-Pierre Hoschédé wrote this about the gardens: "They were unique as a group because they had been imagined, conceived, and executed not by a gardener, but by an Impressionist who created them as he would have created a painting from nature" (J.-P. Hoschédé, op. cit. t. 1, p. 65). Monet painted an enormous number of landscapes of his own garden. They became a veritable obsession. The motif he loved most was the water lilies. These aquatic flowers first appeared in many Normandy gardens at the turn of the century: they had come into fashion along with the taste for all things Japanese. When Marcel Proust describes one of these aquatic gardens on the Vivonne River, one has the impression he is writing of Claude Monet's garden.

> But farther on the current was slower ... causing the little ponds that were fed by the Vivonne to be aflower with water lilies. The river banks were thickly wooded here, and the trees' deep shade usually turned the depths of the water a dark green, though at times, when we were coming home on calm evenings after a stormy afternoon, the bottom of the pond was a clear, crude blue, almost violet, like a Japanese-style partitioned floor. Here and there a water lily floated on the surface, with a scarlet centre and white edges, like a blushing strawberry. Farther on, the flowers were more numerous, paler, less glossy, more seeded, folded more tightly, in groups of randomly disposed spiral patterns... (Marcel Proust, *Á la Recherche du Temps Perdu* [A Remembrance of Things Past], Moscow, 1970, p. 177).

In his garden Monet assembled a multitude of plants of the most varied types. He ordered them by catalogue from various locales, often even from abroad: the water for the pond where the tropical lilies grew had to be artificially heated. The final idea given to him by his garden was a vast panel entitled *Water Lilies* (Paris, Musée de l'Orangerie), composed of fourteen sections. In it Monet at last carried out his conception of monumental painting. Henceforth it was in this refined and fragrant world that the aged Monet was to seek inspiration.

The leaning towards decorativeness characteristic of him in his earlier career becomes dominant in his *Water Lilies*, at least in the first cycle. In the painting *White Water Lilies* (p. 141), now in the collection of the Pushkin Museum of Fine Arts, the artist is almost entirely unconcerned with the problems of conveying air and gradations of light and colour, rather concentrating all his attention upon the decorative resonance between vivid grasses and white and pink water lilies.

San Giorgio Maggiore, 1908.
Oil on canvas, 59.2 x 81.2 cm.
National Museum of Wales, Cardiff.

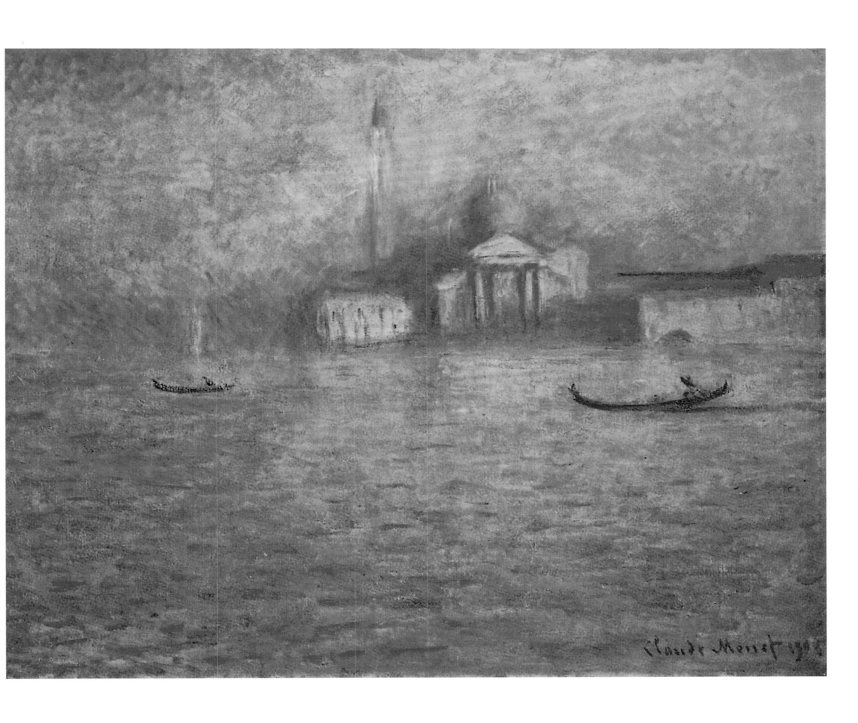

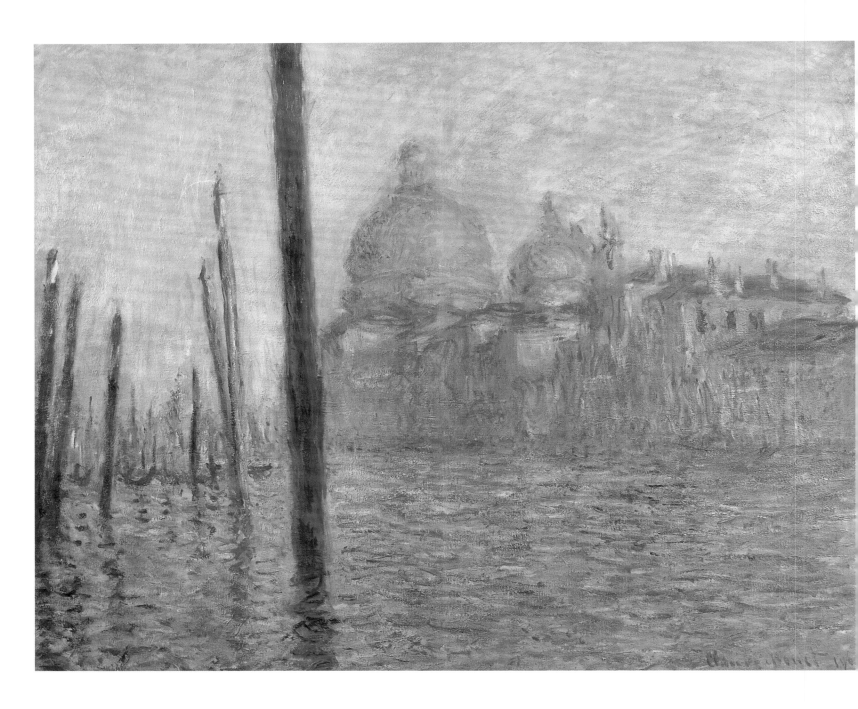

There is common ground between Monet's colouristic solution in the *Water Lilies* and the experiments of the Fauvists, particularly of Matisse and Marquet — yet Monet, nonetheless, remains an Impressionist. In contrast to the Fauvists, he did not turn to the use of spots of colour; his tints remained pure, albeit modulated, for he continued to convey colours by means of abrupt, typically Impressionist brushstrokes.

Still more typically Impressionist is the later series of *Water Lilies*. And yet how lifeless and limp this Impressionism seems compared with the creations of the 1870s to 1890s.

In the first hall of the Orangerie hang nine panels, most of them linked into compositions more than twelve metres in length and some two metres in height.

These are *Clouds* (three panels), *Morning* (three panels), *Green Reflexes* (two panels) and *Setting Sun* (one panel). Displayed in the second hall are the compositions *Two Willows* (four panels), *Morning* (four panels) and *Reflections of Trees* (two panels); the length of one of the ribbons here is seventeen metres! This mania for size scarcely conforms with the manner of the paintings' execution, and indeed, in the very conception of the later *Water Lilies* one senses more the abstract work of intellect than the desire to capture a direct perception — a feature which had always lent an inimitable charm to Monet's works. This can easily be seen by leaving the Orangerie and visiting the nearby Musée d'Orsay.

A squat Normandy farmhouse, bright sailing-boats at Argenteuil, a vast field of red poppies, breakers at Étretat, a puffing steam-engine under the vaults of Saint-Lazare station. Vétheuil sprinkled with snow, stern cliffs in Brittany, Dutch windmills and tulips, the flickering façade of Rouen Cathedral, and the first Giverny water lilies — how many and how varied the motifs, what subtle gradations of emotion and what a wealth of creative invention! And everywhere the winning sincerity of self-expression and endless truth of life. After all, it was for this that Rodin once cried out enthusiastically: "…in the countryside, by the sea, before the distant horizon, before trembling foliage, before the ceaseless whispering of the waves: 'Ah, how beautiful it all is — it is Monet'."

Monet's long life made him a contemporary of all the artistic manifestations of the late nineteenth and early twentieth centuries. Many of the Post-Impressionists rated Monet highly, felt his influence, and even wanted, like Paul Signac and Louis Anquetin, to become his pupils.

Monet, however, avoided all opportunities to give recommendations or advice. Indeed, the words spoken to a journalist from *Excelsior* in 1920 reflected an attitude to the teaching of painting maintained by him over the course of his whole career: "Advise

The Grand Canal, 1908.
Oil on canvas, 73 x 92 cm.
Museum of Fine Arts, Boston.

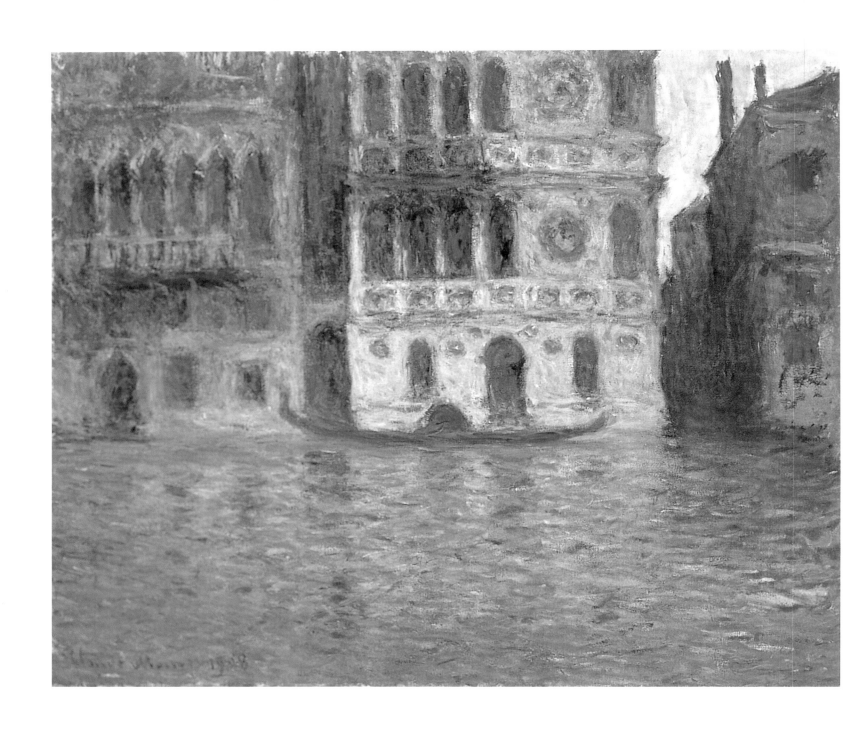

Venice, Palazzio Dario, 1908.
Oil on canvas, 64.8 x 78.8 cm.
Mr. and Mrs. Lewis Larned Coburn
Memorial Collection, The Art Institute
of Chicago, Chicago.

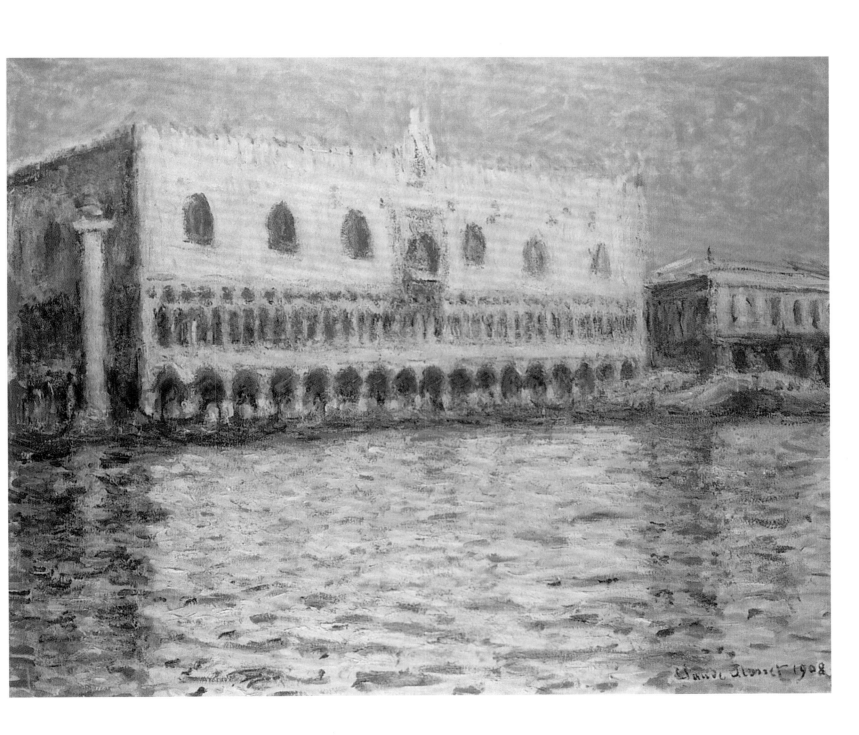

Le Palais Ducal (The Doge's Palace),
1908.
Oil on canvas, 73 x 92 cm.
Mr. and Mrs. Herbert J. Klapper
Collection, New York.

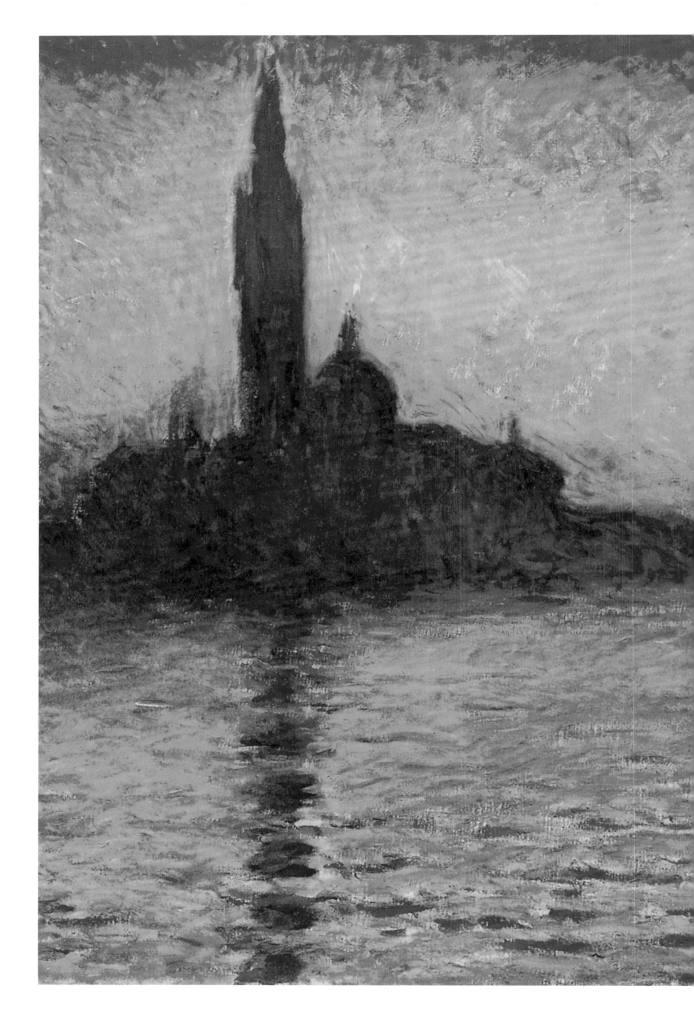

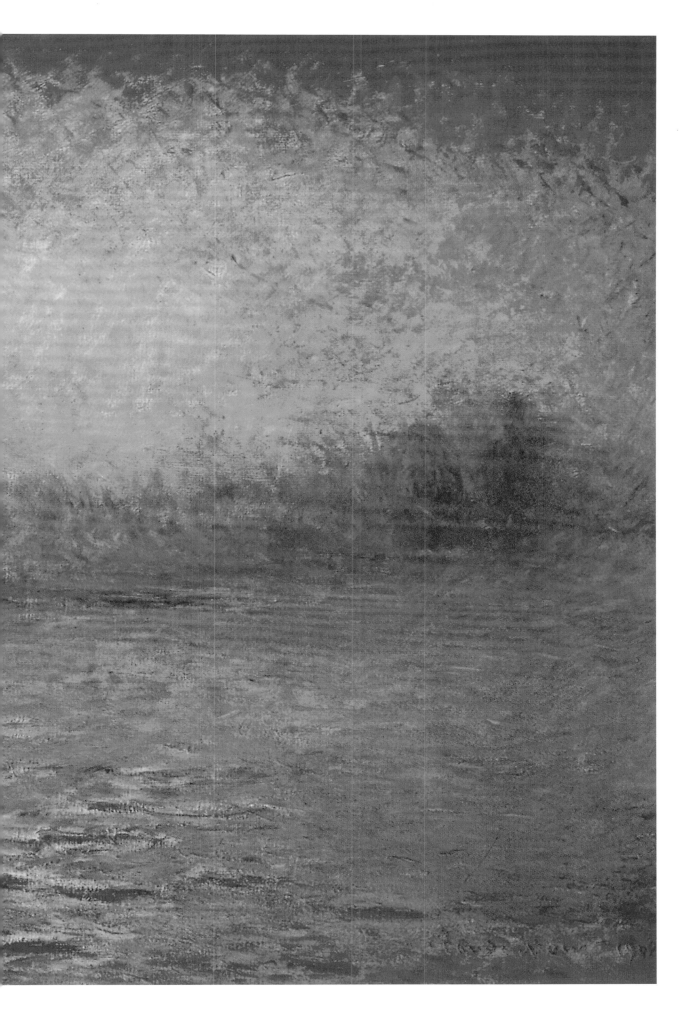

them to paint as they can and as much as they can without being afraid of poor results… If their painting does not improve of its own accord, then nothing can be done… and I could alter nothing."

He then added: "The techniques change, but art remains the same: it is the free and emotional interpretation of Nature." Monet rejected the expediency of practical teaching, but at the same time his own canvases taught many lessons. They taught the Neo-Impressionist Signac, the Nabis Pierre Bonnard and Edouard Vuillard, and they taught Vincent van Gogh, who dreamed of painting figures as Monet painted landscapes. The Fauvists, appearing at the beginning of the twentieth century, also discovered new truths, acquainting themselves with the work of Monet. But for the following generations of artists, Monet's painting seemed completely alien; the Cubists and Surrealists, with their distorted and arbitrary perception of reality, could find no point of contact with his canvases, filled as they were with the joyous assertion of life as it is. The line of continuity appeared to have been broken.

But crucial and formative periods in art do not pass without trace. Impressionism, as one of the most vivid manifestations of nineteenth-century Realism, undeniably belongs to this category, and the art of Monet was at the core of the whole Impressionist movement.

Monet died at Giverny 6 December 1926. He had survived all the other Impressionists, and had seen Matisse and the "Fauves" at the Autumn Salon of 1905. In 1907 he had witnessed the appearance of Picasso's Cubism. He had lost a son, dead in 1914, had watched the second go off to fight in the First World War, and had read the Surrealist Manifesto published by André Breton. The filmmaker Sacha Guitry has handed an extraordinary document down to us from the beginning of the twentieth century: scenes of famous old men and women of the time. The film preserved the features of Anatole France, Auguste Rodin, and of Renoir, trapped in his invalid's armchair. As for Claude Monet, Guitry found him in his garden, with his luxuriant beard, wearing a wide-brimmed panama hat. He is in the midst of painting a landscape, and a little dog is running about at his feet.

San Giorgio Maggiore by Twilight, 1908.
Oil on canvas, 65.2 x 92.4 cm.
National Museum of Wales, Cardiff.

Water Lily Pond, 1907.
Oil on canvas, 100 x 73 cm.
Bridgestone Museum of Art, Tokyo.

It is common to observe that at the end of his life, Monet was no longer an Impressionist. The *Water Lilies* is indeed painted, contrary to his custom, with big brushstrokes, the glittering light has dimmed, the juxtaposed touches of pure colour have disappeared, and the painting has become darker. Certain portions of the panel are painted with such large, indistinct patches of colour that the images of the trees and flowers disappear. The painting becomes almost abstract. But in front of

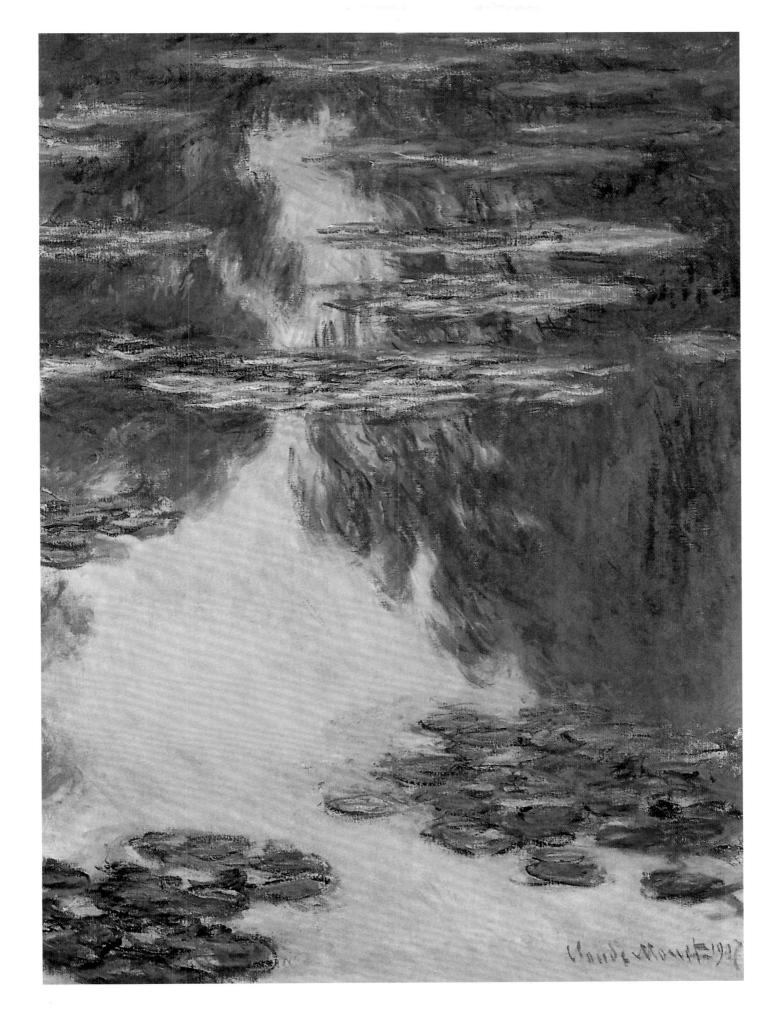

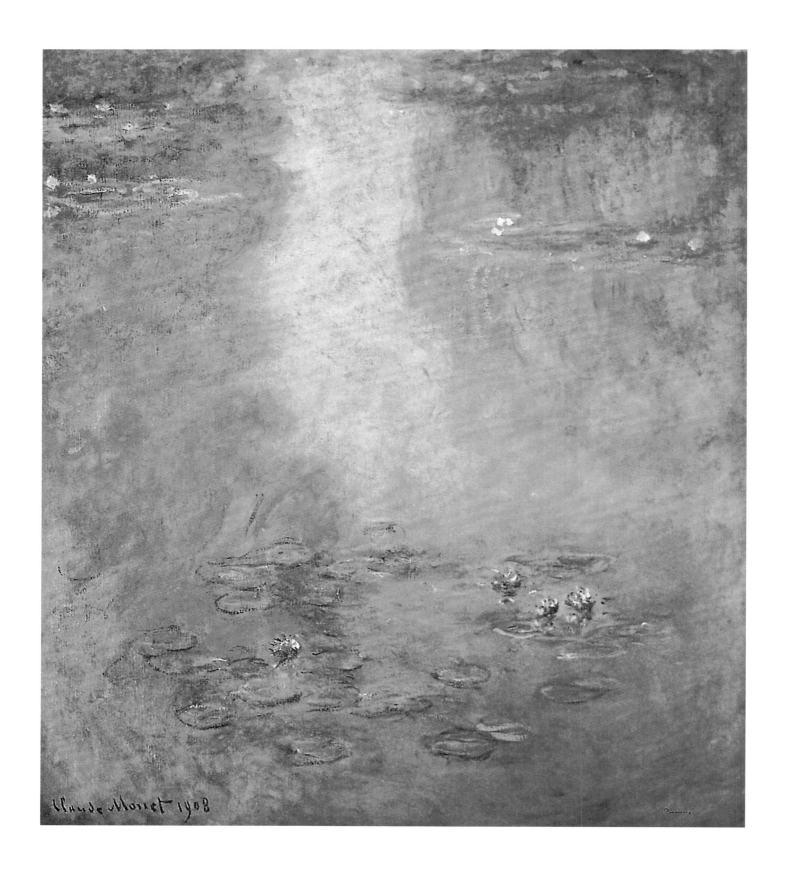

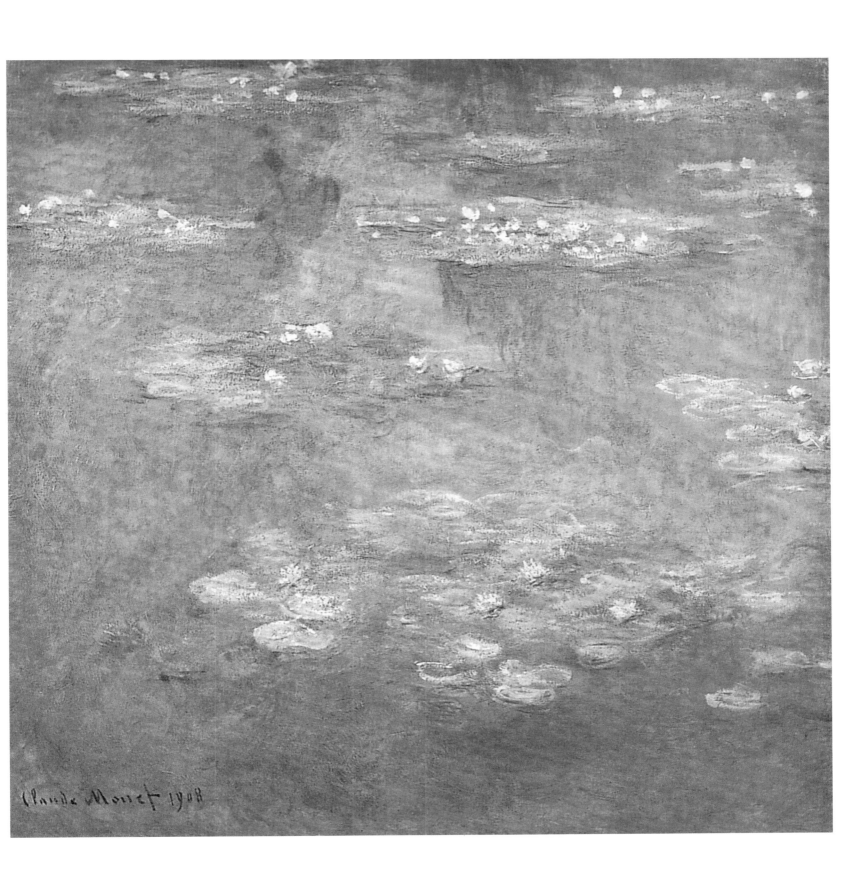

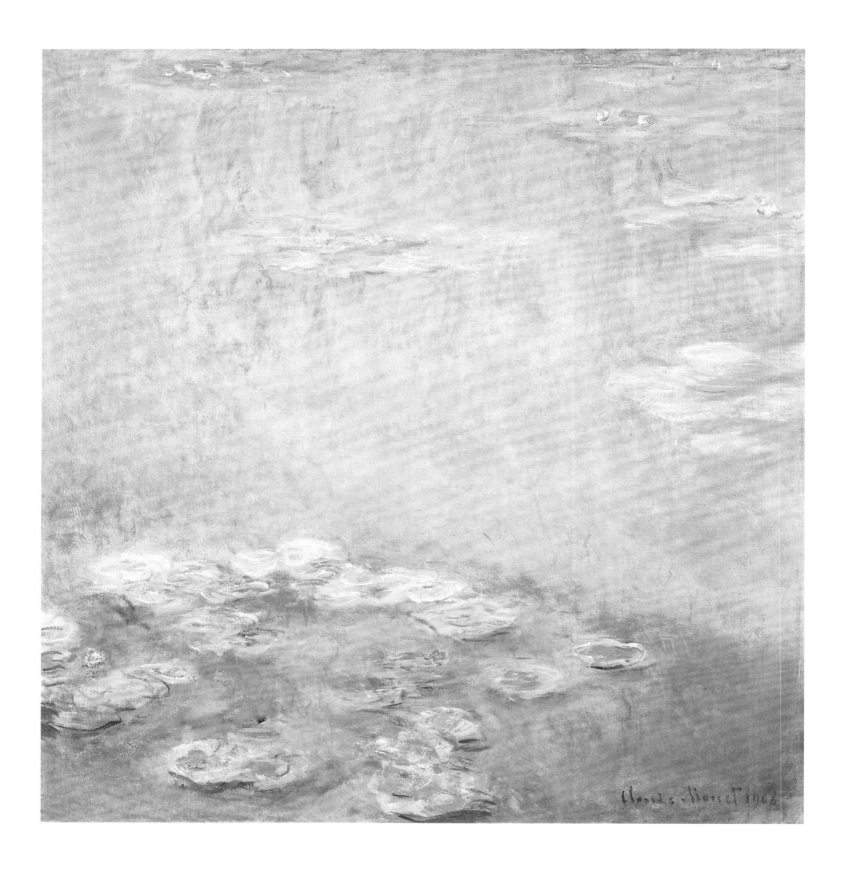

the *Water Lilies* one loses all sense of canvas and of colours. Monet's *Water Lilies* surrounds the viewer with the pond's stagnant water, with the waxy cup-shapes of his flowers, and the weeping willows bent over them. The impression of sensing nature's breath all around one is so intense that only an Impressionist could have produced it.

Monet's Reception in Russia

The question of the interpretation of Claude Monet's work by artists and critics from various countries could be the subject of an extensive study, and such a survey does not fall within our scope. We shall, however, dwell on one aspect of this problem, that is, the reception of Monet's art in Russia.

In 1875 Emile Zola, exiled from the French journals for his bold articles and novels, became, through Ivan Turgenev's mediation, a permanent correspondent of the Russian journal *The Herald of Europe*.

It was in the pages of this publication that in 1876 the name of Monet could be found among those of other artists close to Zola. The novelist remarked upon the brilliance of his brush, the simplicity and charm of his landscapes flooded with sunlight.

Russian artists staying in Paris or visiting the exhibitions in Moscow and St. Petersburg at the turn of the century at which canvases by Monet were displayed invariably lingered before the French master's paintings. Even if they did not accept Impressionism in its entirety or did not approve of Monet's individual manner, they were nonetheless unable to remain indifferent to his work.

Some of their remarks are astonishing in their accuracy, in some cases such as only an artist could achieve.

Thus Ilya Repin, in a letter from Paris to Ivan Kramskoi dated May 1875, noted the "childlike truth of Manet and Monet", finding just the right words to express the absence of premeditation, the sincerity of the artists in their communion with nature. Russian artists who matured in the early twentieth century revealed a still greater interest in Monet's work. In his book *My Life*, Igor Grabar recalls his impressions of Monet's exhibition at the Durand-Ruel Gallery in 1904: "I felt humbled by this titan of painting, who remains for me to this day unsurpassed, one of the greatest geniuses of all time along with Gustave Courbet, Edouard Manet and Auguste Renoir." It might be noted

Water Lilies, 1908.
Oil on canvas, 92 x 90 cm.
Private collection.

Water Lilies, 1908.
Oil on canvas, 90 x 92 cm.
Private collection.

Water Lilies, 1908.
Oil on canvas, 92 x 90 cm.
Worcester Art Museum, Worcester, Massachusetts.

that Monet took an interest in Russian culture too, though in the sphere of literature rather than painting. His letters to Alice Hoschedé from Brittany speak of his wide reading and among his favourite authors is Leo Tolstoy. "Tolstoy is so fine," Monet writes. "Perhaps you will find rambles, socio-philosophical questions, but it is very good, everything has been studied, carefully observed. You can fully imagine Russian life." Monet singled out in particular Anna Karenina and the "very naïve and very lovely fairy-tales for the people."

The displaying of his pictures at art exhibitions in Russia and the acquisition of his works by the well-known Russian collectors Sergei Shchukin and Ivan Morozov made Monet's paintings, like those of the other French artists represented in their collections, a part of the artistic life of Russia. They might be accepted with equanimity or with enthusiasm, rejected punctiliously or vehemently, but in any case people looked at them, and looked at them, moreover, not as at old paintings in a museum, but as at something topical and fresh. Russian criticism was not slow to express its attitude towards the Shchukin and Morozov collections.

They were written about most frequently by Sergei Makovsky and Yakov Tugendhold, mainly on the pages of the Russian journal *Apollo*. Alexander Benois, referring to Monet in *The World of Art*, was markedly restrained, but Makovsky, on the contrary, accepted Monet's art completely, seeing in him one of the seers of contemporary painting.

Of all the articles published in Russia at the beginning of the twentieth century concerning Impressionism and Monet, the most interesting are those of Tugendhold. A great connoisseur of modern French painting, he devoted many pages of his writings to Monet, and several of his articles were subsequently included in the volumes *French Art and Its Representatives* (1911) and *Problems and References* (1915). Well acquainted with many works by "the painter of the sea and the sky", as he called Monet, Tugendhold nevertheless concentrates his attention on the pictures belonging to the Moscow collectors. In his analysis of the paintings Tugenhold demonstrates Monet's evolution from the years of his brilliant successes in conveying sunlight and general movement in nature to his late manner, when, in the critic's opinion, "the exhausted brush of the aged artist could only repeat itself."

The article devoted to Monet in Tugendhold's book *The Artistic Culture of the West* must be seen as his most complete assessment of the artist; here he defines Monet's place from a historical perspective. Tugendhold examines him as an "innovator, as a leader" and also as the "contemporary and comrade-in-arms of a whole group

Water Lilies, 1908.
Oil on canvas, diameter: 81 cm.
Dallas Museum of Arts, Dallas.

Water Lilies, 1914-1917.
Oil on canvas, 200 x 200 cm.
Musée Marmottan, Paris.

Water Lilies and Agapanthus,
1914-1917.
Oil on canvas, 140 x 120 cm.
Musée Marmottan, Paris.

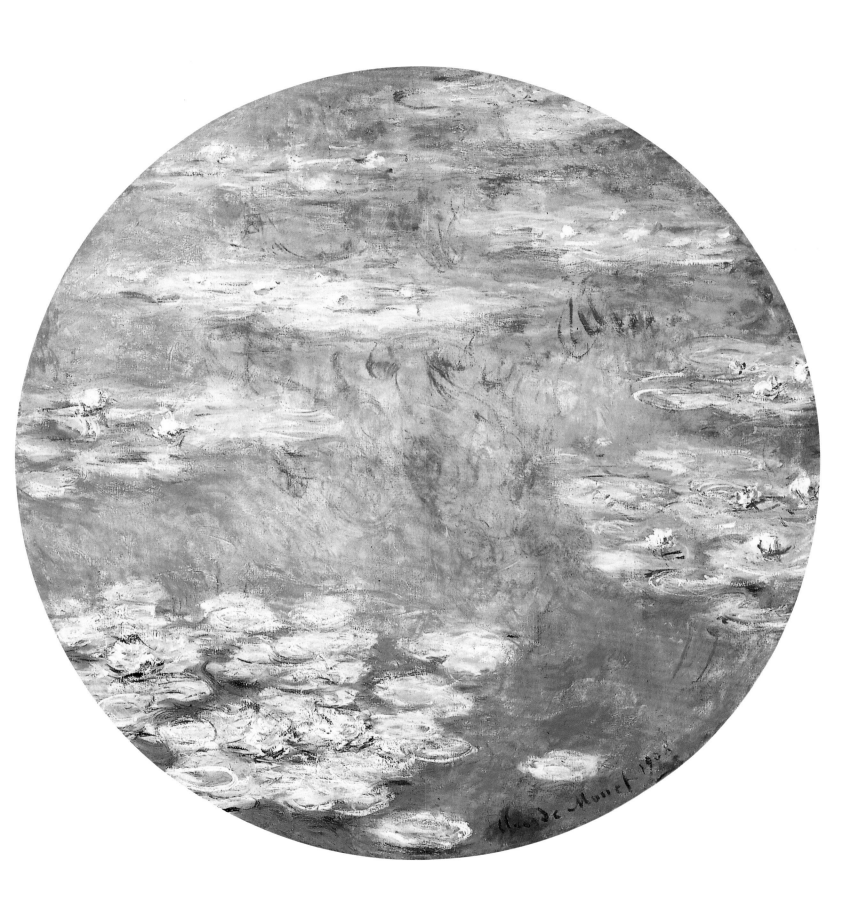

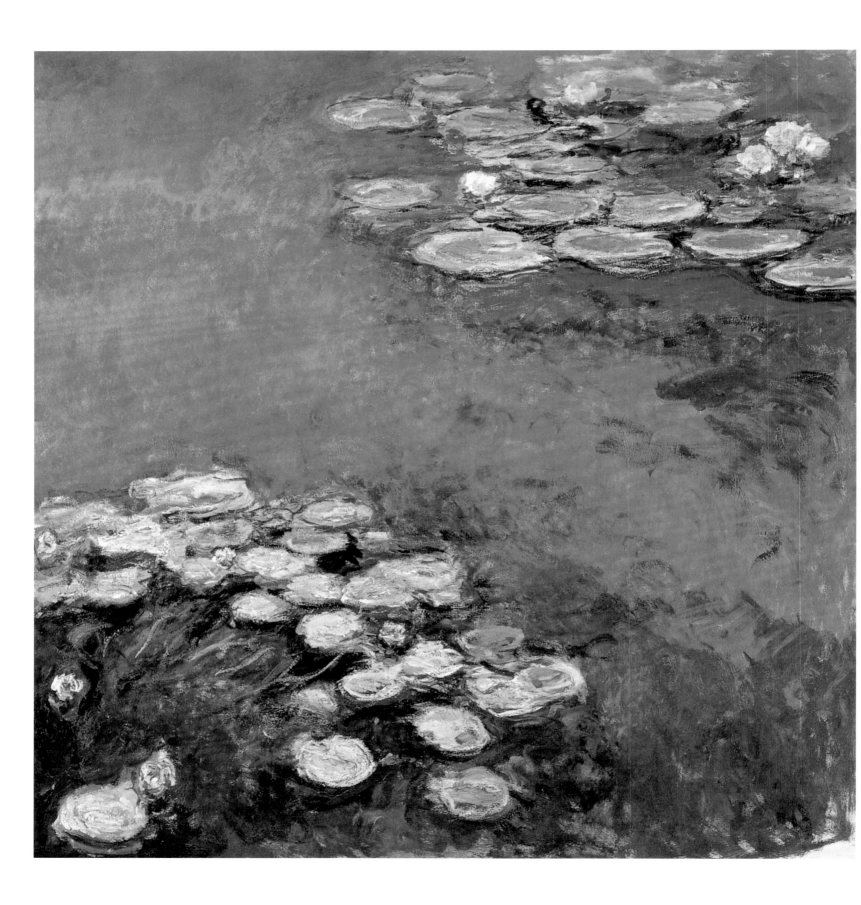

of artists, a spokesman for the ideas of his time." Tugendhold feels that Monet's greatest merit lies in his having captured the spirit of his age, an age which "developed along the lines of positive scientific thought; the light of knowledge strove to penetrate all spheres — even as far as analysis of the rays of the sun itself.

Monet... never theorized, but simply painted from nature, and painted with the spontaneous enthusiasm of a singing bird. But with his tremendous instinct, his feeling for contemporary man, he sensed the demands of his age..."

"Monet's art glorifies the sun, the air, the sea, vegetation... it is imbued with the joyous chimes of colours... even now it awakens in us bright and cheerful emotions." Thus Tugendhold defines the lasting value of the painting of Monet. One of the leading Russian art historians of his day, Boris Ternovets, arriving in France in 1925 and visiting Giverny, wrote afterwards to Monet "of the love for him in Russia, of the great influence he had exerted on Russian art, of the care that surrounded his works in Moscow." To such heartfelt words many a Russian might set his signature — both those who work in museums and those who visit them.

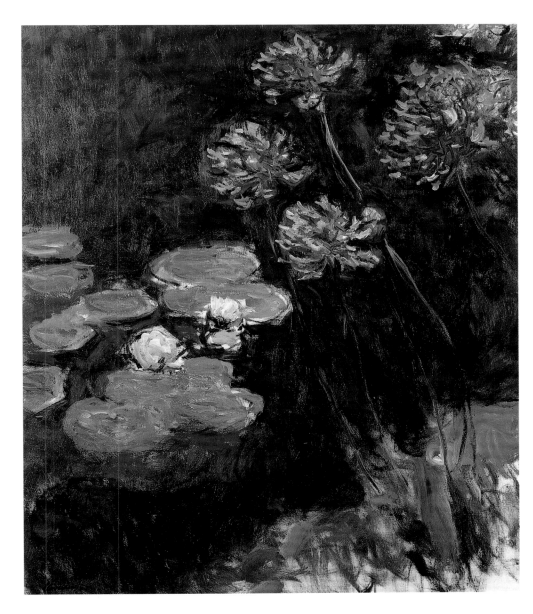

The paintings by Monet exhibited in Moscow and St. Petersburg provide all the necessary material for both close academic study of individual works and for the investigation of general problems. The earliest painting by Monet in Russian collections was done in 1866, the latest is dated 1904 — and thus "the Russian" Monet interestingly begins when the great artist was only just emerging and ends when his mission in art had already been accomplished.

Exhibitions

1874, Paris

"Anonymous society of artists, painters, sculptors and engravers. First Exposition".

1877, Paris

"Third Exposition".

1879, Paris

"Fourth Exposition".

1889, Paris

Georges Petit Gallery. "Claude Monet and Auguste Rodin".

1895, Paris

Durand-Ruel Gallery. "Claude Monet. Views of the Rouen Cathedral".

1900, Paris

Grand Palais. World Fair.

1903, Vienna

"Vereinigung Bildender Künstler (Association of Visual Artists). Austrian Secession".

1904, Paris

9 May – 4 June. Durand-Ruel Gallery. "Claude Monet: View of the Thames in London (1902-1904)".

1906, Paris

Durand-Ruel Gallery. "17 paintings of Claude Monet from the collection of J.-B. Faure".

1906, Berlin, Stuttgart

Paul Cassirer Gallery. "Manet-Monet. Collection of J.-B. Faure".

1907, Mannheim

1 May – 20 October. Städtische Kunsthalle. "International Art Exhibition".

1909, Paris

Durand-Ruel Gallery. "Claude Monet".

1939, Moscow

Museum of Modern Western Art. "French Landscape Painting. Nineteenth and Twentieth Centuries".

Les Arceaux fleuris, Giverny
(Flowering Arches, Giverny), 1913.
Oil on canvas, 81 x 92 cm.
Phoenix Art Museum, Phoenix, Arizona.

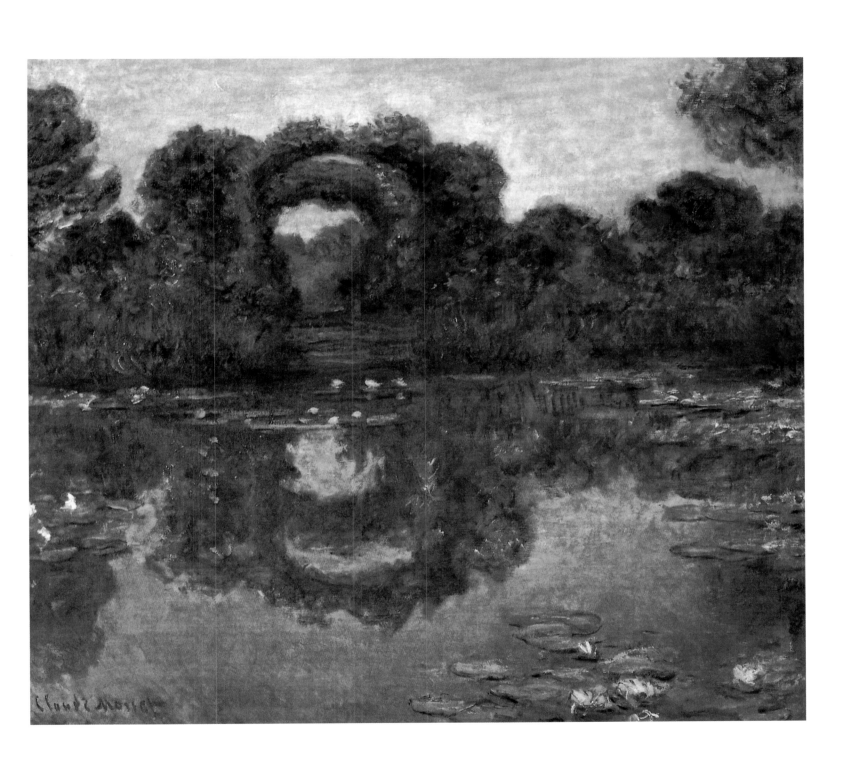

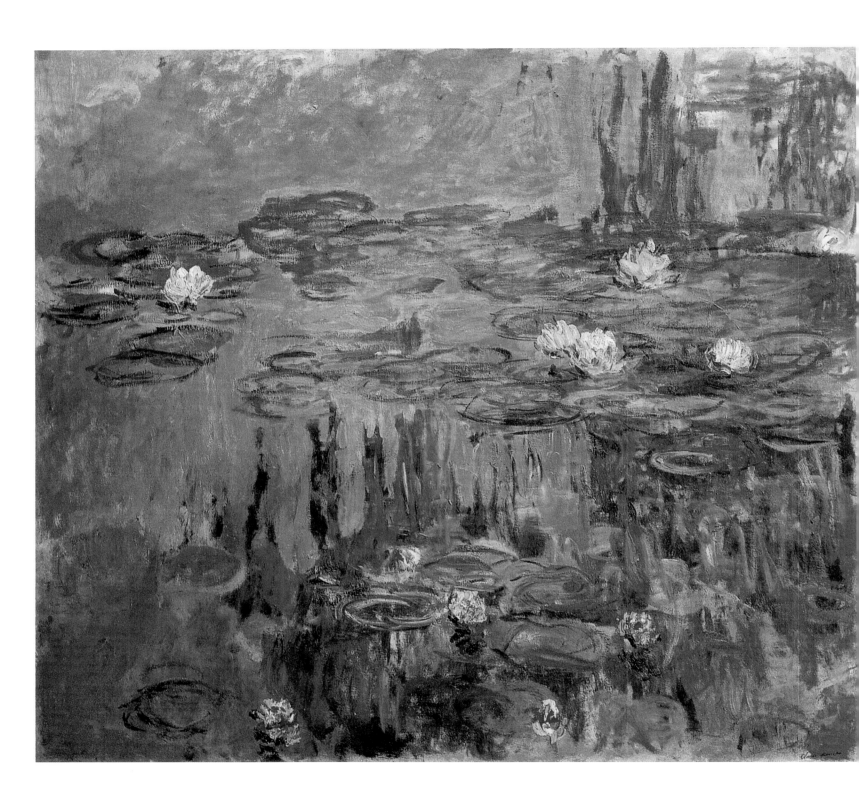

1955, Moscow

The Pushkin Museum of Fine Arts. "Exhibition of French Art: Fifteenth to Twentieth Century".

1955, Riga

Art Museum of the Latvian SSR. "Western European Art: Early Twentieth Century".

1956, St. Petersburg

The Hermitage. "French Art: Twelfth to Twentieth Centuries".

1960, Moscow

The Pushkin Museum of Fine Arts. "Exhibition of French Art of the Second Half of the Nineteenth Century from the Reserves of Soviet Art Museums".

1965, Berlin

National Galerie. "From Delacroix to Picasso".

1965-1966, Bordeaux, Paris

14 May – 6 September. Museum of Fine Arts.
September 1965 – January 1966. Musée du Louvre. "Masterworks of French Painting in the Museums of Leningrad and Moscow".

1966-1967, Tokyo, Kyoto

"Masterpieces of Modern Painting from the USSR".

1971, Tokyo, Kyoto

Tokyo. 10 April – 30 May. Kyoto 8 June – 25 July. "One Hundred Masterpieces from the USSR".

1972, Otterlo

April 30 – July 16. State Museum Kröller-Müller. "From Van Gogh to Picasso. Exhibition from the Pushkin Museum in Moscow and the Hermitage in Leningrad".

1972, Prague

Národní Galerie. "A Century of Drawings by European Masters from the collection of the State Hermitage Museum in Leningrad".

1973, Washington, New York, Chicago

Washington. National Gallery of Art. New York. M. Knoedler and Co. Los Angeles. County Museum of Arts. Chicago. The Art Institute. Port-Worth. The Kimbel Art Museum. Detroit. The Institute of Arts. "Impressionists and Postimpressionists Painting from the USSR".

Water Lilies, 1915.
Oil on canvas, 160 x 180 cm.
Portland Art Museum, Portland, Oregon.

Water Lily Pond, 1917-1922.
Oil on canvas, 130.2 x 201.9 cm.
The Art Institute of Chicago, Chicago.

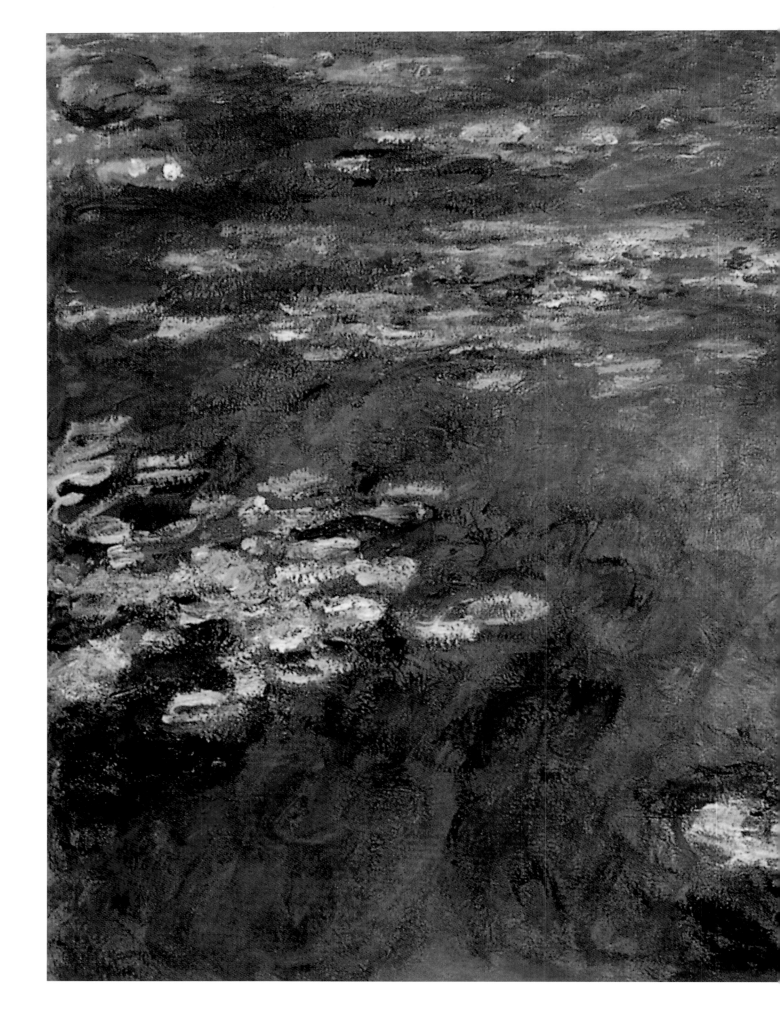

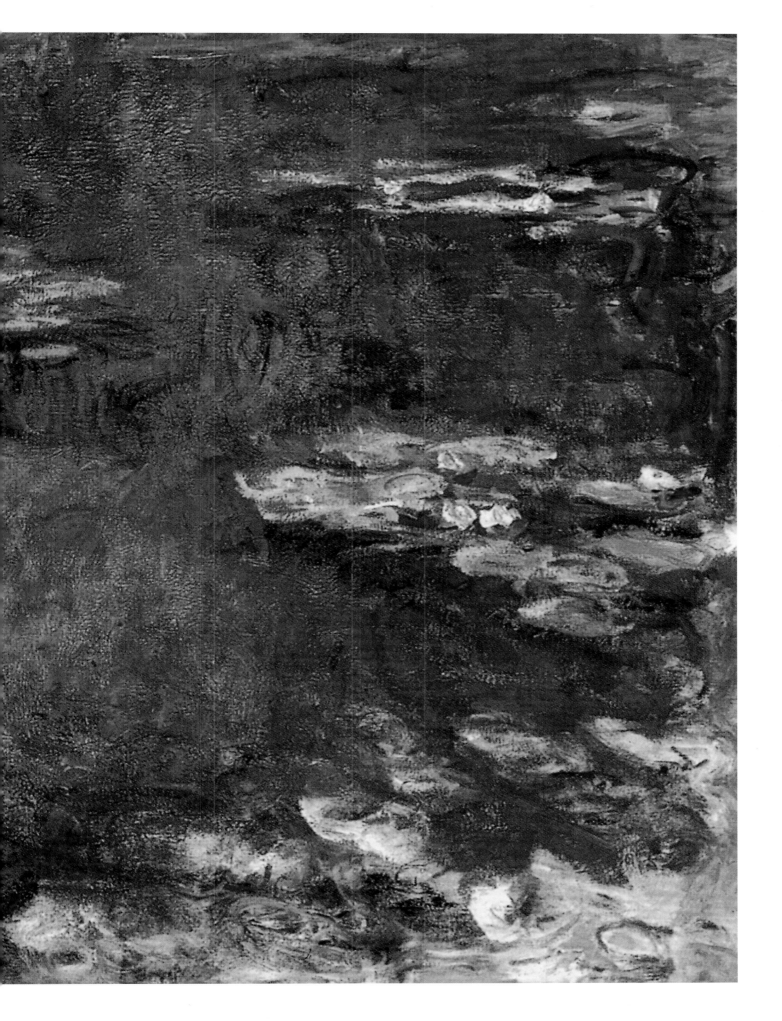

1973, Warsaw

Warszawa. Museum Narodowe. "Eighteenth to Twentieth Century French Painting from the State Hermitage Museum collection".

1974, St. Petersburg

The Hermitage. "Impressionist Painting. The Centenary of the First Impressionist Exhibition of 1874".

1974-1975, Moscow

The Pushkin Museum of Fine Arts. "Impressionist Painting. The Centenary of the First Exhibition of the Impressionists: 1874-1974".

1974-1975, Paris, New York

"Impressionism. Centenary Exposition".

1975, Budapest

"Masterpieces of the fine arts museums of the Soviet Union. An exhibition of select pieces from the collections of the State Hermitage Museum and Tretyakov Gallery".

1975, Moscow

The Pushkin Museum of Fine Arts. "Fifty Years of Diplomatic Relations between France and the USSR".

1976, Dresden

18 September – 31 October. Albertinum. "Masterworks from the Pushkin Museum in Moscow, and the Hermitage in Leningrad".

1978, Le Havre

23 May - 3 July. Musée des Beaux-Arts André Malraux. "Impressionist and post-Impressionist painting from the Hermitage Museum".

1979, Kyoto, Tokyo, Kamakura

"French Painters, Late 19th Century – Early 20th Century from the Hermitage and the Pushkin Museum of Fine Arts".

Les nymphéas à Giverny
(Water Lilies at Giverny), 1917.
Oil on canvas, 99 x 200 cm.
Musée des Beaux-Arts, Nantes.

Water Lilies, 1916-1919.
Oil on canvas, 150 x 197 cm.
Musée Marmottan, Paris.

Water Lilies, 1916-1919.
Oil on canvas, 150 x 197 cm.
Musée Marmottan, Paris.

1980, Paris

5 February – 5 May. Grand Palais. "Homage to Claude Monet (1840-1926)".

1981, Mexico

Museo del Palacio de Bellas Artes (Sala Nacional Cultural). "French Impressionists from the Hermitage and Pushkin Museums".

1985, Auckland

Auckland City Art Gallery. "Claude Monet, Painter of Light".

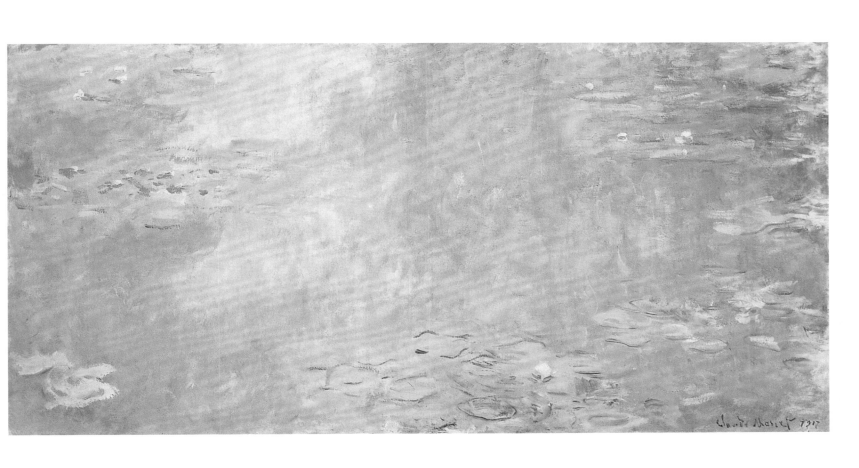

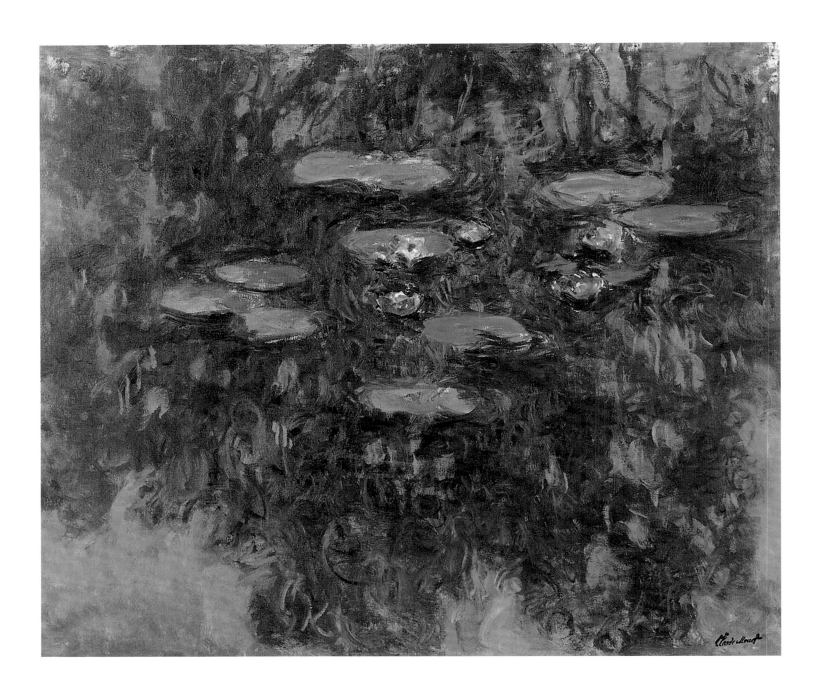

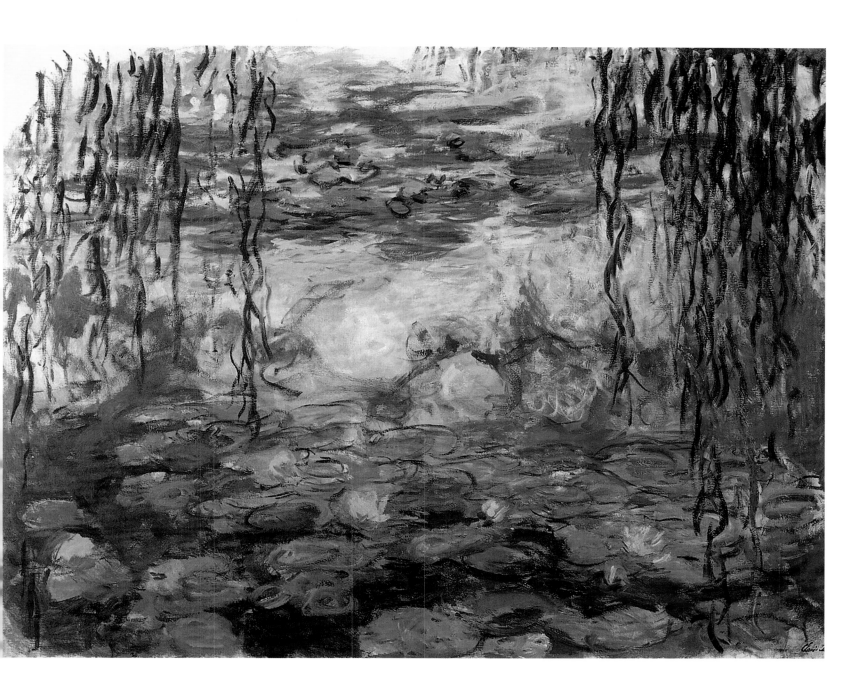

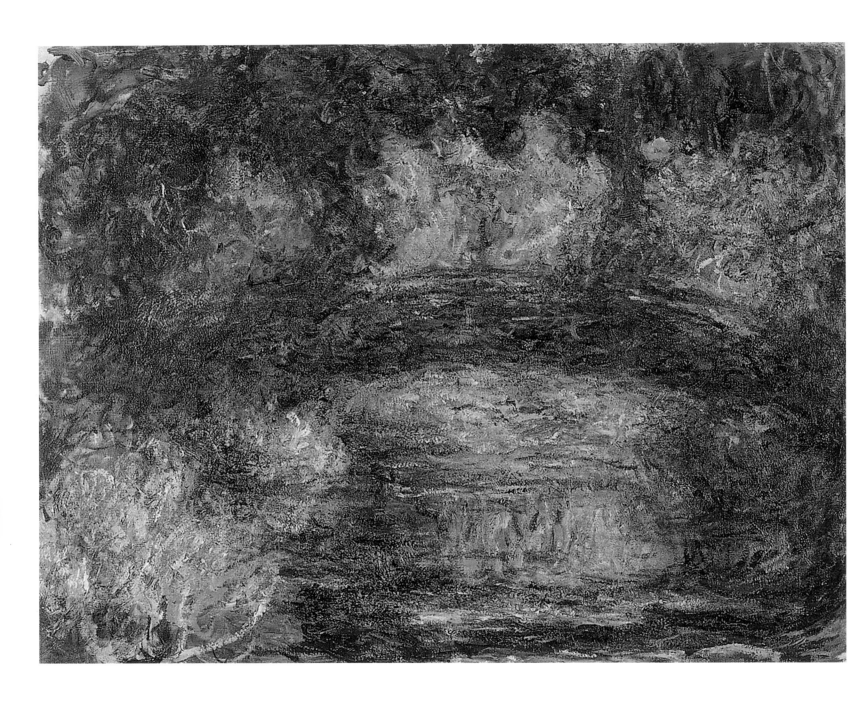

1986-1987, Naples, Milan

3 December – 1 February. "Impressionist Masterpieces from the Museums of America".

3 March – 10 May. "Impressionist Masterpieces from the Museums of America".

1990-1991, New York

14 September – 3 June. Brooklyn Museum. "Curator's Choice: Monet and his Contemporaries".

1992-1993, Fort Lauderdale

22 December – 11 April. Museum of Art. "Corot to Cézanne: 19th Century French Paintings from the Metropolitan Museum of Art".

1995, Chicago

22 July – 26 November. Art Institute of Chicago. "Claude Monet, 1840-1926".

1996, Vienna

14 March – 16 June. Österreichische Galerie. "Claude Monet," Vienna, 1996.

1997, Glasgow

23 May – 7 September. McLellan Galleries. "The Birth of Impressionism: From Constable to Monet," Glasgow, 1997.

1998-1999, Boston, London

20 September – 27 December. Museum of Fine Arts, Boston. "Monet in the 20th Century".

23 January – 18 April. The Royal Academy of Arts, London. "Monet in the 20th Century".

2000, Richmond, Virginia

19 September – 10 December. Virginia Museum of Fine Arts. "Monet, Renoir and the Impressionist Landscape".

2001-2002, Canberra

9 March – 11 February. National Gallery of Australia, "Monet and Japan".

2001-2002, Iwate, Japan

18 December – 11 February. Iwate Museum of Art. "Monet - Later Works: Homage to Katia Granoff".

2001-2002, München

23 November – 10 March. Kunsthalle der Hypo-Kulturstiftung. "Monet and the Modern".

The Japanese Bridge, 1918-1919.
Oil on canvas, 74 x 92 cm.
Musée Marmottan, Paris.

2002-2003, Boston

15 December – 13 April. Museum of Fine Arts. "Impressions of Light - The French Landscape from Corot to Monet".

2003, Edinburgh

6 August – 26 October. National Gallery of Scotland. "Monet: The Seine and the Sea. Vétheuil and Normandy, 1878-1883".

2004-2005, Toronto, Paris, London

12 June – 12 September. Art Gallery of Ontario. "Turner, Whistler, Monet: Impressionist Visions".

16 October – 16 January. Grand Palais. "Turner, Whistler, Monet: Impressionist Visions".

12 February – 15 May. Tate Britain. "Turner, Whistler, Monet: Impressionist Visions".

2005-2006, Bremen

15 October – 26 February. Kunsthalle Bremen. "Monet und Camille".

2006-2007, San Francisco

17 June – 17 September. Fine Arts Museum of San Francisco. "Monet in Normandy". San Francisco, 2006.

15 October – 14 January. North Carolina Museum of Art. "Monet in Normandy". Raleigh, 2006.

2006-2007, Paris

15 November – 25 February. Musée Marmottan. "The Japanese engravings of Claude Monet".

2007, Williamstown, Massachusetts

24 June – 16 September. Sterling and Francine Clark Art Institute. "The Unknown Monet".

2008-2009, Sydney

11 October – 26 January. Art Gallery of New South Wales. "Monet and the Impressionists".

2009-2010, Wuppertal

11 October – 28 February. Von der Heydt–Museum. "Claude Monet".

2010, Madrid

23 February – 30 May. Museo Thyssen-Bornemisza. "Monet and Abstraction".

2010-2011, Paris

22 September – 24 January. Grand Palais Paris. "Monet 2010".

2010-2011, Paris

7 October – 20 February. Musée Marmottan. "Claude Monet, His Museum".

The Japanese Bridge at Giverny, 1918-1924.
Oil on canvas, 86 x 116 cm.
Musée Marmottan, Paris.

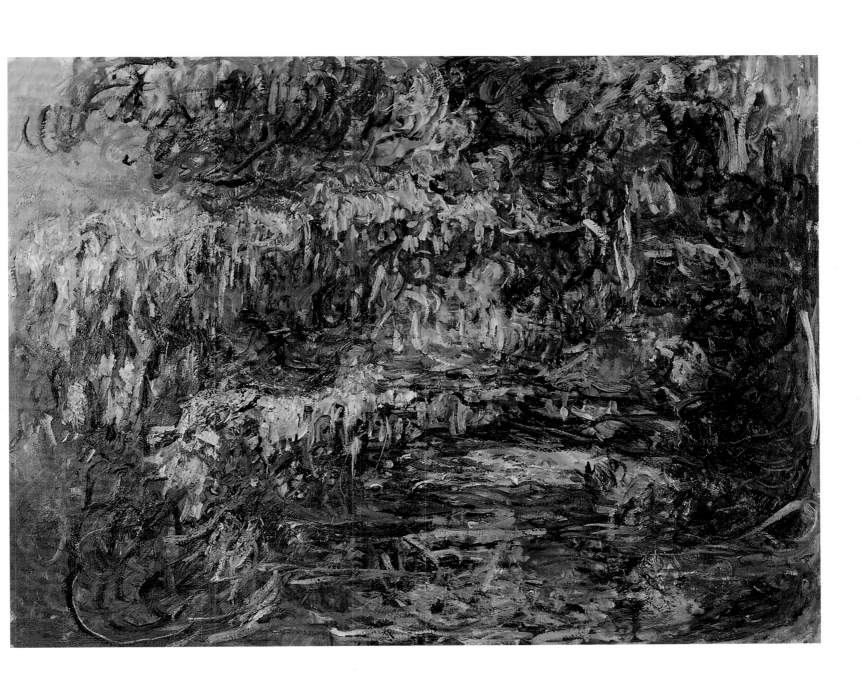

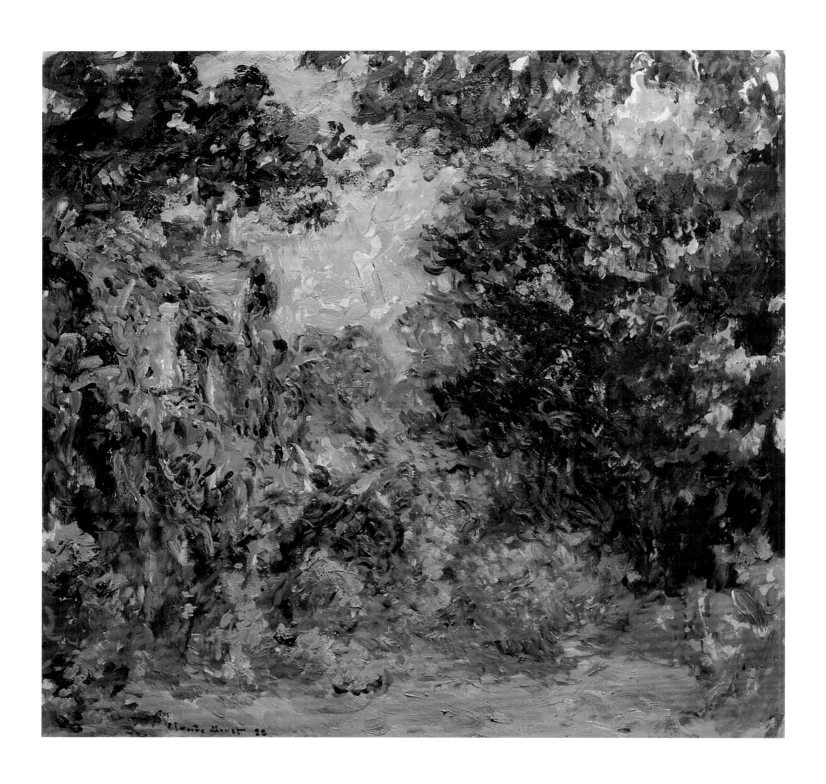

The Artist's House from the Rose Garden, 1922-1924.
Oil on canvas, 89 x 92 cm.
Musée Marmottan, Paris.

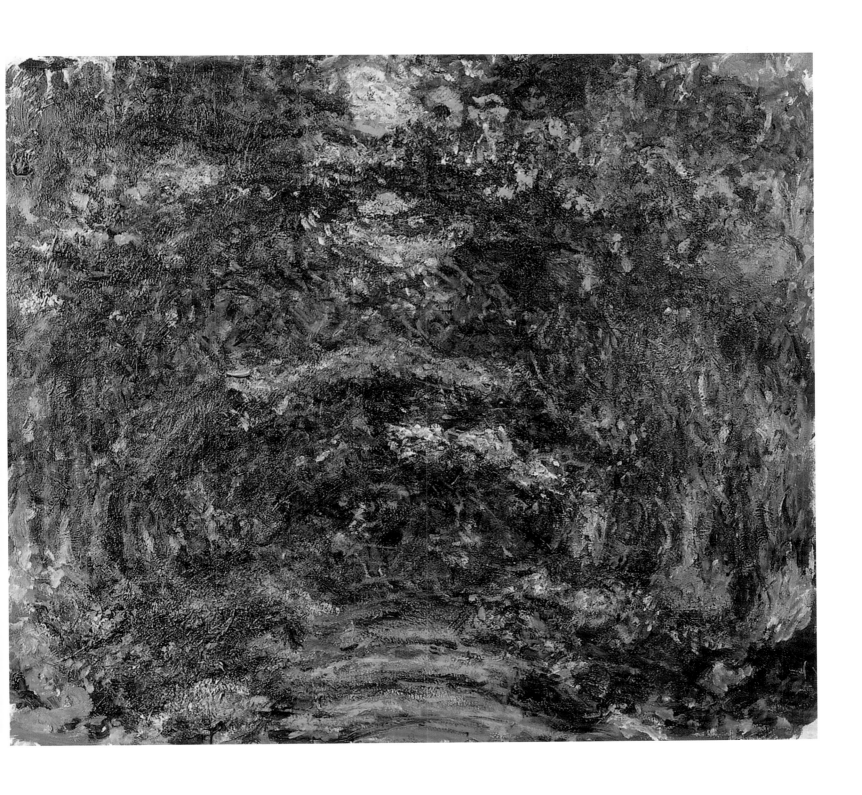

The Rose Path, Giverny, 1920-1922.
Oil on canvas, 89 x 100 cm.
Musée Marmottan, Paris.

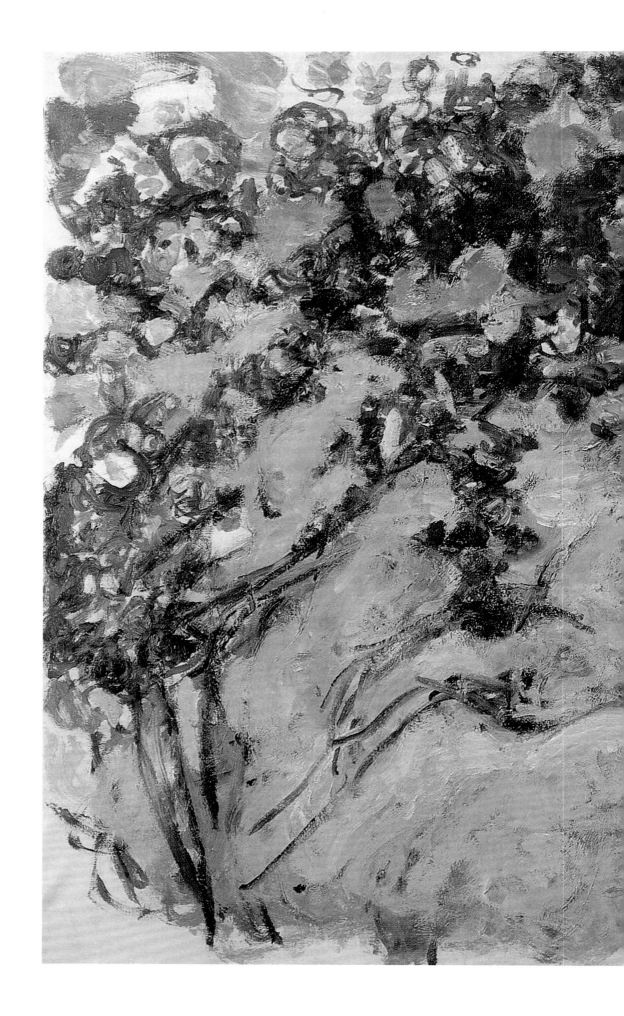

The Roses, 1925-1926.
Oil on canvas, 130 x 200 cm.
Musée Marmottan, Paris.

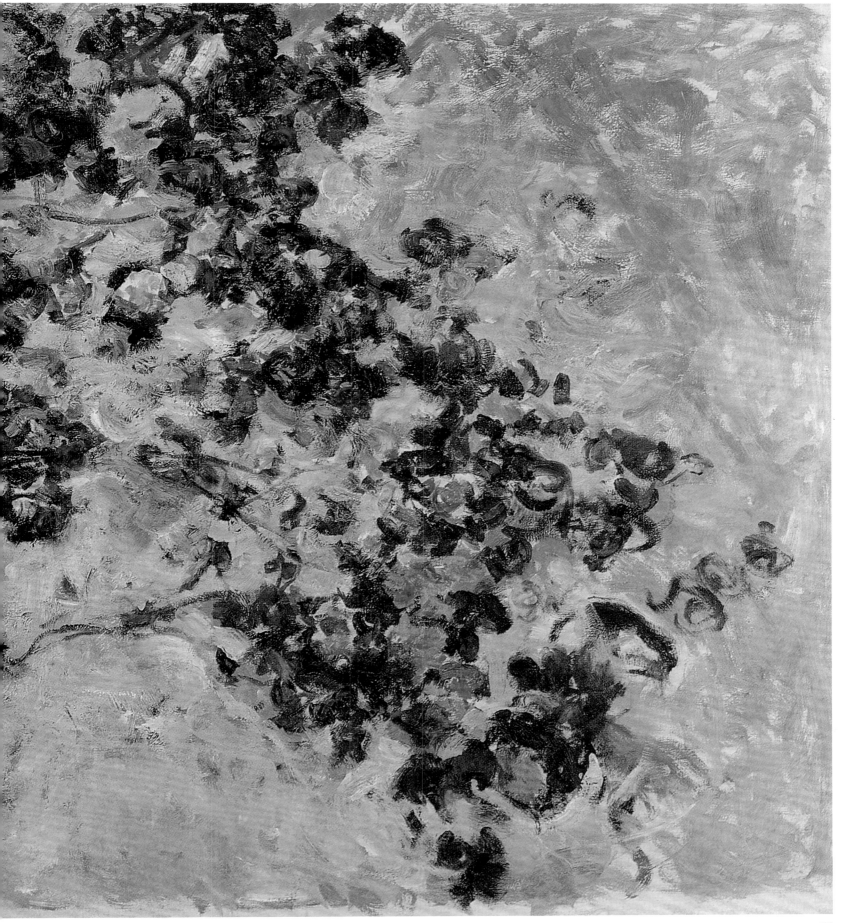

Biography

1840 November 14, Oscar Claude Monet is born in Paris.

1845 The Monet family moves to Le Havre.

1858 Makes the acquaintance of Boudin, who introduces him to plein-air painting.

1859 Goes to Paris. Meets Troyon. Frequents the Académie Suisse, where he meets Pissarro.

1860 Draws at the Académie Suisse. Paints landscapes at Champigny-sur-Marne. In the autumn, is called up for military service.

1861 Serves with the army in Algeria.

1862 Discharged for health reasons. In the summer, works at Sainte-Adresse together with Boudin and Jongkind. In November, returns to Paris. Attends the studio of Gleyre. Meets Renoir, Sisley and Bazille.

1863 Works at Chailly-en-Bière near Fontainebleau. At the end of the year Monet, Renoir, Sisley and Bazille leave the studio of Gleyre.

1864 Works at Honfleur with Bazille, Boudin and Jongkind. In Paris, meets Gustave Courbet.

1865 Exhibits two seascapes in the Salon. Spends the summer at Chailly together with Bazille. In the autumn, works at Trouville with Courbet, Daubigny and Whistler.

1866 Paints views of Paris. Exhibits *Woman in a Green Dress (Camille)* in the Salon. Meets Edouard Manet. At Ville d'Avray, paints *Women in the Garden*; in Le Havre, *The Jetty* at Le Havre; then works at Sainte-Adresse and Honfleur.

1867 Experiences financial hardship. Lives with his parents at Sainte-Adresse. In the autumn, returns to Paris.

1868 Works at Étretat and Fécamp.

1869 Together with Renoir, works at Bougival, where he paints *La Grenouillère*. Moves to Étretat, then to Le Havre.

1870 In September, goes to London.

1871 Stays in London. Daubigny introduces him to Durand-Ruel. Meets Pissarro. Travels to Holland. Reveals an interest in Japanese prints. Returns to France visiting Belgium on his way. In December, stays at Argenteuil.

1872 Together with Boudin, visits Courbet imprisoned for his participation in the Commune. Works at Le Havre, where he paints *Impression, Sunrise*. After his second trip to Holland, settles at Argenteuil (until 1878).

1873 Works at Argenteuil in a studio boat, painting the banks of the Seine.

1874 Shows nine works at the exhibition later to be called the *First Impressionist Exhibition* held at Nadar's (April 15 – May 15, 35 Boulevard des Capucines). Meets Caillebotte.

1875 Continues to work at Argenteuil. Difficult financial situation.

1876 In April, takes part in the *Second Impressionist Exhibition*, at the Durand-Ruel Gallery (11 Rue Le Peletier), showing eighteen works. Begins the *Gare Saint-Lazare* series, which he finishes the next year.

1877 In April, participates in the *Third Impressionist Exhibition* (6 Rue Le Peletier), displaying thirty paintings. Visits Montgeron. In the winter, returns to Paris.

1878 Settles at Vétheuil.

1879 At the *Fourth Impressionist Exhibition* (April 10 – May 11, 28 Avenue de l'Opera) shows twenty-nine paintings. Works at Vétheuil and Lavacourt.

1880 His one-man show at the premises of the newspaper *La Vie Moderne*. Works at Vétheuil.

1881 Works at Vétheuil, Fécamp and, in December, at Poissy.

1882 In March, at the *Seventh Impressionist Exhibition* (251 Rue Saint-Honoré) shows thirty-five paintings. Works at Pourville, Dieppe and Poissy.

1883 In March, holds one-man show at the Durand-Ruel Gallery. In May, stays at Giverny. Works in the environs of Vernon, in Le Havre, and at Étretat. In December, makes a short trip to the Mediterranean with Renoir. Visits Cézanne at l'Estaque.

1884 From January 17 to March 14, works at Bordighera. In April, stays at Menton; in August, at Étretat; in the autumn, at Giverny.

1885 Takes part in the *International Exhibition* at the Georges Petit Gallery. From October to December, works at Étretat.

1886 A brief trip to Holland. Refuses to take part in the *Eighth Impressionist Exhibition* (final). Contributes to the International Exhibition at the Georges Petit Gallery. A show of Monet's paintings in New York. In September, works at Belle-Île, where he meets Geffroy.

1887 Shows two paintings at the Exhibition of the Royal Society of British Artists in London.

1888 From January to April, lives at Antibes. In July, visits London. In September, returns to Étretat.

1889 In July, exhibition of works by Monet and Rosin (145 pieces) in the Georges Petit Gallery.

1890 Begins the *Haystacks* and *Poplars* series. Moves to Giverny.

1891 Continues his work on the *Haystacks* and *Poplars* series. The *Haystacks* series enjoys a success at the exhibition in the Durand-Ruel Gallery. In December, visits London.

1892 Exhibits his *Poplars* series. Begins the *Rouen Cathedral* series.

1893 Continues his work on the *Rouen Cathedral* series.

1894 Cézanne visits Giverny.

1895 In January, travels to Norway. Shows his *Cathedrals* series in the Durand-Ruel Gallery (May 10-31).

1896 In February and March, works at Pourville.

1897 From January to March, stays at Pourville.

1898 In June, takes part in the exhibition at the Georges Petit Gallery.

1899 Begins the *Water Lilies* series. In the autumn, goes to London, where he paints views of the Thames.

1900 In February, visits London again. In April, works at Giverny. Spends the summer at Vétheuil.

1901 In February and April, stays in London.

1902 Spends February and March in Brittany.

1903 Works on views of the Thames in London.

1904 Paints his garden at Giverny. Shows his views of the Thames at the exhibition in the Durand-Ruel Gallery (May 9 – June 14). In October, goes to Madrid to see works by Velázquez.

1906 Works on the *Water Lilies* series.

1908 From September to December, stays in Venice.

1909 In the autumn, returns to Venice, where he paints a series of views.

1912 Shows his Venetian series at the exhibition in the Bernhein-Jeune Gallery (May 28 – June 8).

1916 Begins work on the decorative panels the *Water Lilies*.

1921 A retrospective exhibition in the Durand-Ruel Gallery (January 21 – February 2). In September, a short trip to Brittany.

1922 Suffers from eye disease.

1923 Works on the decorative panels the *Water Lilies*.

1926 December 5, dies at Giverny.

Bibliography

H. Adhémar, "Modifications apportées par Monet à son *Déjeuner sur l'herbe* de 1865 à 1866", *Bulletin du laboratoire du Musée du Louvre*, 1958, No. 3.

A. Arséne, *Claude Monet*, Paris, 1921.

A. Barskaja, "New Information on Monet's work *Woman in a Garden*", *Bulletin from the State Hermitage Museum*, 1967, 38, p. 25-27

A. Barskaja, Claude Monet. *Woman in a Garden*. 1867, in: *Treasures of the Hermitage*, Leningrad, 1969, Erl. 112.

A. Barskaja, *Claude Monet*, Leningrad, 1980.

A. Barskaja, A. Isergina, *French Painting from the Second Half of the Nineteenth and the Beginning of the Twentieth Centuries*. The State Hermitage Museum, Leningrad, 1982.

G. Bazin, L'Époque impressionniste, Paris, 1957.

G. Bazin, Impressionist Painting in the Louvre, London, 1964.

A. Benois, "Letters from the Universal Exposition," Miriskusstwa (World of Art), 1900, No. 21-22.

G. Besson, *Monet*, Paris, 1914.

M. Bodelsen, "Early Impressionist Sales 1874-1894 in light of some unpublished procés-verbaux", The Burlington Magazine, 1968, July.

Catalogue of the Collection of French Art from the Fifteenth to the Twentieth Century, Leningrad, 1956.

Catalogue of the Impressionists Work, Leningrad, 1974.

Catalogue of the Collection of French Landscapes from the Nineteenth to the Twentieth Century, Moscow, 1939.

Catalogue of the Collection of French Art from the Fifteenth to the Twentieth Century, Moscow, 1955.

Catalogue of the Collection of French Art from the Second Half of the Nineteenth Century in the Reserves of the USSR Fine Art Museums, Moscow, 1960.

Catalogue of the Impressionists Work, Moscow, 1974.

Catalogue of Foreign Art from the Beginning of the Twentieth Century, Riga, 1955.

Catalogue of the State Hermitage Museum, Department of Western European Art, Painting Catalogue, Leningrad, Moscow, 1958, Bd. 1.

Catalogue of the State Hermitage Museum, Western European Painting, Volume 1, Leningrad, 1976.

Catalogue of the Louvre Museum, Catalogues des peintures, pastels et sculptures impressionistes. Musée National du Louvre, Paris, 1959.

Catalogue of the State Museum of New Western Art, Moscow, 1928.

Catalogue of Riga Museum, Catalogue of the Paintings. State Museum of Foreign Art of the Latvian SSR, Riga, 1955.

K. Champa, *Studies in Early Impressionism*, London, 1973.

Catalogue of the Pushkin Museum of Fine Arts, Catalogue of the Gallery of Painting, Moscow, 1957.

Catalogue of the Paintings from the Stschukin Collection, Moscow, 1913.

F. Daulte, *Claude Monet et ses amis*, Lausanne, 1993.

M.-Th. De Forges, *Barbizon*, Paris, 1962.

W. Dewhurst, *Impressionist painting*. London, 1904.

M. Elder, *À Giverny chez Claude Monet*, Paris, 1924.

P. Ettinger, "The modern French in the Moscow's collections" Die modernen Franzosen in den Kunstsammlungen Moskaus, Cicerone, 1926, Bd. 1, H. 1.

F. Fels, *Claude Monet*, Paris, 1925.

V. Fiala, *Impressionismus*, Prag, 1964.

G. Geffroy, *Claude Monet. Sa vie, son temps, son œuvre*, Bd. 1, 2, Paris, 1922.

J. Georgijewskaja, Claude Monet. "Le Boulevard des Capucines in Paris", in: *Kunstblatt*, 1962, Abb.

E. Georgijewskaja, *Claude Monet*, Moscow, 1973.

E. Georgijewskaja, I. Kusnezowa, *French Paintings from the Seventeenth to the Twentieth Century*. Moscow, Leningrad, 1980.

O. Grautoff, "Sammlung Serge Stschukin in Moskau", in: *Kunst und Künstler*, 1919, p. 86, Abb.

G. Groppe, *Claude Monet*, Paris, s.a.

The State Hermitage Museum, Leningrad. *French 19th Century Masters*, Prague, 1968.

J. Isaakson, Monet. "*Le Déjeuner sur l'herbe.*" New York, 1972.

M. Iwanow, *West European Artists in Riga State Museum of Fine Arts*, Riga, 1958.

N. Jaworskaja, *Romanticism and Realism in France During the Nineteenth Century*, Moscow, 1938.

N. Jaworskaja, B. Ternovetz, *The Artistic Scene in France in the second half of the nineteenth century*, Moscow, 1938.

I. Leymarie, *L'Impressionnisme*, Genf, 1955.

S. Makovski, "French Artists from the I. A. Morosov Collection" "Französische Künstler aus der Sammlung

I. A. Morosows, *Apollon*, 1912, No. 3-4.

C. Mauclair, *Claude Monet*, Paris, 1906.

C. Mauclair, *L'Impressionnisme*, Paris, 1904.

C. Mauclair, *L'Impressionnisme*, Paris, 1927.

O. Mirbeau, *Claude Monet. Vues de la Tamise à Londres*. Galerie Durand-Ruel, Paris, 1904. Monet (Livre illustré), Claude Monet. Bildband, Leningrad, 1969.

G. Moore, "Erinnerungen an die Impressionisten", in: *Kunst und Künstler*, 1907, p. 149.

P. Muratow, *Stschukin Gallery*, Moscow, 1908.

Le Musée de Moscou, *Le Musée de Moscou*, Paris, 1963.

M. Orlova, "Claude Monet", in: *Iskousstvo*, 1940, No. 6.

D. Pataky, *Monet*, Budapest, 1966.

P. Perzow, *French Painting from the Stschukin Collection*, Moscow, 1921.

G. Pouland, *Bazille et ses amis*, Paris, 1932.

W. Prokofjew (forward by), French Painting in the Museums of USSR. Livre illustré, Moscow, 1962.

A. Proust, *Édouard Manet*, Paris, 1913.

L. Réau, *Catalogue de l'art français dans les musées russes*, Paris, 1929.

R. Regamey, "La formation de Claude Monet", in: *Gazette des Beaux-Arts*, 1927, February.

J. Renoir, *Pierre-Auguste Renoir, mon père*, (OT: Renoir), 1981.

O. Reuterswärd, *Claude Monet*, Moskow, 1965 (Shortened Russian translation of the book: O. Reuterswärd, *Claude Monet*, Stockholm, 1948) abgekürzte Übersetzung ins Russische des Buches).

O. Reuterswärd, *Claude Monet*, Stockholm, 1948.

J. Rewald, *The History of Impressionism*, New York, 1946.

G. Rivière, "L'Exposition des impressionnistes", in: *L'Impressioniste*, 1877, April 6th, No. 1.

M. Roskill, "Early Impressionism and the Fashion Print", in: *The Burlington Magazine*, June 1970.

M. Sakke, A. Kosirowizki, Claude Monet's Painting *Winter Landscape*, Riga, 1959.

G. Sarraute, "Contribution à l'étude du *Déjeuner sur l'herbe* de Monet", Bulletin du laboratoire du Musée du Louvre, 1958, No. 3.

G. Seiberling, *Monet's Series*, New York, London, 1981.

A. Sensier, *Souvenirs sur Théodore Rousseau*, Paris, 1872.

M. Serullaz, *L'Impressionnisme*, Paris, 1961.

N. Sharowa, Claude Monet. 1840-1926. For his 100th Birthday, Moscow-Leningrad, 1940.

Ch. Sterling, *Musée de l'Ermitage. La Peinture française de Poussin à nos jours*, Paris, 1957.

B. Ternovetz, "Musée d'Art Moderne de Moscou", in: *L'Amour de l'Art*, December 1925.

B. Ternovetz, *Selected Essays*, Moscow, 1963.

U. Thieme, F. Becker, *Allgemeines Lexikon der bildenden Künstler...*, Bd. 1-36, Berlin and Leipzig, 1907-1950.

W. Trutowski, "Pjotr Iwanowitsch Stschukin Museum in Moscow," in: *Kunstschätze Russlands*, 1902, No. 6.

J. Tugendhold, *French Art and its Representatives*, St. Petersburg, 1911.

J. Tugendhold, "La Collection française de S. Chtchoukine", in: *Apollon*, 1914, No. 1-2.

J. Tugendhold, *Premier Musée de la nouvelle peinture occidentale. Collection S. Chtchoukine*, Moscou-Petrograd, 1923.

L. Venturi, *Les Archives de l'Impressionnisme*, Paris-New York, 1939, t. I, 2.

L. Werth, *Claude Monet*, Paris, 1928.

D. Wildenstein, *Claude Monet. Biographie et catalogue raisonné*, t. 1, Lausanne-Paris, 1974; t. 2, 3, Lausanne-Paris, 1979.

N. Wolkow, *The Colours in Painting*, Moscow, 1965.

Index